Painting the Gospel

THE NEW BLACK STUDIES SERIES

Edited by Darlene Clark Hine and Dwight A. McBride

A list of books in the series appears at the end of this book.

Painting the Gospel

Black Public Art and Religion in Chicago

KYMBERLY N. PINDER

UNIVERSITY OF ILLINOIS PRESS

Urbana, Chicago, and Springfield

Publication of this book was supported by a generous grant from
the Terra Foundation for American Art and funding from the
University of New Mexico College of Fine Arts

∞ This book is printed on acid-free paper.

Library of Congress Control Number: 2015956691
ISBN 978-0-252-03992-8 (hardcover)
ISBN 978-0-252-08143-9 (paperback)
ISBN 978-0-252-09808-6 (e-book)

The decorative element on chapter opening pages is a detail
from Damon Lamar Reed and Moses X. Ball's *Change Makers*
(figure 5.8 on page 129).

Contents

Illustrations

Figures

Maps

Acknowledgments

This book has been a long journey of biblical proportions for me about who I could be as a scholar and an art historian. I was generously supported by the National Endowment of Humanities, the Ford Foundation, the University of New Mexico, and the O'Keeffe Museum and Research Center. The School of the Art Institute of Chicago (SAIC) brought me to Chicago, where I fell into this topic and proceeded to gently pull the thread of a very complicated but exciting ball of yarn. As with my earlier book, *Race-ing Art History*, the support from my colleagues, administrators, and mentors at SAIC enabled me to pursue scholarship I felt passionately about but that was not necessarily on a traditional path. I must thank my observant and engaged students who traipsed around Chicago with me on occasions to view, photograph, and lend fresh eyes to these murals. I especially thank Jeanine Oleson and LaShawnda Crowe Storm—graduate students who were photographers—and the archivist Kate Dumbleton. Anna Kryzka helped photograph and conduct key research for chapter 2. Also, Cynthia Mills, editor at *American Art*, really helped shape chapter 1 when it was an article. The resources of the Smithsonian Archives of American Art and the Vivian G. Harsh Research Collection at the Chicago Public Library were invaluable. The pastors and dedicated staff at all of the churches were always kind and helpful in helping me navigate their institutions whenever I would ring the office bell, bring students, or call. The patience and perseverance of my editors Dawn Durante and Larin McLaughlin have been immeasurable, and without them and Amanda Wicks this book would have never made it to press. I continue to call "Reviewer B" for the University of Illinois Press my scholarly soul mate who really "got" what I was trying to do, and his/her thorough and loving comments, queries, and edits gave me the exchange I needed to make this book as articulate and legible as it is. Please call me, Reviewer B, we have so much more to talk about!

Befriending the mural community in Chicago and being inspired by the convictions of its champions at the Chicago Public Art Group like John Pitman Weber, Jon Pounds, Bernard Williams, and Jeff Huebner made me commit to public art. I have also had insightful vetting and encouragement by others, such as Ken Wissoker and David Morgan. SAIC professors Thomas Sloan, Lisa Wainwright, Carol Becker, and the late Robert Loescher Jr. were instrumental in encouraging my work. My esteemed colleagues and dearest friends James Elkins and Margaret MacNamidhe have proofread and brainstormed with me from the very first chapter. I also thank Professor Elkins for the numerous recommendations, sage advice, and fun and productive conversations about "what *kind* of writing should art historians and visual culturalists do and why should they even bother." So many of the redirections of this book stemmed from that question and what kind of audience I wanted for this project.

I often remarked before I finished this book that instead of a book I had three children. As they have made me a better person, Cyrus, August, and Eve have also made *Painting the Gospel* a much better book. I am sure you would not be reading this book if it had been the one I started in 1997. The delays caused by raising a family and other meaningful interventions enabled this research to deepen in a way it never would have if I had finished it all within a couple of years. Having grown alongside "Mom's book," my children have learned a lot about public art, radical race politics, and the variety of worship styles in their culture and in others. The main nurturer of my work and my sanity for the thirty years I have known him has been their father, Mark Caughey. His boundless support as a partner, parent, and resident genius has been invaluable. His love and humor have been a lifeline.

I also thank my parents, Howard and Rachel Pinder, who gave me the opportunities to be exactly who I am and to never compromise my goals no matter how long they may take to accomplish.

Painting the Gospel

Visualizing Christ Our Redeemer, Man Our Brother

The maids and the janitors they were in charge in church. They were in the deacon board; they were on the steward board; they were the ministers and such. So church was the place that affirmed your "somebodiness" in a society that treated you as nobody.

James Cone, the architect of Black Liberation Theology, on *Fresh Air*

Two weeks after celebrating the election of the first African American president in Grant Park, I was riding the Madison Street bus from Millennium Park across town to the West Side of Chicago when a local street preacher got on. He pulled a luggage cart with homemade banners of handwritten biblical passages strapped to it. He held two laminated pieces of color photocopies of recent magazine covers, one concerning science and God and another asking "Is Race Over?" with a picture of the newly elected Barack Obama. At one stop the preacher greeted another passenger when he got on the bus, and they immediately started "having church." The preacher, despite the noise and jerks of the crosstown bus ride, took out a bottle of Progresso olive oil and anointed his elderly congregant as we neared the United Center.[1]

Even a crowded urban bus can be a sanctuary serving a traveling ministry. Whether one takes notice of him or not, this spiritual soldier provides a public display of religion, of black religion in downtown Chicago and all along that Madison bus route weekly. His banners and current magazine covers are an organic and vernacular version of Black Liberation Theology, a theology that considers the importance of Christianity specifically for the concerns of black people and others who have been historically disenfranchised, culturally and economically. As defined by its creator, James H. Cone, "Black Theology

must uncover the structures and forms of the black experience, because the categories of interpretation must arise out of the thought forms of the black experience itself."[2] This bus pastor shows how the theological concept Cone named has been a staple of the black American religious experience since slavery and continues to manifest in a myriad of forms. The preacher's ministry is equally about religious salvation and racial politics. He can anoint you while also giving you a lecture on the implications of Obama's election for black Chicagoans.

Another street preacher is Samuel Chambers, who is known as the Old Navy Preacher because daily, he berates passersby to repent in front of the pop clothing store located at State and Washington. He has been preaching on that corner for more than thirty years.[3] The local street rapper Minister Popcorn hawks his homemade CDs just a block down from the Old Navy pulpit on Monroe. For five dollars you can listen to his hip-hop sermons about moral backsliding and how to keep the devil out of your ride.[4]

In June 2011 a large cardboard crucifixion scene appeared at the intersection of Grand, Milwaukee, and Halsted Streets. It was spray painted with biblical texts and multiple bright colors. This street altar dominated the busy intersection for a week until, like most street art, it disappeared.

Street preachers and devout graffiti embody the fusion of public display and pulpit activism that characterizes all of the public art, artists, and pastors in this book. I explore the visualization of religious imagery in public art for African Americans in Chicago between 1904 and the present, examining a number of case studies of black churches—some very prominent, some not—whose pastors have consciously nurtured a strong visual culture within their church. These sites enable me to chart how the arts interact with each other in the performance of black belief in each space, explain how *empathetic realism* structures these interactions for a variety of publics, and observe how this public art sits within a larger history of mural histories.

In 1986 Joseph W. Evans (1908–89) illustrated the motto of the Trinity United Church of Christ, "Unashamedly Black and Unapologetically Christian," with a painting of Jesus with dark brown skin and tightly curled black hair, his arms outstretched behind a smiling African American family (figure 3.1 on page 70).[5] This painting has a central location in the church's lobby and represents the Black Liberation Theology upon which its former pastor, Jeremiah Wright Jr., built the current two-thousand-strong congregation. Black affirmation and Trinity's social work in Chicago's South Side communities drew both Evans and Barack Obama to this church years before most

Americans even knew who Obama was. In his memoir *Dreams from My Father: A Story of Race and Inheritance*, Obama described attending services at Trinity:

> People began to shout, to rise from their seats and clap and cry out, a forceful wind carrying the reverend's voice up into the rafters. . . . And in that single note—hope!—I heard something else; at the foot of that cross, inside the thousands of churches across the city, I imagined the stories of ordinary black people merging with the stories of David and Goliath, Moses and Pharaoh, the Christians in the lion's den, Ezekiel's field of dry bones. Those stories— of survival, and freedom, and hope—became our story, my story; the blood that had spilled was our blood, the tears our tears; until this black church, on this bright day, seemed once more a vessel carrying the story of a people into future generations and into a larger world. Our trials and triumphs became at once unique and universal, black and more than black; in chronicling our journey, the stories and songs gave us a means to reclaim memories that we didn't need to feel shame about . . . memories that all people might study and cherish—and with which we could start to rebuild.[6]

Some of the strong political rhetoric in Wright's sermons almost cost Obama the presidency in 2008, and they made the Obama family break ties with Trinity. The controversy brought the cultural and political aspects of black worship into the spotlight of the popular media and public discourse. It addressed a Christian reality in the United States dating back to slavery: that American churches are some of the most segregated spaces in this country. Some congregants preferred to create a new denomination rather than integrate theirs.[7] Obama also addressed the question "Do black and white people worship not only separately but differently?" His description of how comforting Trinity's racially and historically aware ministry was to its congregation does not shy away from these differences but embraces them.

Trinity's visual material always portrayed a black Christ because the color of God can be at the crux of this segregation of faith. Black pastors have been forced to reconcile a black Christ with the concepts of *logos* (word made flesh) and *imago dei* (in God's image). The African Methodist Episcopal (AME) theologian George Gilbert Walker wrote often of a "God-man" that alluded to a black Christ because "Man is the image of God because man is spirit and personality; communion with God through the Incarnation must be through human personality."[8] There are many representations of black biblical figures, often imaged alongside black historical figures or portraits of everyday black

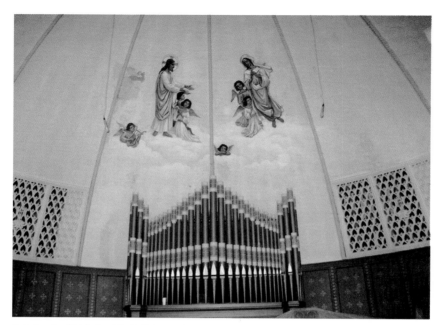

0.1 Proctor Chisholm, *Black Christ and Mary*, oil on plaster, 1904. Quinn AME Chapel, Chicago. Photo courtesy of Christopher Brancaccio.

people from the community. Proctor Chisholm's *Black Christ and Mary* (figure 0.1), dating from 1904, is the earliest extant mural with a black Christ figure in the city. It resides in the AME Quinn Chapel. In response to segregation within the Methodist congregations in Philadelphia, Reverend Richard Allen created this denomination in 1816 to serve the spiritual needs of African Americans throughout the mid-Atlantic states, and the faith quickly had churches in all major U.S. cities. Quinn is the oldest African American congregation in Chicago, founded in 1844, and the church was a site of refuge for the Underground Railroad.[9] In 1892 the current building by Henry F. Starbuck replaced the one lost in the Great Chicago Fire of 1871. Very little is known about Chisholm except that he was a self-taught artist who was a member of Quinn, and his racially empathetic imagery is consistent with the AME's founding principals as articulated in the original motto penned by Bishop Daniel A. Payne: "God our Father, Christ our Redeemer, Man our Brother."

According to the church's oral history, Chisholm painted the angel leaning on her arms at the bottom of the constellation after a young girl who always sat like that, leaning on the pew, each Sunday. The figures float in

the cream-colored space due to water damage. Sometime in the 1960s or '70s the sky background was painted over after peeling from water leakage. Quinn AME Chapel placed murals of a black Christ and Mary in its apse, Pilgrim Baptist Church brought in a muralist to create multiracial images of Christ and Thomas A. Dorsey to teach its choir gospel blues, First Church of Deliverance (FCOD) provided the first televised sermons, Saint Sabina has led national campaigns against gun violence, and Trinity United Church of Christ (TUCC) installed walls of stained glass depicting moments in black history; all are examples of black public religious agency discussed in this book. With more than eight hundred African American churches in Chicago, this book had to be structured around exemplary case studies. It does not claim to be a guide to Chicago's black churches. It is a guide to a number of major examples of religious art associated with some of the city's most historically significant black churches and art in their neighborhoods.

These images are not highly unusual, because placing black imagery in African American churches has become more common in the last few decades. However, it is not as widespread as one would imagine. Many African American churches may welcome pictures of black saints but still adhere to the European image of Jesus. The Afrocentricism of this study's images, made by both academic and self-taught painters, is not incidental. These images and the traditions to which they relate place this art in both a global and national history concerning theology, politics, and racial identity. They were participating in some of the most significant movements of black history, such as the political evolution of the AME Church at the turn of the last century to the activist Mural Movement, led by Chicagoan William Walker, in the 1970s. Chicago's black population, whose growth accelerated right before World War II, has contributed to the nation's cultural richness, from its blues tradition to its many native writers. Like other scholars of the Chicago Renaissance, I shift the spotlight from Harlem to the Second City, in this case to unearth an overlooked cache of cultural production: black public religious art throughout Chicago's South Side. The radical roots of the civil rights movements in the twentieth century in the black church are well known. This book takes this fact and recasts it within the overlooked landscape of the black public art, both inside and outside these edifices, as an active participant in this political history. My study teases out art historical and transdisciplinary lineages, such as the centrality of the visual in the formation of Black Liberation Theology and its role alongside gospel music and broadcasted sermons in the black public sphere. It is here that I am rewriting both mural art and church

histories. I first addressed the black Christ in fine art in my 1997 article "'Our Father God; Our Brother Christ or Are We Bastard Kin?': Images of the Suffering Christ in African American Painting, 1924–45." That imagery, found mostly in museums and private collections, begged two questions: Did most black Christians consume such radical imagery in the public sphere? Were black Christs also on the walls of black churches?[10] As early as 1995 I gave a talk on this material as a job candidate at the School of the Art Institute of Chicago. Once I started teaching there months later, Rolf Achilles, a faculty member and a stained glass historian told me about some relevant images he had encountered in a few local African American churches. As someone who had once researched and published on medieval pilgrimage badges and other private devotional objects, how religious pictures "work" for an individual or a community has always been of interest to me. The public dimension of the art inside and outside of these churches in Bronzeville, the historically African American area of the city that stretches roughly between 12th and 60th Streets, also engaged my research on American, mostly civic, murals in my doctoral thesis.

African Americans in this country and black Christians all over the world have frequently tried to reconcile European Christian traditions with their own cultural contexts in different ways, such as emphasizing the African presence in the Bible. Fashioning a Christ in one's own image is not a new phenomenon in art or religious history. Just as Asian artists in various countries have made the facial features of Buddha similar to those of their people, Ethiopians and other Christians of color have been making dark-skinned Christs and saints for centuries. Nevertheless, for black Christians living in societies that degrade blackness this idea becomes fraught with contradiction. As the black theologian Major J. Jones writes, "In the context of pro-White . . . culture, where one was treated less than human because of color, it became psychologically impossible for Black people not to have problems with God's color."[11] At certain moments of extreme racial disaffection and activism, such as after World War II and during the Black Power Movements in the 1960s and '70s, some blacks rejected Christianity because of its connection with white oppression, and they converted to Judaism or Islam.[12] For others, to reject this deeply rooted element of black culture would be too painful, and they either ignored the hypocrisy or made Christ black. Throughout this text, I will use the words "black," "African," or "Afrocentric," with the help of specific qualifiers, to denote the physicality of race as defined by brown skin, broader facial features, and kinky hair that are distinct from those characteristics associated

with Europeans. I am fully aware that not all Africans have these traits, that non-Africans can have these traits, and that not all black people are African. However, for the artists in this study, such physical markers were essential to their sociopolitical and artistic visualization of a black Christ. The adherence of these artists and their patrons to such essentializations of blackness underscores how high the stakes were and are in this cultural struggle for a positive image of African American spirituality. This disclaimer is acknowledging that the correct and most accurate terminology has yet to be created and that such vocabulary is biased and problematic in light of geographic, demographic, and biological realities.[13]

The black Christ has been a powerful trope for more than a century. Political and religious leaders in the last century, including Henry McNeal Turner, Marcus Garvey, Martin Luther King Jr., Father Divine (George Baker Jr.), and Jesse Jackson, among many others, have deployed the conflation of Christ's suffering with racial oppression, sometimes as a black Christ, in their activism. On August 31, 1924, in New York City, the Fourth International Convention of Negroes of the World closed with a unique ceremony that celebrated the Blessed Black Man of Sorrows and the Blessed Black Mary. With much fanfare and to a hall filled to capacity, a group of African American ministers declared Jesus to be black.[14] During the 1920s and '30s many people were questioning God's relevance to the African American community. In his 1920 poem "A Litany at Atlanta," W. E. B. Du Bois poignantly articulated the anger and the confusion: "Keep not thou silent, O God! / Sit no longer blind, Lord God, deaf to our prayer and dumb to our suffering. Surely Thou, too, art not White, O Lord, a pale, bloodless, heartless thing!"[15] In the March 1969 issue of *Ebony* magazine, Alex Poinsett investigated the trend among activist black pastors to "reject the 'honky Savior' created by whites." This article included large color images of five newly created (or modified) paintings and sculptures in Detroit and Philadelphia. Prominent black church leaders such as Reverends Albert B. Cleage Jr. and Jesse Jackson cite the geographical basis for Christ being nonwhite, which they use interchangeably with black.[16] In 1968 Devon Cunningham created a mural featuring a black Christ surrounded by a racial mix of angels at Saint Cecilia's Catholic Church in Detroit. It was one of the works of art that prompted the *Ebony* article. He was commissioned by the church's white pastor, Father Raymond Ellis, to paint a black Christ in the ceiling and to sculpt a black Mary in direct response to the city's devastating riots in 1967.[17] The centrality of the black Christ and Madonna reflects what I would like to call a "New Negro" shift away from the focus on Old Testament

themes so prevalent in the expressive forms of enslaved Africans when the Exodus narratives of Moses had a very specific relevance. The suffering and salvation of these figures is reflected in such iconic Negro Spirituals as "Go Down, Moses." As the spiritual "illustrates the effort to locate a source of hope and strength outside of the immediate existential reality of the faithful," gospel music provided the modern and contemporary black Christian inspirational figures of Christ and Mary, who were seen as civil rights figures fighting for justice and equality against all odds.[18]

Formally embraced as doctrine by the Black Liberation Theological Movement in the 1970s, the identification of physical and spiritual blackness with suffering and, therefore, with Christ, has been a fundamental theme in the black understanding of Christianity for centuries. One of the best-known spirituals expresses this notion: "Nobody knows the trouble I see / Nobody knows but Jesus." Christ's own difference, for which he was persecuted, becomes a source of empathy and identity for the African American. In this concentration on Christ's persecution, this empathy subordinates his racial alienation. This need to "blacken up" God in the United States began with the first converted slaves in the seventeenth century. Minister Henry McNeal Turner addressed this issue in a sermon in 1898: "Every race of people since time began, who have attempted to describe their God by words, or by paintings, or by carvings, or by any other form or figure, have conveyed the idea that the God who made them and shaped their destiny was symbolized by themselves, and why should not the Negro believe that he resembles God as much as any other people? We do not believe that there is any hope for a race of people who do not believe that they look like God."[19]

Many African American artists, including Jacob Lawrence, William H. Johnson, Aaron Douglas, Archibald Motley Jr., Frederick C. Flemister, Romare Bearden, John Biggers, David Hammons, and Renee Cox, addressed this struggle in their art by depicting racialized biblical subjects in the twentieth century (see figures 0.2 and 0.3). The image of Christ in their work engages issues of African American cultural identity that were relevant then and still are today.[20] As David Morgan forcefully argued in his study of the most popular mainstream image of Christ (figure 0.4) by the Chicagoan painter Warner Sallman:

> The strength of Sallman's *Head of Christ* for many Protestants (and non-Protestants) lies in its capacity to make visual and therefore to sometimes embody, the personal savior who "saves, comforts and defends" them, to borrow a catechetical phrase. The image has allowed many to gaze on what

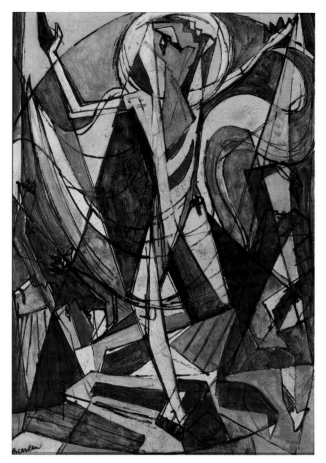

0.2 Romare Bearden, *Passion of Christ* series, watercolor and gouache, 1945. Indianapolis Museum of Art, James E. Roberts Fund, Cecil F. Head Art Fund, Mary V. Black Art Endowment Fund, Roger L. Williams Fund, 2006.111.

they believe Jesus is like, not just physically but spiritually. Physical appearance becomes countenance, a manifestation of personality in the face. In this manner, Christ's personal significance for one's life is made visual: the face that one sees belongs to divinity who cares *personally* for one's welfare. . . . Christ is encountered face to face.[21]

Depictions of a Jesus with dark skin and the conflation of the crucified Christ and the lynched black man present Christ as a symbolic device charged with racial-religious meaning.

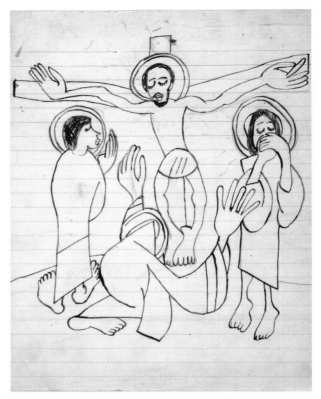

0.3 William H. Johnson, *Jesus and the Three Marys*, pen and ink and pencil on paper, 1939. Smithsonian Museum of American Art, Gift of the Harmon Foundation.

In some instances from the first half of the twentieth century, a one-to-one correlation was made between the crucified Christ and the lynched black man. In his recent book on this relationship as represented in African American literature, music, and theology, James H. Cone writes, "The lynched black victim experiences the same fate as the crucified Christ and this became the most potent symbol for understanding the true meaning of the salvation achieved through 'God on the Cross.'"[22] Although Cone does not illustrate one visual example,[23] artists have frequently depicted this trope in their paintings; for example, in Frederick C. Flemister's (1917–76) *The Mourners* of 1942, a woman wearing a shroud supports the languid form of the dead lynched man. A number of these paintings appeared in protest exhibitions at the height of a push for an antilynching law in the 1930s.[24] This racial and

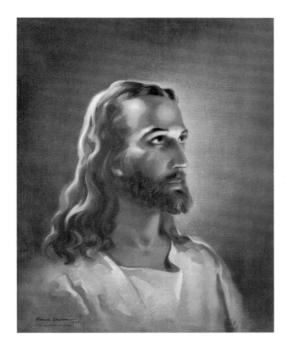

0.4 Warner Sallman, *Head of Christ*. ©1941 Warner Press, Inc., Anderson, Indiana. Used with permission.

religious conflation also had a contemporary literary tradition, as seen in Countee Cullen's epic poem "The Black Christ," published in 1929, in which the protagonist is lynched and then, like Jesus, resurrected:

> The world's supremest tragedy,
> Until I die my burden be;
> How Calvary in Palestine,
> Extending down to me and mine,
> Was but the first leaf in a line
> Of trees on which a Man should swing?
> World without end in suffering
> For all men's healing, let me sing.[25]

Of course, one cannot address African American religious painting without discussing Henry Ossawa Tanner (1859–1937). Although he is more widely known in the United States for his two genre scenes featuring African American subjects, *The Thankful Poor* (1894) and *The Banjo Lesson* (1893), this son of an AME bishop was the most internationally acclaimed black painter of the

nineteenth century for such religious works as *Raising of Lazarus* (1897), which won the Paris Salon Gold Medal in 1897. The racial authenticity of Tanner's biblical characters was important to him, and in the orientalist tradition, he made numerous studies of Jews in Palestine.[26] Tanner's work and influence on William E. Scott and his Chicago murals is addressed in chapter 1. William Edmondson, Clementine Hunter, Elijah Pierce, Thornton Dial, and Sister Gertrude Morgan are just a few in the long tradition of self-taught and vision-ary African American artists who create primarily religious imagery. These artists provide a broader context for such Chicagoans as Proctor Chisholm at Quinn, Reverend Samuel David Phillips, and Mr. Imagination (a.k.a. Greg-ory Warmack). As with the Madison Street bus preacher who traveled with magazine covers on cardboard, Sister Gertrude Morgan (1900–1980) painted placards to illustrate her street sermons in New Orleans in the 1950s and '60s. The preacher-painter Reverend Samuel David Phillips (1890–1973) was the pastor of his own storefront church, the Progressive Pentecostal Mission located at 43rd and State streets in Chicago, around the corner from Quinn, where he painted and hung elaborate Pentecostal charts and biblical illustra-tions mostly from the Book of Revelations on banners of oilcloth (figure 0.5). The public sculptor Mr. Imagination, or Gregory Warmack (1948–2012), was another local self-taught African American; his mosaic grotto is located in an art park, the Donnelly Community Center near Quinn, and other works of his appear in other locations in the city. Biblical figures were his most consistent subjects. Warmack was known for his site-specific work in which he covered entire façades with bottle caps, broken glass, and other such detritus. He was an artist for the House of Blues club and restaurant franchise. He exhibited his work nationally and internationally for decades. With the founding of the Intuit Center for Intuitive and Outsider Art in 1991, Chicago acknowledged the city's role in the history and preservation of self-taught art in the United States. The religious impulse in self-taught black art informs the particular history of visual piety that this book addresses.[27]

This book has three goals. The first goal is to embrace the definition of public art as a diverse set of visual gestures that provoke a dialogue in a public setting, either in a church or on the street—even moving through the community as clothing on one's body. I use the term *black public art* in the title of this book in order to signal the very complicated designations for the works herein. *Black*, as opposed to *African American* or *people of color* or *people from the African diaspora* (all terms I do use throughout this text), alludes very specifically to a politicized notion of a community that can be

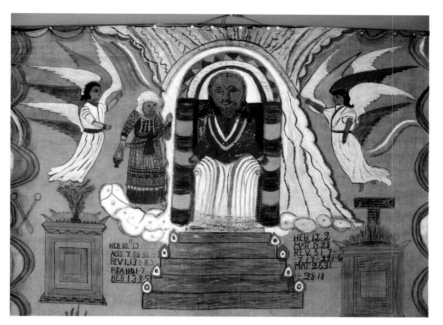

0.5 Reverend Samuel David Phillips, *Kingdom of Heaven*, pencil and crayon on oil cloth, ca. 1950. Created by the late Rev. Samuel David Phillips. Property of Turtel Onli, MAAT. Photo copyright Turtel Onli 2008. Courtesy of Mr. Turtel Onli.

both monolithic in its goals for equality and racial pride while also representing diverse individuals. The unwavering didactic nature, theological and racial, of every image in this book warrants the use of such a starkly political term. *Public art* is equally as fraught with both anchored and shifting meanings. In his introduction to *Dialogues in Public Art* (1992), Tom Finklepearl writes, "the word 'public' is associated with the lower classes (public school, public transportation, public housing, public park, public assistance, public defender) as opposed to the word 'private,' which is associated with privilege (private school, private car, private home, private country club, private fortune, private attorney)."[28] I trouble this binary in *Painting the Gospel*, not only with the addition of race but also with the relationship between the words *public* and *community*. *Black* and *public* highlight that the ideological goals of these works are to provide the social uplift and empowerment of their African American audiences.

Herein, *public* not only refers to that which is accessible to a large audience in a public space such as a church or street; it also implies a very specific

notion of community or belonging that is extremely positive despite the fact that the members of these communities may be accessing many of the public class symbols listed above.

As the sculptor Richard Hunt, whose abstract sculptures appear inside churches and on the streets of Chicago and elsewhere, articulates, "Public sculpture responds to the dynamics of a community, or of those in it, who have a use for sculpture. It is this aspect of use, of utility, that gives public sculpture its vital and lively place in the public mind."[29] I find the broad definition that Malcolm Miles offers in *Art, Space, and the City: Public Art and Urban Futures* the most useful as he cites the changing arenas and intentions for art in specific sites making this art more appropriately considered "the reception of art by publics."[30] John Pitman Weber, muralist and cofounder of the Chicago Mural Group and Restore Public Murals, contextualizes this type of art: "Community public art practice was created to function as a public space for symbolic free speech in neighborhoods—a space for expression created and leveraged by the various social movements of the 1960s and 1970s."[31] In her essay "The Public Display of Religion," Sally M. Promey reminds us of how unstable publics can be: "To discuss publics is thus to deal with entities both kinetic and partial. . . . The public display of religion is thus fundamentally interactive, the full range of interpretive responses inherently unpredictable."[32] For all of the works in this book, there are multiple publics or viewers, some known and others unknown passersby.

Another significant phrase for this work is its engagement with what Houston Baker has called *black publicness*.[33] A black publicness refers to an enactment of black identity in the public sphere that therefore enters, purposefully or not, into all representations of blackness. The history of negative imagery in American visual culture, in turn, always makes this dialogue public (with private ramifications) and constantly monitored. Rebecca S. Chopp adds spiritual identity into this equation when explaining the "narrative identity of the public," the stories we tell ourselves about ourselves, that provide "our fundamental assumptions, our images upon which we build our norms, our values such as courage, respect, dignity, and compassion."[34] As I will show, liberation theologies like black, feminist, and queer theologies have continued to create new forms of public discourse, and the artists and pastors in this book were shaped by these activist traditions. Their murals, stained glass, and sculptures address blackness in public art for black publics, and assert political agendas of equality and humanity through religious imagery.

The second goal of the book is to bring much needed attention to works of art that have been largely excluded from art historical, theological, and sociological scholarship because of their racial or religious particularity. And the third goal is to enable the real or virtual walker to consider the many conceptual, historical, and geographical connections among the art works through the actual maps in appendix 1. My readings of the public art herein are also about the spaces they and their viewers inhabit, black spaces. I bring these dynamic works of religious art into conversations—scholarly, preservationist, and otherwise—that make their importance known. The scholarship of architect and theorist Craig L. Wilkins has led this line of inquiry. In *The Aesthetics of Equity: Notes on Race, Space, Architecture, and Music*, Wilkins addresses Foucault's concept of heterotopias by creating an alternate category to those of crises and deviance, one that is celebratory:

> Celebratory heterotopias are created by spatial practices that challenge the very limitations and boundaries of crisis/deviant definitions. The relations that construct the celebratory contest constantly work and rework the very authority of these particular categorizations, in the process appropriating and palimpsestically altering dominant spatial understandings. The performed communication of the celebratory challenges the dominant spatial paradigm's essentializing ideology and questions its appropriateness as a "universal" aesthetic by demonstrating that alternate relations can be created. As such, it follows that alternate spaces—and heterotopias—can also be created.[35]

For Wilkins's thesis, hip-hop culture, especially its music, formed these spaces of resistance and identity formation. For the art in *Painting the Gospel*, Afrocentric religious imagery and faith help carve out celebratory heterotopias as they always have, even within hip-hop culture.

The academy, and especially those areas that examine modernism and postmodernism, have often dismissed such art because of its popular medium, its religious content, and its often noncanonical makers. As such scholars as David Morgan, Sally M. Promey, and James Elkins have noted, popular religious art forms often fall through the cracks of academic scholarship due to a confluence of factors, from the secularization of modernism, to shifts to formalism in art history, and to the ways such forms straddle multiple disciplines, among other reasons. Promey describes this exclusion in her 2003 *Art Bulletin* article as "a kind of figurative academic iconoclasm in art history's hesitation to authorize certain sorts of images and image content. Pursuing this line of thought to its logical conclusion, art history itself, especially in

the process of canon formation, can be seen as an inherently 'iconoclastic' discipline, granting standing, and thus visibility, to some visual practices and denying it to others."[36] I have followed the study of this type of imagery and the practices that produce them for the same reasons David Morgan articulates in his preface to *Visual Piety: A History and Theory of Popular Religious Images*: the "justification of historical analysis comes together in the investigation of how popular images contribute to the construction of reality, how, in other words, people use images to make and maintain their worlds."[37]

The scholarship on religious art is just one area that *Painting the Gospel* addresses; others include research on murals and church histories in Chicago. There is the more general historical work on African American religion by Franklin E. Frazier, Eric C. Lincoln, and Albert J. Raboteau. Anthony B. Pinn, a leader in the next generation of these scholars, explores the significance of popular culture in African American religious expression including his seminal text on rap music, *Noise and Spirit*. For examinations of African American religion in Chicago, the seminal 1945 sociological study by St. Clair Drake and Horace Cayton, *Black Metropolis: A Study of Negro Life in a Northern City*, was the first contextualized look at African American religion in the city. This work has become the cornerstone of such subsequent work as Wallace D. Best's *Passionately Human, No Less Divine*. Best fleshes out the histories of a number of prominent churches in Bronzeville and provides essential information on specific mid-twentieth-century religious leaders in the city. His examination of the First Church of Deliverance and its charismatic founder Clarence Henry Cobbs in his chapter on southern immigration's influence on the city's black churches was invaluable. However, like all of the church histories I have encountered, Wallace does not mention the murals and decorative doors by Frederick D. Jones that are such prominent features of the church. One recent book that addresses the aesthetics of some African American churches is photographer Dave Jordano's *Articles of Faith*.[38] This book of photographs with informational captions and a brief essay by the artist Carla Williams is exclusively about storefront churches in the city. Jordano shows the way in which each church created its own adornment using mostly found materials.[39] Among the sixty photographs in Jordano's book, only three show an image of a black Christ, because traditional white biblical imagery or representations of historical and contemporary African Americans are more common. The transient (these churches often close within two years) and conservative nature of these churches place them outside of my study.[40]

In terms of mural histories, Eva Cockcroft, John Pitman Weber, and James D. Cockcroft *Toward a People's Art*, the first comprehensive history of community-based murals from the 1970s to 1990s, focused on those in Chicago, Detroit, New York, and Los Angeles. In 2001 Mary Gray published *A Guide to Chicago's Murals*, which provided a much needed guidebook to many of the murals from the nineteenth century to 2000 throughout the city of Chicago. While Gray gives one-page descriptions of a number of African American murals, as well as secular murals by Scott, she only discusses two of the church murals and none of the mosaics or stained glass discussed here. *Urban Art Chicago*, by artists Olivia Gude and Jeff Huebner, is yet another guidebook to public art in the city. Like Gray's pocket guide, this study provides cursory descriptions but many images, often of work such as famous signs throughout the city. The conservationist Heather Becker's *Art for the People* provides an extensive record of those murals extant and lost in Chicago's public schools. Three of Scott's murals in schools are discussed. A recent book on African American murals, *Walls of Heritage, Walls of Pride*, edited by Robin Dunitz and John Prigoff, focuses on secular murals, mostly those created after 1970. The increase in civic funding for community murals around the country in the last two decades has encouraged more people to record the histories of these murals, as seen in Janet Braun-Reinitz, Amy Goodman, and Jane Weissman's recent book *On the Wall*.[41] Religious imagery remains largely outside of these surveys. As for religious art in American culture, David Morgan and Sally Promey have led the way in confronting the fear and neglect of religious art in academia, most notably in their edited volume, *The Visual Culture of American Religions*.[42] Religious historians Edward J. Blum and Paul Harvey recently published *The Color of Christ*, which offers a broad survey of how theologians, politicians, nationalists, and activists have used the race and ethnicity of Jesus in the United States for centuries. Unfortunately, the art is often illustrative and not always closely examined.[43]

Despite this body of literature, the significance of the African American church in Chicago's history is evident, yet the role of visual art in this history is still missing. In chapter 1, "Painting the Gospel Blues: Race, Empathy, and Religion at Pilgrim Baptist Church," I discuss Scott's murals at Pilgrim Baptist Church, a city landmark. Originally a synagogue designed by Louis Sullivan and Dankmar Adler in 1891, Pilgrim became the home of one the country's most politically influential black congregations when sold to the congregation in 1920. In the 1930s Thomas A. Dorsey introduced blues singing into

regular church services, making it the birthplace of gospel and one of the first megachurches in the United States. During these very same years, William E. Scott, who had painted a number of public and private murals in Chicago and Indianapolis, was painting multiracial interpretations of the Bible on the church's interior—according to surviving congregants, he worked even during Sunday services and choir rehearsals. I insert Scott's 1936 *Life of Christ* mural series into this rich narrative of artistic, sociological, political, and musical history. Gospel music also played a key role in the work of Dorsey's protégée Sallie Martin in a nearby Spiritualist church, the First Church of Deliverance (FCOD), that openly catered to working-class blacks, gay Bronzevillians, entertainers, and prostitutes that I discuss in chapter 2, "Come unto me all ye that labour and are heavy laden: First Church of Deliverance and its Media Ministry." FCOD's charismatic founder Clarence Henry Cobbs commissioned the black architect Walter T. Bailey to renovate his church, a converted hat factory, and hired Frederick D. Jones to paint a set of murals that emphasized the inclusive and progressive aspect of his urban church. FCOD was also the first black church to have televised services in 1953, making it a forerunner in the worldwide televangelist movement. I consider Jones's murals as one piece in Cobbs's media ministry.

Chapter 3, "Black Liberation Theology, Black Power, and the Black Arts Movement at Trinity United Church of Christ" addresses the Black Mural Movement in the context of much of this church imagery by focusing on the evolution of Joseph W. Evans Jr.'s art. In 1986 Evans (1908–89) illustrated the motto of Chicago's Trinity United Church of Christ, "Unashamedly Black and Unapologetically Christian" with a painting of a Jesus with dark brown skin and tightly curled black hair, his arms outstretched around a smiling African American family. He had not always painted Christ black. In fact, his murals dating from the 1950s in the Metropolitan Community Church, located farther north, show a European figure based on the more mainstream images by Warner Sallman. In the 1970s Evans joined TUCC, where the pastor, Jeremiah Wright Jr., promoted Black Liberation Theology and recommended specific texts and sermons for the artist to study that transformed his conception of Christ.

Evans painted other murals in the city, and one can trace the radicalization of his faith through them as he increasingly made the imagery in the biblical stories relate to his African American audience. Evans used his talents to start an art program at the church, becoming the primary designer for all of Trinity's materials, and with Wright he started a collection of African and African

American art for the church, including stained glass windows installed after the artist's death. I discuss all of this activity in relation to the Organization for Black American Culture (OBAC) and the Black Mural Movement, both founded in Chicago in the late 1960s. The maps at the end of the book help show the links among artworks discussed in chapters 1 through 4. For example, Evans's first religious murals at the Metropolitan Community Church are located close to William E. Scott's series at Pilgrim and numerous murals by William Walker, Mitchell Caton, and others from Afri-COBRA (African Coalition of Bad Relevant Artists) and OBAC. Walker summed up the purpose of this work in the community: "Our murals will continue to speak of the liberation struggles of black and Third World peoples; they will record history, speak of today, and project toward the future. They will speak of an end to war, racism, and repression; of love, of beauty, of life. We want to restore an image of full humanity to the people, to place art into its true context—into life."[44] One can easily walk from one location to another as Evans may have done, since he also lived in that neighborhood. Also nearby is Scott's mural *Mind, Body and Spirit* (1936) in the Wabash YMCA, which depicts African American Christians active in all professions. It is my contention that the Afrocentric, race-affirming imagery found in a variety of popular arts, including murals, stained glass, printed programs, and television broadcasts produced for these African American churches and their artists, provided a very accessible model of black nationalist public art decades before the much better known "race" movements.

The fourth chapter, "Father Tolton's Soldiers: Black Imagery in Three Catholic Churches," examines the Faith Community of Saint Sabina, Saint Elizabeth Catholic Church, and Holy Angels churches because each has pastoral leadership that makes a conscious effort and commitment to engage a visual culture for the spiritual benefit and racial uplift of their congregants. Sabina's activist white pastor Michael Pfleger leads this church with more than seven hundred African American members and features interior decorations that include a baptismal font shaped like an African drum and a mural of a black Christ at the altar. Pfleger has led very public campaigns to protect prostitutes, to eliminate alcohol in local advertising, and, most recently, against school violence. I examine the role of the visual, such as crosses and coffins as props in Pfleger's public, often televised, demonstrations and his own refashioning or "blackening" of his white body with certain garments, language, and performative gestures during Sunday services. Deploying recognizable black religious traditions, Pfleger foregrounds his

activist ministry in the visualization of the real and the imagined blackness of his congregants and himself. The discussion of the art history of African American Catholics continues in the chapter with Saint Elizabeth Catholic Church's exterior mosaics of black martyrs and church fathers. The church also houses two large-scale portraits of black saints that appear to be by Pilgrim's muralist, William E. Scott, discussed in chapter 1. Artist Ildiko Repasi sheds light on how her mosaics adorning the exterior of Saint Elizabeth's had to conform to the spirit of the heavily damaged work that she was initially commissioned to repair. Those compositions from decades earlier focused on the history of those figures in Catholicism relevant to black Catholics and Saint Elizabeth's history. This chapter ends with the most abstracted work in this study, the liturgical sculptures of Richard Hunt at Holy Angels Catholic Church.

In the book's final chapter, "Urban Street Faith: Murals, T-shirts, and Devout Graffiti," I discuss more contemporary work, such as Bernard Williams's black biblical figures in the apse of Saint Edmund's Episcopal Church. As a principal artist in the Chicago Public Art Group (CPAG), Williams has been the lead restorer for most of murals by William Walker discussed in relationship to the Black Mural Movement and Black Liberation Theology in chapter 3. Williams discusses what he learned from working with Walker and how the Saint Edmund's committee directed the content of his mural there in relation to the newly installed stained glass program of important black heroes. Father Richard Tolliver considered murals and stained glass an integral part of his revitalization of Saint Edmund's. Williams also helped restore Jones's FCOD mural and created a copy of it in the current pastor's private home. He also created a number of local community murals. *Painting the Gospel* ends with the mural ministry of Damon Lamar Reed. Reed was trained at the School of the Art Institute of Chicago, where he became involved in restoring a number of murals with CPAG as an apprentice to Williams. This work led to him creating his own murals throughout the city. In all of his art making, he uses his faith to guide others. Reed creates murals, T-shirts, graffiti, and rap music that reflect his devout Christian principles.[45] Many of his images include a youthful black Christ on the cross. Reed's consumers are predominantly African American and below the age of thirty. There is a local hip-hop Christian ministry scene in Chicago to which he belongs that also caters to this group of young Christians. Their services frequently feature rapping and graffiti writing. Reed's multimedia outreach introduces the T-shirt as public art. Like the conflations of the black Christ with the pastor

at Pilgrim and FCOD, Reed's work also merges the painted image of Jesus with that of a real black body, the one within the T-shirt. The conceptual artist Vito Acconci has also written about the T-shirt as public art: "Or, instead of spaces that people have to stop at and slip into, public art furnishes spaces that house people as they keep moving: it might be in the form of vehicles, or it might be clothing, that takes as its model the T-shirt that invites you to read text at the same time as it dares you to stare at the breasts behind it. The end is public, but the means of public art might be private."[46] The political power of the portable, concealable, and mass distributed T-shirt is not at all new. Wearing T-shirts with political leaders or slogans on them has been a powerful subversive practice for most of the twentieth and twenty-first centuries. During the height of protest against racial apartheid in South Africa, that government even banned T-shirts that depicted the radical leader, later martyr, Steve Biko. Distributors were jailed and some were killed. During election years in the United States there are always incidents over controversial shirts and bumper stickers. Schools often ban certain types of messages, logos, and even styles of T-shirts, recognizing this potential power of clothing. In the last decade, the extra large "white T," an icon in hip-hop culture, has made aerosol artists consider the body as a "wall" for celebrations of and memorials to musicians, rappers, or loved ones, as in the ubiquitous RIP compositions that feature a painted or silk-screened photo portrait with graffiti embellishments.

This book not only contextualizes these murals, mosaics, sculptures, and stained glass but also offers maps and weblinks to encourage readers to visit these large-scale works. Mirroring what is covered in the text, appendix 1 lists addresses of sites and maps at the end of the book that enable the real or virtual walker to consider many of the art works in a conceptual, historical, and geographical framework that includes other significant African American art and relevant sites nearby. The sites are organized as thematic tours that highlight the vibrancy of the connections among the works and how visually and culturally layered this area of Chicago is. These suggested tours are based on actual tours I have given in the city to my students and visiting scholars. Taking cues from the reality of moving through the streets of Chicago's South Side itself, I have connected the many church decorations to murals and sculptures one also encounters near these sites, such as those commissioned by the 1994 City of Chicago's Bronzeville Public Art Project, which involved more than twenty artists commissioned to create sculptures for the main thoroughfares that surround the churches in this book. Or there

is Richard Hunt's *Jacob's Ladder* (1971) in the Carter G. Woodson Library, located across the street from Trinity United Church.

As the gospel song laments, "it's been a long time comin." I started researching black Christs and this church imagery in Chicago more than a decade ago, and my journey as a scholar with this material reflects how the intersection of religious art and black history transformed how and why I write. Having to speak to so many different people in many different "languages," from academic to vernacular, from art historical to theological, shaped the goals of this book over time. As Dwight Hopkins mandates in his book *Heart and Head: Black Theology—Past, Present and Future* (2002), "Unfortunately, academic institutions have not appreciated fully the rich experiences and accumulated wisdom within faith communities and the broader American public. . . . African American theologians must maintain creative and critical relationships to the black church—whether in forms of teaching . . . or regularly sharing their ongoing academic work with laypeople . . . and place liberation theology in conversations at different levels."[47]

This book provides a logical ligature within a chronology, a geography, and themes concerning black public art and religion in Chicago's African American communities. Through this process I learned how much something as grand and imposing as a thirty-foot-long mural can become so much a part of its location that it is almost invisible and how much an art historian can miss something as grand and imposing as spiritual inspiration while only seeing the aesthetic object in front of her. Approaching these objects less as objects and more as entities in their own right helped me further understand the complicated position that some of these images have held for their viewers and caretakers.

The strength of these particular images lies in their ability to empower viewers through what I call in the book empathetic realism. Bill Walker or Joseph Evans may have called it a "full humanity." According to Cone, the black Christ helps all viewers see the universality of suffering. My term "empathetic realism" is very similar to the literary term "poetics of testimony," which, according to Chopp, "not only invites these diverse voices to speak and be heard, questions the politics of the private/public separation, and requires the ethos of the public to be guided through an ethical responsiveness to the other or an ethos of cultivating compassion."[48] Christ as a dreadlocked black man on the cross, hip-hop youth kneeling at his feet, and Mary as an African woman in traditional Nigerian dress activate personal narratives for a black audience where private and public, the personal and the holy, the

real and the represented, all meld allowing for a spiritually transformative experience. Because the physicality of the black body is a significant locus for expressions of black faith and black theology, as Cornel West describes, "Existential freedom in black Christianity flows from the kinetic orality and affective physicality inherited from West African cultures and religions. This full-fledged acceptance of the body deems human existence a source of joy and gaiety. Physical participation and bodily involvement in religious rituals epitomizes this kind of freedom."[49] The realism in these works is defined by both their representational nature and their attention to the everyday experience—often combining biblical and historical figures and events with contemporary ones. The transformative power of experiencing the black Christ for the black viewer can also be explained by David Freedberg's description of the spiritual empathy one may experience upon seeing the realistically rendered sculptural tableaux of biblical scenes known as *sacri monti* that became very popular in Europe in the sixteenth century. These scenes, often made of life-size figures with real clothes and human hair were so effective because they provided the "automatic transition from seeing to empathy and involvement."[50] Oppressed Christians who already feel an affinity with figures like Mary and Christ through suffering are more primed for such a transition. As the historian of African American religion Albert J. Raboteau has so eloquently described this intimate and racialized relationship between blacks and Christ:

> Black Christians believed that they belonged to a long line of prophets, saints, and martyrs, a tradition of spiritual aristocracy made up of those who suffer for the truth of God's elect. . . . The articulation of this suffering in the expressive culture of African American Christianity, especially the spirituals, achieved worldwide recognition for the authenticity that comes, that can only come from suffering. Thus the relationship between race and religion in this model is one that might be called transposition. The racial degradation of African Americans is transposed or inverted in to a racial election, a moral superiority of authentic—and even—heroic Christianity.[51]

The story of Exodus and Christ's resurrection are two such biblical narratives that have always had a special resonance with oppressed Christians around the world.

Like the sermons and gospel lyrics often heard in these churches, these visual images merge the lives and concerns of their audiences with their more abstract spiritual content. By deploying the basic principles of Black

Liberation Theology, consciously or not, these artists have created biblical images that mirror the faces of their African American audiences. This art has allowed many socially or economically disenfranchised people of color in the city to see themselves in the source of their salvation, internalizing the equation "divinity equals blackness," which transforms their "nobodiness" into "somebodiness."

Painting the Gospel Blues

Race, Empathy, and Religion at Pilgrim Baptist Church

"One of the most amazing things that would get me was to look up there and see the Last Supper and see them all sitting there with Jesus—right in front of us. It was like it was so real. It *was* so real."[1] This description is by William L. C. Bynum, the rector of Pilgrim Baptist Church in Chicago for more than three decades. Church members could fully engage with the biblical figures in William E. Scott's mural series that adorned the church for more than seventy years because he merged an academic style, learned at such schools as the School of the Art Institute of Chicago and L'Ecole des Beaux Arts in Paris, with an unconventional racial fluidity not often seen in church interiors in the 1930s, or even much today. Scott's images of Christ and other biblical figures represent different racial types through skin color, features, and hair texture. In this program, fair-skinned and dark-skinned Christs appear simultaneously as interchangeable figures in the same narrative. Filling most of the apse from floor to ceiling, these paintings held their own in an already lavish interior (figure 1.1). This imagery allowed the members of the congregation to see themselves in the life-size multiracial figures acting out the life of Christ on the walls in front of them.

Austin's Mission for Pilgrim, 1926–68

Scott's goals to create images that promoted black pride through a very conventional, representational painting style found great support at Pilgrim Baptist Church in the person of Junius C. Austin (1887–1968), a prominent advocate of social change and African American empowerment. As Henry

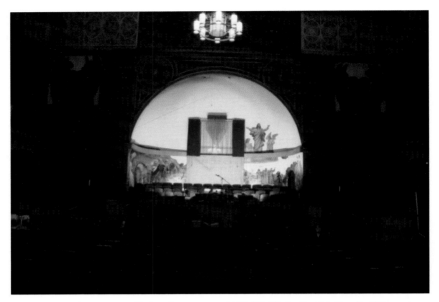

1.1 William E. Scott, *Life of Christ*, oil on canvas, 1936–37. Pilgrim Baptist Church, Chicago (now lost). Photo courtesy of Jeanine Oleson.

Louis Gates Jr. and Cornel West wrote in their book *The African-American Century*, "Before Gardner Taylor, Sandy Ray, Samuel Proctor, J. H. Jackson, and Martin Luther King Jr.—all twentieth-century preachers of enormous influence—there was Junius C. Austin."[2] Before moving to Chicago, Austin had been president of the Pittsburgh chapter of the NAACP. He encouraged southern blacks to move north, and he established the Steele City National Bank and the Home Finder's League to help blacks once they arrived in Pittsburgh. Austin, raised in a log cabin built by Carter G. Woodson, the great African American historian who created Negro History Week in 1926 in rural Virginia, had a personal and passionate interest in these migrants.[3] He began preaching at the age of eleven and earned a BA, BD, and DD from the Virginia Theological Seminary. Austin also became a supporter of Marcus Garvey and his Universal Negro Improvement Association (UNIA) because of its community-based programs and focus on making ties with Africa. Austin even gave the keynote address at the UNIA's Third International Convention of the Negro Peoples of the World on August 1, 1922, in which he declared his allegiance to Garvey and acknowledged what it had cost him, declaring, "We have to teach the world the truth about ourselves and we have to teach

the world the truth about God. I am true to this organization. I am one of your earliest friends. I have lost friendship with people within my church for defending Marcus Garvey's name."[4]

Through these connections Austin became the leading black Christian nationalist figure beginning in the 1920s. When he was not yet forty years old, in 1926 he became the pastor at Pilgrim Baptist, where he would remain until his death in 1968. Pilgrim's congregation was large and grew along with the city's black population. Between 1920 and 1945, Chicago's South Side witnessed an increase in its African American population of more than 200 percent as people migrated north in search of better lives. By 1930 Pilgrim (figure 1.2) was one of the ten largest churches in the United States.[5] Austin was such a dynamic preacher that people lined up hours early to get good seats for both of his Sunday services. His sermons were broadcast on the radio, and, it was rumored, he had to remove his notes quickly from the pulpit after he spoke to prevent aspiring young preachers from stealing them. Austin's appeal was not only his oratory power but also the social content of his sermons.

Austin took the helm of the church only four years after the congregation had moved into a former synagogue. Louis Sullivan and Dankmar Adler

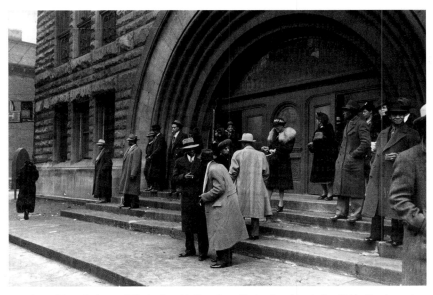

1.2 Russell Lee, *In front of Pilgrim Baptist Church on Easter Sunday,* photo, 1941. Courtesy of the Library of Congress.

had designed the building between 1890 and 1891 for the oldest Jewish congregation in the city, Kehilath Anshe Ma'ariv. As demographics changed and Bronzeville, the area between 12th and 51st streets, became predominantly African American, Pilgrim's bought the synagogue in 1921. The architects had designed the building in an auditorium-style format with impeccable acoustics to accommodate one of the city's largest Jewish congregations and to provide a venue for speakers and performers. In keeping with Jewish religious restrictions on representation, the space had very little ornamentation outside of Sullivan's signature terracotta foliage, which gave it a grandeur similar to that of his Auditorium Theater located downtown.

By the late 1930s Pilgrim Baptist had constructed a new gymnasium, a community center, and a housing project. Austin had turned the church into a resource for welfare, education, health care, and job training.[6] The church had also begun to establish several missions in African countries and soon ranked as the Baptist Church's third-largest contributor to foreign missions.[7] Africa was a central concern for Austin, and he was elected chairman of the Foreign Mission Board in 1924, right before he became pastor at Pilgrim. In 1950 he traveled to several West African countries, and during this trip reported seeing the realization of many of the Afrocentric goals he had worked toward at Pilgrim: "I saw and counselled with a black president and a black secretary of state. . . . I saw black clerks and managers working in stores and black officials high in government everywhere I went. I went to Africa only to be convinced that not only the hope of the black man, but the hope of peace and the hope of the world rests in Africa."[8]

In addition to commissioning Scott to cover Pilgrim's walls with paintings, in 1932 Austin hired Thomas A. Dorsey (1899–1993) to be the church's musical director. Known as the grandfather of gospel, Dorsey fused sacred music and the blues, often premiering new songs performed by such singers as Ma Rainey and Mahalia Jackson at Sunday services. Soon after migrating to Chicago from Georgia, Dorsey, the son of a preacher, had had a successful career as the blues pianist and composer Georgia Tom. Before a series of religious conversions, he had gained wide acclaim for such carnal songs as "Tight Like That" and "You Got That Stuff." The importance of Dorsey and the freedom he had to develop his music at Pilgrim cannot be overstated. It was at Pilgrim that Dorsey took a young Jackson under his wing, helping her hone her voice to serve this new type of black music. She became one of his promoters, performing his songs on the corners of Bronzeville while Dorsey sold the sheet music. His gospel anthem "Precious Lord, Take My Hand,"

written about the death of his wife and baby during childbirth, launched her career and cemented his as a gospel composer.[9]

In countless interviews, Dorsey told the story of how many pastors in Chicago threw him out when he introduced compositions that caused such fervor among the congregants because they considered it unholy "alley junk," too closely tied to the sexually charged blues played in the nearby clubs and gin joints.[10] Austin, understanding the importance of the appeal of this music, especially for his younger congregants and those most recently relocated from the South, welcomed Dorsey, whose family had been members of Pilgrim since 1914. With Pilgrim as his base, by 1933 Dorsey had founded the National Convention of Gospel Choirs and Choruses and held the first National Convention of Gospel Choirs at Pilgrim. Although Austin was a university-trained, old-line pastor who went so far as to relegate the unstructured, preworship services to the basement, he was still widely known for his electrifying sermons. Religious historian Wallace D. Best has suggested that Dorsey's gospel programs encouraged Austin to perform more "mixed-type sermons" that combined prepared written lectures on the scriptures with extemporaneous and emotive passages. With the great influx of southern migrants, Chicago's pastors had to resist or adapt to their congregations' changing demographics. Some church leaders crafted a hybrid or "mixed-type" style of preaching that was a "performed sermon" which "satisfied the intellectual elite, convinced the skeptic and . . . electrified the washer woman."[11]

Dorsey and Gospel's Sonic Realism

Gospel blues, like "mixed-type" preaching, appealed to the southernness in both the newly migrated and the urban African American churchgoer. The blues and preaching had traditionally been linked in black rural culture. As gospel historian Michael W. Harris writes:

> The blues soloist was the figure in traditional Afro-American culture responsible for emoting and otherwise expressing feeling to the group through music. Another individual, the preacher, was likewise responsible to a group, but he communicated through speech. . . . One sang in a secular setting; the other spoke in a religious setting. But the bluesman and the preacher, beyond surface distinctions, were cultural analogues of another. The structure and delivery of sermons and blues songs bear more resemblance than dissimilarity. At the foundation of the art of each was a common creative mode: improvisation.[12]

Expressive singing and dancing had been commonplace in the many Holiness Pentecostal storefront churches in the city for decades. To make his fusion of blues rhythms and sacred songs, Dorsey changed a traditional hymn in two distinct ways: he played parts of it in a lower blues key, or the "blues seventh," which is the lower seventh of the subdominant chord; and he altered the hymn's lyrics, often writing completely new ones that used phrasing and sentiments found more often in blues music, such as drawing on everyday life to personalize religious doctrines.[13] His new sound was labeled gospel blues or sacred blues, because it combined the raunchy music found in speakeasies and dance clubs with sentiments of church hymns. For example, in his first gospel hit, "If You See My Savior," which he wrote for a mother at Pilgrim whose son had died suddenly, the lyrics mirror typical blues songs. The first few lines are:

> I was standing by the bedside of a neighbor
> Who was bound to cross Jordan's swelling tide
> And I asked him if he would do me a favor
> and kindly take this message to the other side
> If you see my Savior tell Him that you saw me
> Ah, and when you saw me I was on my way
> When you reach that golden city think about me
> And don't forget to tell the Savior what I said.[14]

The 1920s blues song "Deep River Blues" by Rosa Henderson has these lyrics:

> My heart is breakin' as I watch the evenin' tide,
> Because I'm over here; my man is on the other side. . . .
> "Deep river! Deep river!
> When I sleep beside you, I never fear;
> You'll always be, you need to be
> A friend so dear,
> And if you see my man, please tell him that it's lonesome here!"[15]

Dorsey has simply replaced a woman longing for her man who has migrated north of the Mississippi with one longing for Jesus who is just over the River Jordan. These songs speak to each other: they are two sides of one coin. The gospel blues offered uplifting messages on top of an engaging and energetic sound. Gospel lyrics proclaimed a more intimate relationship with God through the language of everyday relationships and concerns.[16]

The Paintings at Pilgrim

Although much has been written about the composer's role in Pilgrim's history, much less is known about the painter's. This imbalance is all the more unfortunate because a fire destroyed the church on January 6, 2006, and Scott's murals were destroyed.[17] Despite this loss, Scott's work can be placed in the center of Pilgrim's early church and gospel history. Scott's images of multiracial Christs inflect this stylistically traditional imagery with the same tragic pathos that Dorsey's gospel blues possess.

Between 1936 and 1937 Scott painted six murals in oil on plaster in the interior of Pilgrim Baptist Church. He covered the walls in the apse, the upper galleries of the church, and the foyers on the first and second floors. The largest paintings were on either side of the altar. On the left could be seen the crucified Christ flanked by the two thieves (figure 1.3). The hunched

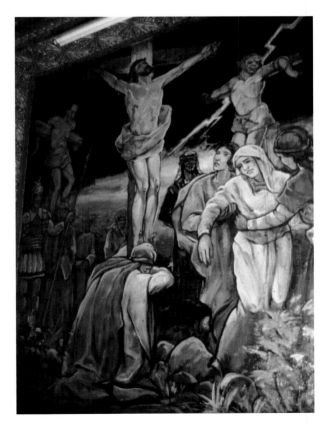

1.3 William E. Scott, *Crucifixion and Angels*, 1936–37. Pilgrim Baptist Church, Chicago (now lost). Photo courtesy of Jeanine Oleson.

31

figure of John knelt at the foot of the cross while a male and female figure supported the grieving Virgin Mary. All of the figures in the Crucifixion were light-skinned with fine features except for a darker-complected disciple with broad features standing behind the cross and looking out toward the viewer. In the apse, a Christ figure with medium skin tone, darker hair, and slightly coarser features ascended into heaven with arms outstretched. The Christ figure in the Crucifixion scene looked as though he was of European descent and conformed to the widely popular images of Christ by Warner Sallman, while the figure in the Ascension scene could be read in the most general of ethnic terms as Middle Eastern because of his olive complexion and large eyes and nose. The mural originally included a host of angels, although water damage had caused much of this celestial scene to be painted out. To the right of the altar, a Christ clearly of African descent, displaying dark brown skin, a broad, flattened nose, and black, wavy hair, presided over the Last Supper, with his disciples including the youthful John and a brooding Judas (figure 1.4). Scott painted the disciples in varying skin tones that ranged from light beige to medium brown. Following convention, each of the disciples reacted to the announcement that one of them will betray Christ. Despite the golden rays

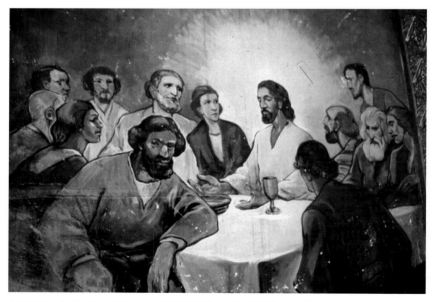

1.4 William E. Scott, *Last Supper*, 1936–37. Pilgrim Baptist Church, Chicago (now lost). Photo courtesy of Jeanine Oleson.

behind Christ's head, the large figure of Judas, as dark-skinned as Jesus, drew the most attention because of his prominent size and the fact that he turned away from the table and was the closest to the congregants. The upper galleries featured a Nativity scene on the left and Christ in the Garden of Gethsemane on the right. In the first-floor foyer was a Baptism of Christ, and the Miracle of the Loaves and Fishes appeared in the second-floor foyer. As in the main scenes at the altar, Scott painted a different Christ (corresponding to those in the apse) for each of these scenes. The baby Jesus was fair-skinned, as were his parents. The adult Christ figures being baptized and performing miracles were dark skinned with flatter noses, full lips, and curly hair (figure 1.5).

Scott's murals at Pilgrim strikingly presented more than one conception of Christ simultaneously. Angels of different races also appeared in the murals (figure 1.6). This multiracial treatment of biblical texts was rare but not without precedent. Only a few blocks south of Pilgrim, in the apse of the Quinn Chapel African Methodist Episcopal (AME) Church, church member Proctor Chisholm painted a black Christ, Mary, and angels in 1904 (figure 0.1, p. 4). Even though the AME denomination was founded specifically to serve African Americans, its church decoration in the first half of the twentieth century on

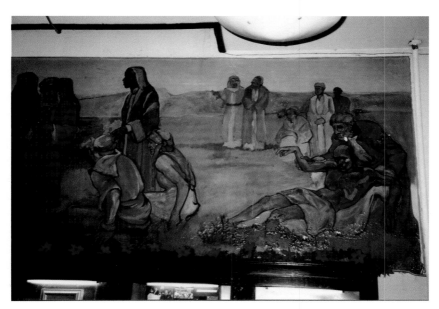

1.5 William E. Scott, *Christ Performing Miracles*, 1936–37. Pilgrim Baptist Church, Chicago (now lost). The Conservation Center and "Art for the People" by Heather Becker.

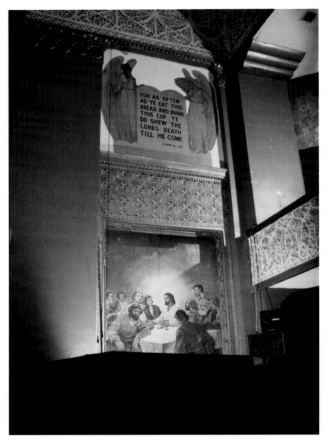

1.6 William E. Scott, *Angels*, 1936–37. Pilgrim Baptist Church, Chicago (now lost). Photo courtesy of Jeanine Oleson.

the whole adhered to traditional European models. Even in the numerous working-class storefront churches, which were predominantly Pentecostal, Spiritualist, and Baptist, a white Christ on the crucifix at the pulpit was standard, as can be seen in a Baptist storefront interior in Chicago about 1940, in which a large painting of a fair Jesus on the cross hangs on the back wall; an image of a white saint appears to the left (figure 1.7). Especially, in urban centers, black churches were considered the main vehicles for assimilation; black Christs were not.[18] Although many black churches promoted racial affirmation and uplift, to image a black Christ was still uncommon during most of the twentieth century. Most examples of images of black Christs in

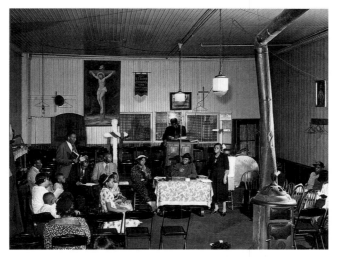

1.7 Russell Lee, *"Storefront" Baptist church during services on Easter morning,* photo, 1941. Chicago, Farm Security. Courtesy of the Library of Congress.

the United States can be found in easel paintings that were not created for public church adornment, such as William H. Johnson's *Jesus and the Three Marys* (1939–40) (figure 0.3, p. 10).

Those few artists experimenting with the race of Christ were also fully engaged in such modernist art styles as expressionism and abstraction.[19] Scott, by contrast, adhered to a conservative style while injecting progressive content such as a black Christ into it. Austin's commission enabled Scott to push against boundaries regarding religious imagery and partake in the type of race-affirming institution that appealed to his own politics as an African American painter pursuing an international career while still creating public art to uplift his race and combat negative stereotypes. By 1949, according to an article in the *Chicago Sunday Tribune* of that year, Scott had completed more than thirty murals in Chicago and Indianapolis.[20] However, despite the fact that only a fraction of these murals are known to exist and very few were ever documented, Scott included multiracial figures in most of the surviving works, and he was committed to pursuing black subject matter all of his life.

The Race Painter

In *Black Metropolis: A Study of Negro Life in a Northern City*, the ground-breaking sociological study of African Americans in Chicago, St. Clair Drake

and Horace R. Cayton quote a young Bronzeville resident's definition of the popular term "race man": "[He] is proud of his race and always tries to uphold it whether it is good or bad, right or wrong[;] . . . the Race Man is interested in the welfare of the people."[21] This term was in common parlance for decades, and a cursory glance at black publications such as the *Chicago Defender* or *Negro World* during the first half of the twentieth century reveals its wide use. This era shaped Scott's racial consciousness.

The artist was born in Indianapolis on March 11, 1884, to Edward Miles and Caroline Russell Scott, who had migrated from North Carolina in 1841.[22] The elder Scott had secured a solid middle-class life for his wife and two sons as a railroad employee. William displayed artistic gifts at a young age. In high school, the European American painter Otto Stark encouraged Scott's talents and even made him an instructor at the school once Scott had graduated in 1903. This appointment made Scott the first African American to teach in the Indianapolis public schools.

Within a year Scott was accepted into the School of the Art Institute of Chicago, one of the only art schools in the country that taught mural painting. The Art Institute was also a haven for young African Americans at a time when most met with prejudice elsewhere. As noted in Charles C. Dawson's unpublished autobiography, "the policy of the Art Institute was entirely free of bias! They were very proud of some prior brilliant Negro graduates, such as William A. Harper and William E. Scott."[23] Scott attended the Art Institute between 1904 and 1909. While there he won more than fifty awards and prizes. Chicago's Lane Technical College Prep High School houses some of these early murals, such as *Dock Scene*.[24] With a handful of other African American Art Institute students, including William McKnight Farrow and Harper, Scott founded the Chicago Art Students League, an organization for local black artists.[25]

Between 1909 and 1914 Scott made three trips to France. During some of his time in France he studied briefly at the Académie Julian (1912 and 1913) and the Académie Colarossi (1913).[26] Juries for both the Paris Salon and the Royal Academy of Arts in London accepted his work. During his visit in 1912, like many other African American artists, he made a pilgrimage to see the legendary painter Henry Ossawa Tanner at his home in Étaples, where Scott painted *Rainy Night, Étaples* (1912). Tanner was the most important influence on Scott's work. By the time he visited Tanner, Scott had literally become a starving artist—without food or lodging. According to Scott's daughter, Tanner allowed him to stay at his home and subsist on, among other things, the great store of potatoes in his cellar.[27] Scott said of his time with Tanner:

"Studying with Mr. Tanner was a source of great inspiration to me. He is pains-taking, conscientious and a real genius."[28] Although most art history survey texts reproduce Tanner's black genre work such as *The Thankful Poor* (1894) and *The Banjo Lesson* (1893), these are the only two scenes by Tanner apart from portraits of his parents that feature African Americans.[29] As the son of an African Methodist Episcopal bishop, he focused on biblical scenes, such as *Christ Walking on the Water* (undated) and *The Annunciation* (1898) soon after settling permanently in France.[30] Tanner painted the now lost *Christ at the Home of Lazarus* in 1912, the year Scott visited.[31] In this picture, Tanner placed himself and his wife, Jessie, at the table with Christ. Injecting himself into this biblical scene reflects some of the most basic empathetic tenets of his African Methodist Episcopal faith as expressed in their motto, "God our Father; Christ our Redeemer; Man our Brother." Surely, Scott saw this painting and even witnessed the older artist making it while he stayed at the Tanner home.[32]

Scott's Other Religious Work: A Context for Pilgrim

Scott painted his earliest religious compositions in Indianapolis in 1915: twenty-two canvas panels depicting the life of Christ and other biblical scenes, including women of the Bible, for the Indianapolis City Hospital (now Wishard Health Services).[33] His mentor Tanner had provided a similar series for the *Ladies' Home Journal* in 1902. Unfortunately, only one of Scott's panels survives; the others were destroyed or painted over. In the surviving work, Simeon is holding the baby Jesus. According to one *Indianapolis Star* article, the infant is one of the Stuart brothers who later founded a funeral home.[34] Scott's fair-skinned child with auburn hair serves as a credible biblical type. The debate over what the historical Christ looked like has endured for centuries and been a political pawn during times of racial or ethnic strife. In their book *The Color of Christ*, Edward J. Blum and Paul Harvey survey these moments and especially American racialized ideologies about Christ from the conversion of slaves and Native Americans to the rhetoric of white suprema-cists and anti-immigration activists.[35]

In a number of interviews, Scott's mentor Tanner discussed the ethnicity of Jesus and other biblical figures. In commentary accompanying "The Mothers of the Bible," his illustrations in the *Ladies' Home Journal*, Tanner wrote:

The physical characteristics of the child Jesus will always remain a point of discussion. No artist has ever produced a type, nor ever will, that has in it all that the varying minds of all time will acknowledge as complete. It was my

chance in Jerusalem to run across a little Yemenite Jew. Where could a better type be found than this swarthy child of Arabia, of purest Jewish blood—nurtured in the same land, under the same sun, and never neither he nor his ancestors, having quitted its (at times) inhospitable shores.[36]

For Tanner a Semitic type was more authentic, and according to the art historian Kristin Schwain could also have broader interpretations: In Tanner's Orientalism "the Jewish past and African American present, biblical history and contemporary realities coincided with the AME Church's interpretative traditions more broadly," as they believed the historical persecution of the Jews aligned them with blacks.[37] One could easily interpret Scott's darker representations of Jesus as kin to Tanner's "swarthy child of Arabia."

A fair-skinned African American as Christ also reflected slavery's legacy of racial mixing, which created a diverse spectrum of complexions, facial features, and hair textures among African Americans.[38] Many different people could see themselves in Scott's imagery. To represent such racial terms as "blue black" and "high yella" he used blues, grays, and purples. "Blue black," "redbone," and "high yella" are terms used then and now to describe this spectrum of skin tones among African Americans with varying degrees of derision and admiration.

In 1946, ten years after painting the Pilgrim murals, Scott made five biblical paintings, one for each viewing room in the Stuart Mortuary, an African American funeral home in Indianapolis. In this suite of large-format paintings on canvas, he depicts a white Christ with very fair skin, narrow nose and lips, and long, straight, medium-brown hair. In one painting, *Come unto Me, All Ye That Labor* (figures 1.8 and 1.9), a young African American man in yellow who looks directly out at the viewer is Bodie Stuart, the brother of the mortuary's owner who died in a car accident. His hands are crossed on his chest as if he is prepared for burial. It was this brother's death that prompted Joseph S. and Charles E. Q. Stuart to start their own funeral home, because they were so dissatisfied with how the mortician had handled his burial. This painting is the only one in the funeral home that has such prominent black figures in it, and there are no known portraits in the other biblical scenes there. Scott had already painted formal full-length portraits of the mortuary founders' parents, Dr. William Weir Stuart and Mae Lewellyn Stokes Stuart. Although Scott did not deviate from the traditionally European Christ figure, he did offer another visual device of pathos: family members standing in Christ's presence.[39]

However, in the *Last Supper* panel (figure 1.4), Scott makes Christ dark-skinned and represents the disciples with an array of skin tones. A

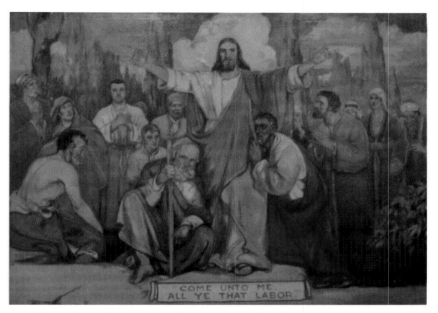

1.8 William E. Scott, *Come Unto Me, All Ye Who Labor*, 1946. Stuart Mortuary, Indianapolis. Photo courtesy of LaShawnda Crowe Storm.

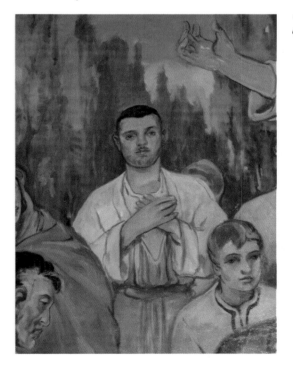

1.9 William E. Scott, *Come Unto Me* (detail).

predominantly African American audience could easily have read these many shades as corresponding to the spectrum of hues among our country's black population. Therefore, one could read the multiple Christs at Pilgrim either as representing different races or as reflecting the differences within the black race itself.

Austin commissioned Scott to paint murals in his church to enhance this close connection between his congregation and their God, and during the eighteen months that Scott painted the murals, he often worked during Sunday services. Austin knew of Scott because he, like Dorsey, was a church member. According to the artist's daughter, Joan Wallace, Scott and Austin had a very good relationship until Austin's death.[40] Austin would have seen Scott's work in such secular buildings in Chicago as public schools and field houses. In addition, Scott was a prominent portraitist for the city's black business and community leaders. No doubt during some viewings following funerals, Austin had seen an eight-by-four-foot mural entitled *His Part of Ascent of the Cross* (now lost) that Scott painted in 1934 in the Thomas E. Nolan Funeral Home only a few blocks south of Pilgrim.[41] A reproduction from the *Chicago Defender* newspaper shows that the picture was a tight composition depicting a black Simon lifting the bottom of the cross; a white Christ staggers under its weight while Roman soldiers, with arms folded, look on. In the *Defender* article about the unveiling of this mural, the author wrote, "The face of Simeon [*sic*] is meant by the artist to portray strength and sympathy and the willingness to do his bit toward bearing the burdens of the world. Simeon, Scott thinks, is symbolic of the modern Negro."[42] Scott executed the same scene twelve years later for the Stuart Mortuary in Indianapolis (figure 1.10).

The more traditional representation of Jesus in these two versions of the Simon narrative highlights the radical departure of the multiraced Pilgrim imagery even more. Since one Simon painting came before and the other one much later, the pictures are not evidence of any kind of evolution in Scott's thinking about the ethnicity of Jesus but, more likely, of the different tastes or politics of his patrons. Overall, Scott's work consistently included multiracial subjects, often highlighting those of African descent as positive, collaborative, and inspirational.

In the context of both the funeral home and the position of the African American in the 1930s, this image of a black man helping Christ with the cross was a metaphor for duty in black public culture. For example, in 1927 Aaron Douglas illustrated a book of poems by James Weldon Johnson based on Negro sermons titled *God's Trombones*, in which the black Simon dwarfs

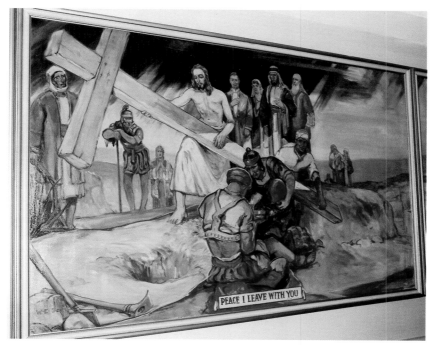

1.10 William E. Scott, *Peace I Leave with You*, 1946. Stuart Mortuary, Indianapolis. Photo courtesy of LaShawnda Crowe Storm.

the small, white, haloed figure of Christ between the black man's legs (figure 1.11). Simon's body lifting the cross fills the entire picture; black struggle overshadows that of Christ. In 1921 Marcus Garvey invoked Simon in a speech on equality and Negro empowerment:

> Oh Jesus the Redeemer, when white men scorned you, when white men spurned you, when white men spat upon you, when white men pierced your side . . . it was a black man in the person of Simon the Cyrenian who took the cross and bore it to heights of Calvary. As he bore it in your Calvary, so now, when we are climbing our Calvary and the burden being heavy—Jesus we ask you to help us on the journey up the heights.[43]

At Pilgrim, on the second-floor foyer that led into the main church, Scott had painted a seaside scene that alludes to the Miracle of the Loaves and Fishes. A black Christ holds a loaf of bread from which he has miraculously

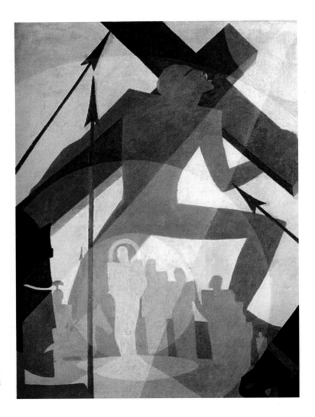

1.11 Aaron Douglas, *Crucifixion*, oil on board, 1927. The Camille O. and William H. Cosby Jr. Collection of Fine Art, Los Angeles, California.

produced many loaves of bread for the sick and needy. To the right of this main scene was an older brown-skinned man helping an almost naked, very dark-skinned man who is so weak he cannot stand. This couple also alludes to the Good Samaritan parable that teaches forgiveness, since the Samaritan put aside his conflict with the Jews to aid an individual in need. Each time the congregants in Pilgrim entered and left the service they were faced with this lesson in inter- and intraracial cooperation, forgiveness, and uplift. Due to the racism embedded in American culture, many Americans have often associated lighter skin with superiority. Therefore, this image would have additional meanings regarding color politics among its Bronzeville viewers—don't ostracize your darker brethren. Austin reiterated this message, which also supported his pan-African ideals in his sermons: "We belong to the human race. Our law becomes the law of love, and our object in living is immediately the welfare of the other fellow."[44]

In the same year he began the Pilgrim murals, Scott also tackled color politics and racial uplift in one of his most acclaimed Chicago murals, *Mind, Body and Spirit* at the Wabash YMCA in Bronzeville (figure 1.12). He represents the civic services upon which the YMCA was founded and he painted Boy Scouts, nurses, doctors, lawyers, artisans, and sports players in the many hues of the race, from "blue black" to rosy-cheeked pink. These figures stand on either side of an African American youth who kneels in the center with his back to the viewer and his hands stretched out in supplication as the lessons of service and citizenship wash over him; above float clouds from which God's hand extends a candle in front of the Y's iconic red triangle and

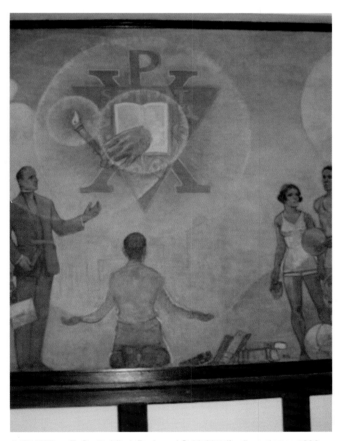

1.12 William E. Scott, *Mind, Body and Spirit* (detail), oil on plaster, 1936. Wabash YMCA, Chicago. Photo courtesy of author.

the Bible. According to the *Chicago Defender*, Scott interpreted "the spirit of the YMCA as conceived by George R. Arthur, the executive secretary of the branch."[45] The YMCA, like the churches, was a significant organization that provided a site for community and recreation for those newly immigrating to cities around the United States.[46] As Davarian L. Baldwin describes, the Y's all-black recreation space and the teams sponsored by the Y "fostered a stronger sense of race pride based on athletic, even professional, competition above and beyond the 'higher ideals' of sport as exclusively an expression of amateur character development."[47] Scott appropriately presented the Y as a benevolent source of divine intervention and inspiration on behalf of all black Americans. The attention paid to showing a range of African Americans in physical type and occupation is relevant to his images at Pilgrim because it emphasizes two important messages: blacks lived within communities that consider a wide range of skin tones as belonging to their race; and racial uplift by example was a consistent element in the visual imagery in these social spaces for an exclusively African American audience.

The figures in these murals were consistent with others Scott painted throughout the city. His many murals in park district field houses, schools, and civic buildings consistently included ethnically diverse figures or focused exclusively on African American history. One of his murals at John D. Shoop Elementary School (now The John D. Shoop Academy of Math, Science and Technology) from the 1920s, *Du Sable Trading with Indians at Fort Dearborn*, shows the founder of Chicago and its first recorded black resident, Jean Baptiste Pointe du Sable (ca. 1745–1818), at the fort that became the city. Of Haitian and French descent, Du Sable continues to be a point of pride for black Chicagoans; the city's African American heritage museum, founded in 1961, is named after him.

In 1940 Scott was busy doing work for the American Negro Exposition held in Chicago. According to a *Chicago Tribune* article, he designed scenes for a diorama concerning black achievement throughout history, and he painted a mural of portraits for a "Hall of Fame . . . of Negroes or part-Negroes, including Alexander Pushkin, Russian poet; Alexander Dumas, French novelist; Maj. Robert Lynch, one of the first Negro congressmen; Duke Ellington, and the late Robert S. Abbott, editor of the Chicago Defender."[48] In 1943 Scott won a nationwide competition to paint a mural for the Recorder of Deeds building in Washington, D.C., with his composition *Frederick Douglass Appealing to President Lincoln and His Cabinet to Enlist Negroes*.

At Pilgrim, Scott brought this racialized, visual rhetoric into the church interior. In the *Crisis*, the publication of the National Association for the

Advancement of Colored People (NAACP), one could occasionally see images of dark-skinned biblical figures in Nativity scenes. The black Christ and Madonna make these figures discernible as people the devout can relate to and envision as real—as real, that is, as the friend or family member sitting next to them. Such charismatic leaders as Daddy Grace and Father Divine fulfilled the need for a black God by believing in his incarnation on the present-day earth as an actual black man.[49] This relation between the image of devotion and the devout is empathetic realism. When Scott created the murals at Pilgrim, most African American churches still worshiped a Christ visualized as white even though the sermons at those churches may have suggested otherwise.

Rebirth as Racial Metaphor at Pilgrim

The underlying theme of much of the rhetoric about the future of African Americans at the time was that of rebirth or resurrection, politically and socially. Terms such as "Renaissance," the "New Negro," and "race men and women" alluded to the creation of a consciousness that rejected the image of the uneducated, poor, disenfranchised nineteenth-century slave and aspired to a new, reborn African American who both adhered to standards of white, middle-class behavior and accomplishments and maintained a strong black pride.[50] This theme of rebirth allowed the political agenda to parallel a relevant religious one for most African Americans, who were predominantly Baptist. Baptists practice "believer's baptism," that is, full-body immersion in water, and the Lord's Supper (or communion) as the two acts of faith they believe Christ commanded them to obey. Baptists reject baptism at birth because they contend one must be mature enough to reject sin and accept Jesus as one's savior consciously and with free will. Such a focus on self-determination and choice paralleled the race rhetoric of the time, which emphasized the role of autonomy in the New Negro's rebirth. In both sermons and political speeches by "race men" like Austin, these two ideologies were often united. In a sermon entitled "Advancing the Kingdom of God in Business," Austin presented a spiritual rebirth as a means to a societal one:

> The first great principle of the Kingdom, or secret of entering the Kingdom of Christ is by the way of a new birth; a thorough transformation of thinking, a change of heart which gives to the believer a new conception of the world as to his relation to man and things. This new birth has as its purpose the obliterating of racial barriers and antipathies and even national prejudices, and the making of men brothers in Christ Jesus. . . . By this new birth our

45

race relationship becomes human. We belong to the human race. Our law becomes the law of love, and our object in living is immediately the welfare of the other fellow.[51]

Before entering the chapel, Pilgrim's members first saw the Baptism scene in the foyer. Here, an olive-skinned John the Baptist poured water over a praying Christ, similar in appearance to the one ascending into heaven above the altar. The presence of a number of multiracial figures attending the baptism underscored the relevance this rite has for all Christians. Small scenes in the upper galleries that showed a Nativity on the right and shepherds at the manger on the left reinforced the theme of rebirth that dominated the murals. These scenes encouraged viewers to read back and forth across the apse while also discouraging reading it left-to-right in chronological order. This disrupted narrative allowed the viewer to step into it more easily, privileging the message instead of the sequence of events. The appearance of the Crucifixion on the left and the Last Supper on the right downplayed such a linear interpretation and, therefore, more forcefully equated the death of Christ with his rebirth through the Last Supper. The text that the angels held on tablets in the panels flanking the apse (figure 1.6) alluded to this theme in the context of the Last Supper pictured below it: "For as often as ye eat this bread, and drink this cup, ye do shew the Lord's death till he come" (1 Corinthians 11:26). This passage and the following verses, through 11:31, also allude to Pilgrim's food pantry and other services that helped hundreds in the community each week. The role of self-examination in relation to the Last Supper can also be easily read in the context of racial uplift and autonomy: "Wherefore whosoever shall eat this bread, and drink this cup of the Lord, unworthily, shall be guilty of the body and blood of the Lord. But let a man examine himself, and so let him eat of that bread, and drink of that cup. . . . For this cause many are weak and sickly among you, and many sleep. For if we would judge ourselves, we should not be judged."

The fact that Judas—the largest figure and the only disciple in the scene who looks directly out at the congregants with a stare that could be either guilty or accusatory—is painted as a black man is significant. Scott drew his viewers into the betrayer's dilemma: Can one turn back to Christ as Judas should? The black Christ at the table is the same Christ who is feeding the multitudes in the second-floor foyer.

The most striking incorporation of the Resurrection metaphor into the mural could be seen in the entrance to Christ's tomb painted around the door of the sanctuary (figure 1.13), through which Austin emerged, fully reborn,

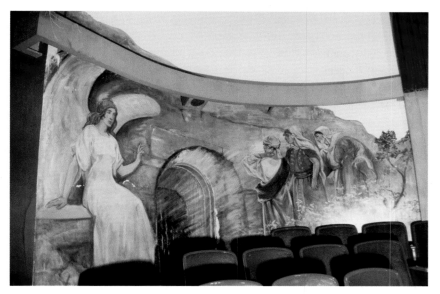

1.13 William E. Scott, *At the Tomb*, 1936–37. Pilgrim Baptist Church, Chicago. Photo courtesy of Jeanine Oleson.

before each service. Small spotlights on the floor extended the painted rays of yellow and white light onto the actual body of the pastor as he entered.[52] As in a *tableau vivant*, Austin, transformed into a black Christ, came to life as a painted angel to his right greeted him with a benediction represented by the two raised fingers.[53] On his left the three Marys would have appeared startled by the pastor's sudden presence. Once he had taken his position at the pulpit, they would then silently gape at the empty tomb. Dorsey's choir would, of course, have added to this dramatic effect. Austin's interaction with the mural activated specific biblical passages regarding the empty tomb, the resurrected Christ, and his own racially politicized presence. Here, Austin's identification with the resurrected Christ reinforced the congregants' identification with the different Christs in the surrounding scenes. This theatrical device reflected the doctrine of Christian rebirth especially in the context of Austin's social reform rhetoric. Austin was speaking to African Americans who felt crucified by humiliating acts of racial oppression on a daily basis, ranging from inadequate housing and education to segregated living and police brutality. These Christians in Chicago needed to witness the resurrection of their savior as many times and as often as possible as they struggled to resurrect themselves. Austin himself cited the urgency and need for the daily testament to Christ's

triumph over death in a 1935 sermon: "Ride on, Jesus, we still need to see you passing along the streets and highways of our life. You gave humanity the ideal of righteousness, ride on until it is realized; ride on until men become brothers and every man shall wish for every other man the same chance at the good things of life which he would like to see his brother have."[54]

As many black theologians had argued before and would continue to do throughout the twentieth century, Christ's suffering, endurance, and just rewards on his return resonated in a different way for the black American living in an environment that constantly degraded his or her sense of self-worth. As Anthony B. Pinn articulates in his study on black redemptive suffering, *Why Lord? Suffering and Evil in Black Theology*, for some religious leaders God created the suffering of African Americans to bring about the true understanding of his word via the empathy they expressed and inspired around the world. Pinn addresses this concept through the writings of the Reverend Reverdy Cassius Ransom, who served as a traveling AME preacher between 1886 and 1912. Between 1896 and 1904 he was in Chicago, where he published essays and sermons in a number of local publications. Ransom believed that "ultimately, it is through Black Americans that the teleological design is completed and global brotherhood (i.e., The Kingdom of God) established. . . . Black suffering is God's refining of African-American collective character in order to equip them for a special role in world progress."[55] The symbolic saviors painted in and stepping out of Scott's murals provided the same "intimacy and the theological immediacy of black gospel music,"[56] and the redeemer in Dorsey's gospel songs is an intimate and supportive friend reaching out to his followers. Nowhere is this more evident than in his anthem "Precious Lord, Take My Hand," which he wrote in 1932, after his wife and newborn died during childbirth:

Precious Lord, take my hand
Lead me on, let me stand
I'm tired, I'm weak, I'm lone
Through the storm, through the night,
Lead me on to the light
Take my hand precious Lord, lead me home

When my way grows drear, precious Lord, linger near
When my life is almost gone
Hear my cry, hear my call
Hold my hand lest I fall
Take my hand, Precious Lord, lead me home.[57]

The biblical text on the tablet that the angels hold above the crucifixion articulates the empathetic exchange of suffering between Christ and the viewer at Pilgrim:

> He hath born our griefs and carried our sorrows.
> He was wounded for our transgressions.
> He was bruised for our inequities.

The presence of angels and images of a Christ who may look like you or someone close to you reinforced the empathetic atmosphere that Austin and Dorsey cultivated at Pilgrim. This realism—a term used here to connote both a representation that mimics nature *and* a representation close to the viewer—is exactly what Austin wanted his congregation to experience at his church. He wanted there to be little, if any, ideological or experiential distance between his flock and his message. In his controversial speech to the UNIA, Austin spoke about the truth in his religion—a truth grounded in an authentic and affirmed self that he felt was compromised by racism: "Let us be real in character; let us be real in our aims and let us be real in our faith in God. Don't say that you have to go to the white man for the word of God and that he gave to the world a religion to give away. The idea of the one true and living God came from Abraham."[58]

The empathetic stylings of Austin's sermons and Dorsey's lyrics, in which the speaker or the singer places himself alongside his audience through the use of the first person, are examples of what theological scholarship calls "ecclesiastical nudism," during which pastors lay themselves bare before the congregation in an emotive process that "affirms the preacher's [and performer's] personhood in a positive, healing catharsis . . . in which the whole congregation participates and from which it benefits both vicariously and directly."[59] This term is essentially describing my term "empathetic realism." Pilgrim's African American audience understood themselves in Austin's sermons, they heard themselves in Dorsey's music, and they saw themselves in Scott's paintings. It is this assertion of personhood, in this case a racialized religious subject, that is significant in relation to Scott's varied representations of Christ in Pilgrim's murals. Scott offered faces of the savior present in the sermons and in the music that visualized what Pilgrim's hundreds of congregants sought there, spiritual and cultural affirmation. One could read these Christs as being from different races or coming from within the same race. The different Christs do not reflect racial contradiction but inclusion in the same way that African American communities acknowledge and include

a spectrum of skin tones. The physiognomic variety Scott painted would have mirrored the diversity seated in the church each week.

Austin, Dorsey, and Scott were all three manipulating specific traditions—religious, musical, and artistic—to create innovative forms that appealed to the African Americans at Pilgrim. Their goal was to foster a strong sense of empathy that would allow congregants to identify with the message they heard there each Sunday. To do this, they had to see themselves in Austin and in the Christs above him and to feel themselves in the music that surrounded them. Austin's plan worked. He was able to erase the church's debt and increase the church's membership from three thousand to ten thousand members between 1926 and 1940, making Pilgrim one of the first megachurches in the country. Austin, with his own interest in Garveyite black empowerment, offered a sympathetic site in which Scott and Dorsey could have an audience for their artistic fusions of the traditional with the radical. Each artist manipulated an existing form to serve the spiritual needs of the members of the church's congregation, to help them identify with Christ, and to feel at home in their place of worship, using images that looked like them and music that was more like what they heard on the streets and in the clubs of Bronzeville. In a society in which whiteness was ubiquitous and normative and blackness was demeaned or invisible, Scott and Dorsey created a visually and sonically inclusive atmosphere that was welcoming. It also served the political agenda of Austin, who was inspired by Garveyism and other contemporary black, nationalist movements. Austin used these popular arts to promote racial pride, uplift, and preservation. Scott's mural cycle of the life of Christ merged contemporary messages of racial equality with traditional religious imagery, while Dorsey played tried-and-true hymns and their sentiments with soulful blues tempos and lyrics—conservative means for radical ends.

Come unto me all ye that labour and are heavy laden

First Church of Deliverance and Its Media Ministry

> You in the taverns tonight; you on the dance floor; you in the poolrooms and policy stations; you on your bed of affliction—Jesus loves you all, and Reverend Cobb[s] is thinking about you, and loves every one of you. It doesn't matter what you think about me, but it matters a lot what I think about you.
>
> The introduction to the weekly sermon by Reverend Clarence H. Cobbs, ca. 1945

> You tell the truth, really. Make it flamboyant and beautiful, but tell the truth.
>
> Frederick D. Jones about his art, 1987

Reverend Cobbs and the Common Touch

In 1946 Frederick D. Jones (1913–99) painted *Neighborhood People Flocking to the Lord* (figures 2.1 and 2.2) in the foyer of the First Church of Deliverance (FCOD). One of the first things one notices in this mural, which stretches across the entire wall of this intimate space, is a cab driver in front of a bright red taxi who is leading two angels toward the worshipers surrounding an elegant and ethereal black Christ. In 1928 twenty-year-old Clarence Henry Cobbs, a young Pilgrim member, heard God on a downtown bus.[1] God told him to start preaching. The following year Cobbs did just that with an ironing board as his lectern in his mother's living room at 3363 S. Indiana Avenue, just blocks away from Pilgrim, the first church he joined when he arrived in Chicago from Memphis. By 1940 one in ten churches (out of the total five hundred) in Bronzeville was Spiritualist, and the majority were

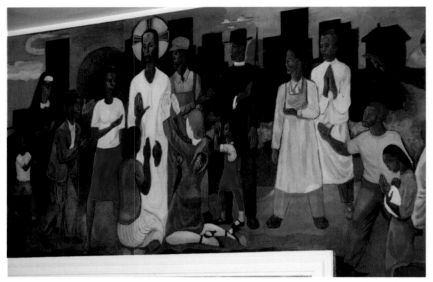

2.1 Frederick D. Jones, *Neighborhood People Flocking to the Lord* (detail), 1946. First Church of Deliverance, Chicago. Photo courtesy of the author.

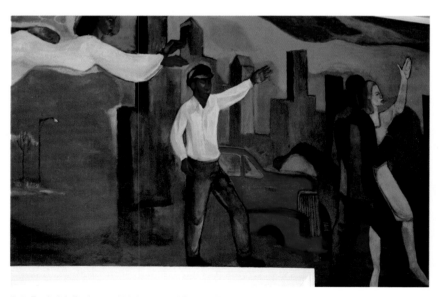

2.2 Frederick D. Jones, *Neighborhood People Flocking to the Lord* (detail).

storefronts.[2] Similar to Pentecostal worship, Spiritualist practices were "emo-
tionally demonstrative" and included "divine healing, psychic phenomena
and séances."[3] But by 1938 Cobbs had more than nine thousand congregants
at his Spiritualist church, the First Church of Deliverance. They met in an old
hat factory at 43rd and Wabash, which the church had purchased in 1933. The
many portraits that still adorn the interior of the current church show Cobbs,
or "Preacher," as he was affectionately called, as a self-possessed young man
who looks more like a movie star than a pastor with his handsome face and
smoldering stare.

In 1934 Cobbs was one of the first African American church leaders to
broadcast his sermons on the radio and in 1953 the very first to do so on tele-
vision.[4] In these broadcasts, his conversational and informal oratorical style
sprinkled with slang made him seem like a concerned confidante whisper-
ing advice. Cobbs was the forerunner of Billy Graham, Robert Schuller, Joel
Osteen, Pat Robertson, Eddie L. Long, and T. D. Jakes, to name a handful of
the most successful megachurch televangelists of the last two decades.[5] All
of these spiritual messengers make millions feel as if they are not only pres-
ent in the pews while listening or watching the television, but actually being
physically touched by the pastor. Although today's ministers have the tech-
nological benefits of high-definition transmissions, live podcasts, and social
networking. Cobbs made these connections through his electrifying voice
and intimate sermons. Generations of Chicagoans listened to his Sunday
night broadcasts. FCOD was the largest Spiritualist church in the country by
1940. His critics called him a "man of the street" who adhered to the tenets
of material success in this world instead of condemning them:

> He uses all of the props—good-luck charms, healing, advice, electric guitars,
> several pianos, a swinging choir, and other resources. His support of blacks
> in the very actions [for] which most black religionists condemn ensures his
> identification with them in their love of material success. For then he is an
> example of one who has made it without losing the common touch.[6]

In St. Clair Drake and Horace Cayton's seminal sociological snapshot of black
Chicago, *Black Metropolis*, the authors characterize the church's appeal to
citizens who may have been less welcome in other churches: "The Spiritual-
ist church in Bronzeville has no unkind words for card-playing, dancing,
policy [illegal lottery]. Ward politics, or the 'sporting life.' . . . [Cobbs] was
the alter-ego of the urban sophisticate who does not wish to make a break
with religion, but desires a steamlined church which allows him to take

his pleasures undisturbed."[7] Kenneth Morris wrote "How I Got Over," the church's theme song, whose title overtly refers to crossing the River Jordan to enter heaven, but FCOD's street savvy audience would have also understood "getting over" to mean performing a con and inferred that enough repentance could secure salvation. Cobbs was a populist. He held candlelight services in the White Sox stadium (now U.S. Cellular Field) and sold his healing candles there; at another service at a downtown auditorium he drew ten thousand supporters to prove that newspaper articles accusing him of immoral behavior had not weakened his celebrity status. This approach did attract some people who were considered outsiders and unwelcome in most of the city's larger churches, but it also brought in a great number of upwardly mobile young Bronzevillians with respectable jobs and families. Unlike some pastors, Cobbs did not vilify material success. He often peppered his sermons with encouragement to succeed: "The man that is slothful, who is not making any effort to better his condition attracts little or no attention. But the minute he tries to better himself, listen for some[one] to say, 'Uh huh, he thinks he's something. He's getting biggety. . . . Let us pity the man who does not think he is something, nor who does not want and try to be a step farther today than he was yesterday."[8] For many years "Come unto me all ye that labour and are heavy laden" was the verse placed above the title of the church's weekly newsletter. One Sunday he did not even give a sermon but instead told his audience to go home and "do something nice for your own self for a change. . . . Go out and buy yourself some records. Buy yourself a bag of apples and oranges and every night before you go to sleep eat a piece of fruit and read something good from the Bible. Be nice to yourself. Amen."[9]

In July 1949 *Ebony* magazine dubbed him the most popular black radio preacher, stating that his sermons reached an estimated one million listeners each Sunday on the station WIND. The article characterized Cobbs as a "six-foot tall smart dresser" whose church pays its poor congregants' medical bills and collects $1,700 a week in donations, all of which is "tabulated [by] electric counter."[10] The reporter notes Cobbs's "lace robe which is reputed to be as costly as the cloak which Pope Pius XII wears," and that he has a lavish three-story home and three cars. The extensive philanthropic efforts of FCOD countered any disdain for its pastor's personal extravagance. On the contrary, the congregation considered the cars and vacations abroad to be well-deserved gifts for a spiritual leader who had guided so many out of the darkness of poverty and degradation.[11]

Walter T. Bailey, Frederick D. Jones, and the Afro-Art Moderne

The choir helped tune in more listeners, and the newly renovated building brought them through the doors. Cobbs's personal style highlighted how different he was compared to the older, more traditional pastors as so too was his church the epitome of modernity. In 1933 the African American engineer Charles Sumner Duke (1879–1952) planned the renovation of the hat factory into a church.[12] In 1939 an African American architect Walter T. Bailey (1882–1941) renovated the building to double its width and add office space and the radio broadcast booth (figure 2.3).[13] Bailey was born in Kewanee, Illinois, and in 1904 he became the first African American to graduate from the architecture program at the University of Illinois. He went on to serve as the head of the architecture department at the Tuskegee Institute in Alabama and established a national reputation designing churches, banks, bathhouses, and Pythian Temples for a predominantly black clientele. In Chicago, he was one of the architects for the Ida B. Wells Housing Project (1941) and

2.3 Walter T. Bailey, First Church of Deliverance, façade, 1939. Chicago. Photo courtesy of the author.

the National Pythian Temple (1926–28). The temple, a meeting center for the African American fraternal order Knights of Pythias, was an eight-story brick-and-terra-cotta structure located at 37th and State Street, not far from FCOD. Catering to the racial interests of his clients, Bailey included Egyptian motifs on the temple's façade.[14] Bailey deployed a variety of styles, from medieval to Art Moderne in his buildings. At FCOD he used glass bricks and light green and cream terra-cotta blocks. The green blocks create bands or "speed lines" along the width of the façade that are characteristic of the Art Moderne style. The reflective surface of the ceramic blocks makes the building radiant. The two towers, added later by the firm Kocher, Buss and DeKlerk, also help the building stand out in the center of the block. The use of this particular architectural style at FCOD gives it a contemporary presence among the residential buildings on this street. Mikael David Kriz suggests that the choice of Art Moderne reflected Cobbs's contemporary ministry via his radio and, later, televised sermons.[15] The building became a logo for the church. It was featured as FCOD's weekly newsletter's masthead, and Cobbs frequently referred to the two towers as the "Old Testament and New Testament." The interior originally had a recessed cross trimmed in stainless steel in its ceiling that was replaced in the 1950s with a cross-shaped light that lit the interior with multiple colors. These theatrical details and the original acoustical plaster were installed specifically to enhance the radio and television broadcasts.

Cobbs hired Jones to create art that reflected the pastor's vision of a contemporary urban church serving a contemporary urban flock. Jones began the two murals, one in the foyer of the church and the other above the altar, and the carved wooded doors at the entrance in 1946. He finished in 1955 and then returned in 1987 to restore the murals after they had been damaged by a broken water pipe. Jones was born in Georgetown, South Carolina, in 1913. While a teenager in Atlanta, Jones had taken a job filling bottles in a Coca Cola plant where an executive of the company, Harrison Jones (no relation), took an interest in his art making and funded his education in Chicago. Jones came to Chicago to study at the School of the Art Institute of Chicago (SAIC) in 1940 after studying with the African American painter and printmaker Hale Woodruff at Talladega University in Atlanta. Jones continued to work for Coca Cola in Chicago until he retired in 1973 to devote the rest of life exclusively to art making. He attended the School of the Art Institute intermittingly from 1940 until 1947 due to serving in the navy. According to his transcript, Jones took the standard

curriculum there, with courses in everything from landscape painting and lithography to art history and book illustration. He went on to show work as a painter, printmaker, and enameler.[16] He began showing his work in Chicago at the South Side Community Art Center (SSCAC), which opened in 1940. Located at 3831 S. Michigan Avenue, it remains the only Works Progress Administration art center in the country still operating. Jones became a part of the close-knit community of African American artists at the center while using its facilities and serving as its assistant director for a year. Jones carved the FCOD doors at SSCAC. The center was and still remains an important nexus for the African American arts scene in the city. Charles White, Gordon Parks, Gwendolyn Brooks, and Eldzier Cortor were among the artists who influenced Jones the most in their interactions at the center. Jones liked to include specific aspects of the city in his work, as seen in the FCOD murals that feature Chicago's skyline, including the Hancock Building and the ubiquitous water tanks. That reportage element in his work was something shared by other SSCAC artists. As Jones said about Parks, "We said he was a painter with a camera, because he'd watch us. He would see what we did, and he would go back and go out on a field trip and try to match what he had seen us do."[17] It is important to note that in the summer of 1942 Parks shot his iconic series documenting the daily life and struggles of the Washington, D.C., office cleaner Ella Watson for the Farm Security Administration. The best-known image of this series is Watson holding a mop against an American flag purposely alluding to Grant Woods's *American Gothic*, one of the Art Institute's most famous American paintings. However, the majority of the photographs Parks took in this series were during services at Saint Martin's Spiritual Church, a church affiliated with FCOD that conducted such practices as the blessing of congregants with flowers and holy water (figure 2.4).[18] It was at SSCAC that Jones met Cobbs. The pastor liked art and frequently came by the SSCAC "bringing a basket of sandwiches and pop for the artists."[19]

Cobbs's patronage was significant for Jones because of the prestige of his church and the size of his congregation. Most African American artists in Chicago were trying to court both black and white patrons. In the early 1940s Jones had broken into the white art market up north through SAIC connections: "We were doing a lot of selling to white people. They appreciated us, and they used to invite us to show in their little shows. They had little groups and they'd have us to show a piece with their group when they were showing. Of course, that came from intermixing down at the Art Institute. . . . They [fellow

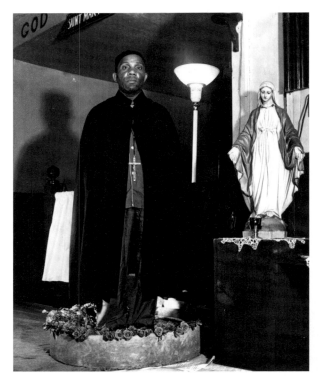

2.4 Gordon Parks, *Washington, D.C. Reverend Vondell Gassaway, pastor of the St. Martin's Spiritual Church standing in a bowl of sacred water banked with roses, each of which he blesses and gives to a member who has been annointed and prayed for by a long line of disciples during the annual "flower bowl demonstration,"* photo, 1942. Courtesy of the Library of Congress.

classmates] would go around and ask about your work all through the school from your professors."[20] The opportunities that arose from this "intermixing" led to representation at Associated American Artists of New York, numerous acquisitions from such corporations as IBM, and installations of his work in the U.S. embassies in Belgium and Afghanistan.[21] Although he had limited mural experience, having worked only briefly with Hale Woodruff and Wilmer Jennings on their mural series, The *Amistad Murals* (1938) at Talladega University, Jones still took the commission at FCOD. Jones, Woodruff, and Jennings had painted the Talladega mural on canvas squares and then installed them. The FCOD mural, however, was a much bigger challenge as it was painted directly onto the wall.

Critics and curators have characterized Jones's eclectic style with a cacophony of adjectives such as "neo-romantic" and "abstract."[22] The artist credited a range of influences, including Chagall, Picasso, and African sculpture, to the creation of his style, which marries the elongation of Yoruban ibeji figures with the bold color and distortion of the European Expressionists. His mentor Woodruff had similar influences, which eventually led him to explore his African heritage through abstraction. While at SAIC, Jones took a history of art course with Kathleen Blackshear, who was known for taking her classes to the Field Museum to study African and Oceanic art there. Jones cites African masks as important to his style: "I learned a lot from African art by just looking at some of the things they did. I didn't know how they could be so wise, especially, when I looked at the structure of some of the masks that the Africans did. Oh, boy, that's beautiful. That's the truth."[23] In his painting *Untitled (Two Figures)* (figure 2.5), from

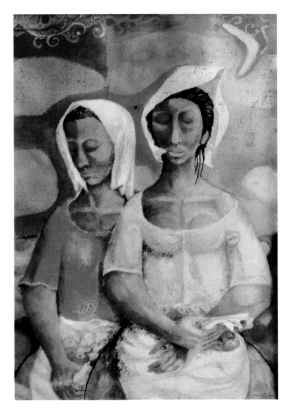

2.5 Frederick D. Jones, *Untitled (Two figures)*, oil on canvas, ca. 1950. Collection of Gary and Denise Gardner, Chicago.

ca. 1955–1960, Jones combined Cezannesque scumbling with a distorted treatment of exaggerated facial features and elongated limbs and neck. The almond-shaped eyes, loops of color, and "long, flowing, loose figures" as in the angels and Christ figure in the FCOD murals are elements that Jones called his "African mark."[24] These were stylistic aspects of his work and that of other African Americans that Jones felt were innate and difficult to conceal. The elongated, graceful nudes of Eldzier Cortor, a fellow SAIC student and friend at the SSCAC, also display these qualities. In *Room VI* (figure 2.6) Cortor paints four sleeping figures, two adults and two children, lying on a bed viewed from above. Each body extends beyond the picture plane. They sleep head to toe or head to head to maximize space on the small, cramped mattress; Cortor has created a jigsaw of bent and outstretched limbs that vary from Amazonian to petite proportions, blue-black to copper in skin tone. Their bodies' glistening dark colors and stiff angularity conjure carved West African fetishes or doorposts. Body parts and floorboards mingle with the textile and wallpaper patterns, offering a cacophony of color, shapes, and angles. The patches of tattered sheets, blankets, and the exposed mattress and scattered newspapers on the floor look like a quilt and reinforce a collage aesthetic—a device Cortor used often. Influenced by African art he saw at the Field Museum and the pro-black advocates he knew in the South and in Chicago, Jones believed in an aesthetic that reflected his cultural connection to Africa. Jones presents in his references to African sculpture although his characterization of painting this aesthetic was more conflicted than celebratory:

> You know, when you're in art school and around the art community a lot, you try to—I don't know what the word would be, but you try very hard to be real sophisticated and you try to do these things. Then when you look, you think, "Oh, my goodness. I shouldn't have done that. I'll paint out a thing and start it over." It's going to tell. It's going to come out in your paintings anyway. You can't completely paint like a Caucasian.[25]

In this passage Jones uses the word "sophistication" for the more appropriate and less biased "assimilation." He sees the attempts of black artists to conform to certain stylistic standards they perceive as institutional and therefore European or white as obscuring parts of their own expressive selves. His ideas reflect these lines by Don L. Lee in the introduction to the catalog for the 1970 exhibition *The Black Experience in the Arts* at Beloit College that included Jones's work: "Black. Poet. Black poet am I. This should leave little doubt in the minds of anyone as to which is first. Black art is created from black forces

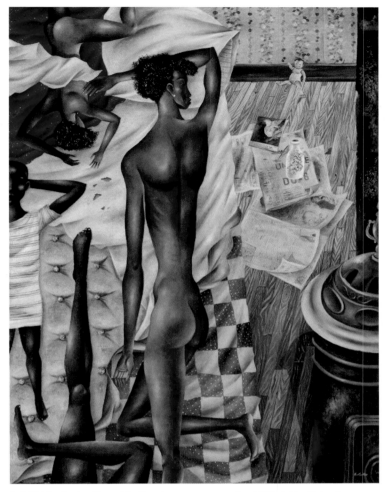

2.6 Eldzier Cortor, *Room VI*, oil and gesso on masonite, 1948. Art Institute of Chicago. Through prior acquisition of Friends of American Art and Mr. and Mrs. Carter H. Harrison; through prior gift of the George F. Harding Collection, 2007.329 © Eldzier Cortor. Courtesy of Michael Rosenfeld Gallery, LLC, New York, N.Y.

that live within the body."[26] This pro-black attitude is clearly visible in the representation of the congregants and the pastor in the murals. The majority are African American and are shown as pious, respectful, and joyous as they are blessed by the Christ figure in the foyer or by Cobbs in the interior. Jones was very much a product of his generation and upbringing in Atlanta, where he knew such figures as Martin Luther King Jr., Benjamin Mays, and

Benjamin J. Davis. He grew up with some of them and was mentored by others while in school at Morehouse College. In an interview, Jones described his approach to his heritage:

> It was a black thing . . . I saw the black struggle in two phases. I saw the real struggle that we were having. Then I learned how to get a fantasy out of it—how to tell a story. Soon I met a friend who had the same idea, and we worked at it a long time. That was Eldzier Cortor. We had the same idea about it. You don't really have to go into all that struggle that way. You could make it beautiful. That's how I got off into doing the black things with a bit of flair and beauty behind it.[27]

These sentiments appear in the murals and in Cobbs's ministry. He brought the work of this young, rising painter into his ministry as yet another piece in his multifaceted media machine that fueled the financial and political support of many African Americans in Bronzeville. Cobbs understood the power of images of himself and of his God that he presented to his congregants. Jones meticulously represents key themes of the FCOD ministry, such as class diversity and inclusivity, and specific aspects of the Spiritualist service and the church's interior.

Man of the Street

FCOD and Cobbs had a definite celebrity status in the city. His 11 P.M. service reached out to those residents of the South Side who worked—or partied—late.[28] No other pastor of a large church in the city spread the "good news" until midnight. FCOD became known for its famous guests, such as the Sallie Martin Singers, Nat King Cole, Mahalia Jackson, Louis Armstrong, Billy Holiday, Jesse Jackson, and Miles Davis, to name a few. Some infamous congregants also added to the overall "buzz" about FCOD. A number of Bronzeville's policy kingpins were often seen at the church, their luxury cars and drivers waiting outside.[29] "The World of the Lower class" map in Drake and Cayton divides the South Side into different ethnic and class sections, and FCOD is in the area where "most lower-class institutions and families are found."[30] The pastor's far-reaching political influence, acknowledged by many of the city's white politicos like Mayor Richard J. Daley, was in part because of his open-door attitude toward what were widely considered the lowest elements in the neighborhood.[31] Unfortunately, in the 1930s and '40s, gay and transgendered people ranked among "the lowest elements." Cobbs welcomed gay members, and it was widely rumored that Cobbs was gay.

Wallace C. Best is the only historian who has directly addressed this aspect of FCOD in his book, *Passionately Human, No Less Divine: Religion and Culture in Black Chicago, 1915–1952*:

> Many of these men[who attended Cobbs's eleven pm service and then went to nearby clubs] were young and from the South and apparently drew little distinction between what occurred in First Church of Deliverance and what took place in the local gay clubs. Both were deemed safe (perhaps even sacred) spaces from which they received inspiration, community and social acceptance. . . . In the context of a dynamic working-class African American urban religious culture, Cobbs and others who espoused nonconventional sexualities operated freely, seemingly with little rebuke or condemnation.[32]

Jones depicts the class diversity of the congregation throughout his work in the church. Starting with the carved entrance doors, he depicts families with heads and arms raised in the *orans* gesture (figures 2.7 and 2.8). These gestures

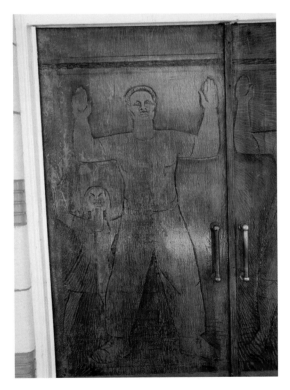

2.7 Frederick D. Jones, entrance doors, First Church of Deliverance, Chicago. Photo courtesy of the author.

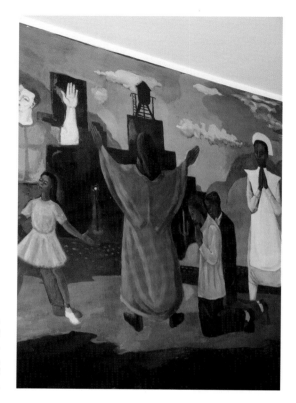

2.8 Frederick D. Jones, *Neighborhood People Flocking to the Lord* (detail), 1946. First Church of Deliverance, Chicago. Photo courtesy of the author.

of open and raised hands are prescribed motions for receiving God's grace and an essential part of Spiritualism and many other evangelical denominations. No doubt Jones had witnessed such gestures during services at the church.

A number of people wear white shirts or gowns in both murals, which was the required attire at FCOD services. This request did not symbolize purity but was a strategy to abolish class inequities. For many less fortunate black Chicagoans, the fashion show of Sunday best often prevented them from attending services. Most people owned something made of white cotton, because it was cheap. This dress code lessened the visible differences between the haves and have-nots because helping the poor was central to Cobbs's ministry. FCOD distributed food baskets, organized a blood bank for Provident Hospital, rehabilitated unwed mothers and prostitutes, and established a community center, preschool, migrant center for new arrivals to the city, and affordable housing units.[33] The appeal of FCOD was an egalitarian one as Cobbs explained in a 1938 interview: "The church was established for all the people from every walk

of life. It is for those who thirsteth, for those who hungereth for the truth. It is 'The Peoples church' and its doors stand wide open in invitation to all alike."[34] These were the exact sentiments Cobbs asked Jones to represent in the murals: "The man who ran the church when I first did it was Reverend Cobbs. He was a great man. He was wonderful. He had a spiritual desire for the finer things, and he always wanted a mural on his wall depicting the people of his community in which his church was built. And so that's who that church is built around—the characters and the people in that community."[35]

The thirty figures in the foyer mural depict nurses in uniform, pastors, women in aprons, men is overalls and suits. Many children of varying ages also appear. According to the title, these are "neighborhood people flocking to the Lord" in an open plot of land with downtown Chicago in the background.[36] It was thought that many of his congregants had even worked in the old hat factory Cobbs converted into a church. Four flying angels usher the crowd toward the central black Christ figure. He is so much larger than the congregants that he looms against the skyscrapers, and his halo touches the top edge of the picture frame.

In all of this imagery, Jones is recording actual Spiritualist practices. Inside the sanctuary of FCOD, Cobbs appears alongside Christ in the mural in the rear of the church (figures 2.9 and 2.10). Surrounded by congregants, the

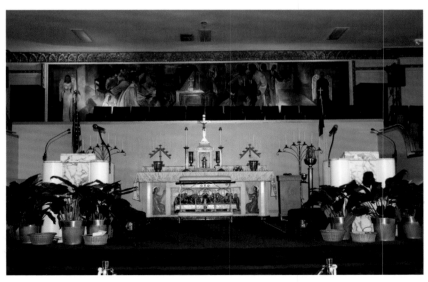

2.9 Frederick D. Jones, *Reverend Cobbs Blessing Congregants at the Altar*, 1946. First Church of Deliverance, Chicago. Photo courtesy of the author.

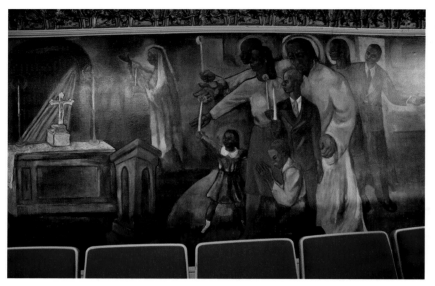

2.10 Frederick D. Jones, *Reverend Cobbs Blessing Congregants at the Altar* (detail).

pastor blesses a kneeling boy (figure 2.11). The altar in the painting is a replica of the real altar in the center of the church that still stands there today. The altar on a dais provides a pulpit in the round. The choir filled most of the rear area, but Cobbs could face multiple sections of his congregation as he and his staff distributed the blessed items, such as fresh flowers and candles that Spiritualists believe can heal. To the right of the altar in the mural, a black Christ resembling Cobbs stands behind a young mother and her three children, who each hold these blessed candles that congregants received at every FCOD service (figure 2.10). Christ gestures with bleeding hands toward Cobbs, his double at the altar. Jones painted rays of light shooting diagonally from right to left onto the altar that created the illusion that they come from the ceiling light above the mural. Similarly, the spotlights beneath the bottom of the painting enhance the painted lit candles at the altar. As with the relationship between the painted altar and the real altar in the midst of the congregants, these divine rays come from the florescent fixtures of the church.

This conflation of the real and the painted Cobbs and Christ can be considered hubris, savvy marketing, or empathetic realism—most likely, it is all three. Cobbs performed as himself *and* the black Christ in the mural behind him much in the same way Austin entered as Christ through Scott's painted

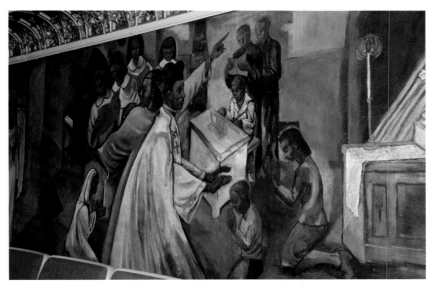

2.11 Frederick D. Jones, *Reverend Cobbs Blessing Congregants at the Altar* (detail).

tomb at Pilgrim, as discussed in chapter 1. The painted pastor alongside Jesus reinforced the impact and sanctity of the live performing pastor at each service. Unlike the scenes at Pilgrim, these at FCOD were not biblical scenes but events that included the viewer in real time. These visual devices helped the congregation and Cobbs to be in the presence of Christ, his suffering, and his grace. Jones also emphasizes this aspect of realism in the foyer mural where this world, represented by the city of Chicago, and the next are presented together as a water tank atop a large building standing next a golden palace rising up into the sky to the far right.

Like Austin at Pilgrim, Cobbs also understood the importance of having visual and musical attractions. Before he hired Jones to decorate the walls, Cobbs appointed Kenneth Morris in 1938 to direct the church's gospel choir.[37] Morris introduced the Hammond organ at FCOD. Invented in 1934 and purchased by churches as a cheaper electric alternative to the larger pipe organ, this instrument revolutionized the gospel sound. Exposed to a national audience through the FCOD radio broadcasts, Morris's compositions changed the history of gospel music almost as much as Dorsey's work did at Pilgrim. Elder Lucy Smith was the other prominent preacher who attracted a large following of working- and middle-class Bronzeville residents with her live

broadcasted sermons and singing. Often Cobbs and Smith were back-to-back on the evening programming at WIND.[38] The scholar Josepha R. Washington Jr. remembers the power of Cobbs's broadcasts:

> As a youngster I used to lie in my bed on Sunday nights listening to this fantastic music, puzzling over how it was possible for such a low-key preacher to be so successful. Most of all, it was this mystical note which he struck in contrast to the jubilant music that was fascinating. Since he so fully identified with the people and deeds I had heard condemned earlier in the day [at the speaker's own church], I could never figure out the meaning of those mystery words repeated Sunday after Sunday—"it matters a lot what I think about you.".... Cobb[s] made no pretension of being anything but a religious leader who loved the ways of black folk. He offered them his counsel and advice, allowing them to state the contradictions of their life.[39]

Black Liberation Theology, Black Power, and the Black Arts Movement at Trinity United Church of Christ

"To me, it was obvious that Christ could not be the conception of Sallman or Metro, Goldwyn, or Meyer. It was obvious, also, that those who made this declaration had to be persons with whom I could share this faith." In 1986 Joseph W. Evans Jr. (1908–89) wrote these words in the explanatory pamphlet for his illustration of the motto of the Trinity United Church of Christ: "Unashamedly Black and Unapologetically Christian." His image of a Jesus with dark brown skin and tightly curled black hair, his arms outstretched behind a smiling African American family (figure 3.1), was Evans's vision of being black and Christian. This Christ directly addresses the popular white images of Christ propagated throughout mainstream society through the popular press, television, and film. In 1979 the artist joined Trinity United Church, where its pastor, Jeremiah A. Wright Jr., promoted Black Liberation Theology and continued to do so until his resignation in 2008. In 1972, when Wright first arrived at Trinity, the congregation was an intimate 90 members. Today it is 8,500 strong and the largest United Church of Christ in the country.

Wright Reeducates Evans: Black Theology and Pan-Africanism at Trinity

As Trinity's official artist and director of its art program, Evans created the visualization of Trinity's black Christian community and its ideologies. Decades before 2008 most Chicagoans were aware of Trinity's pro-black interests and

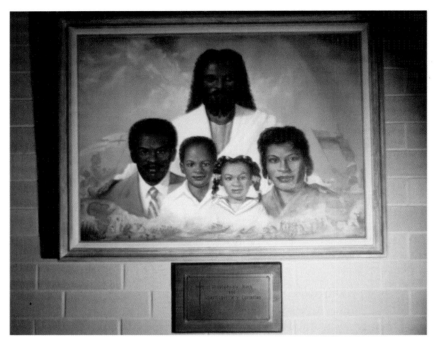

3.1 Joseph Evans Jr., *Unashamedly Black and Unapologetically Christian*, 1986. Trinity United Church, Chicago. Photo courtesy of the author.

its fifty-year legacy of social work, including one of the first AIDS ministries established in a black church, in the South Side communities. This reputation drew Evans and many other African Americans to Trinity. Evans used his talents to start an art program at the church, becoming the primary designer for all of Trinity's materials.

By the 1980s black Christianity had gone through a transformation, much in the same way that Evans's own ideas about the color of God had evolved. Black Liberation Theology played a great part in these transformations. Crystallized in the 1960s and '70s during the height of the civil rights era, Black Liberation Theology is an openly politicized Christianity that is not removed from one's daily experiences. Its main architect, James H. Cone, posed the following to the white Christian tradition, most specifically those aspects highlighted for the oppressed: "A Black theologian wants to know what the gospel has to say to a man who is jobless and cannot get work to support his family because the society is unjust. He wants to know what is God's Word to

the countless Black boys and girls who are fatherless and motherless because White society decreed that Blacks have no rights. Unless this is a word from Christ to the helpless, then why should they respond to him? How do we relate the gospel of Christ to people whose daily existence is one of hunger or even worse, despair? Or do we simply refer them to the next world?"[1] As Cone, Theo Wvilet, Benjamin Mays, and other black theologians have advocated, the "Blackening" of Christ is an essential step for the black Christian to fully realize the *vita christi*—making the black Jesus function as a representation of self for the black person, the true *imago dei*.[2]

Reverend Wright shaped his ministry at Trinity around Black Liberation Theological concepts that influenced the way Evans visualized this ministry. Evans made the black family the focus of his *Unashamedly Black and Unapologetically Christian* in 1986. Beginning in 1979 when Evans and his wife Mildred joined Trinity, Wright recommended the artist read such texts as Cheikh Anta Diop's *African Origin of Civilization*, Cain Hope Felder's *Troubling Biblical Water: Race, Class, and Family* and *The Original African Heritage Bible*, and Latta Thomas's *Biblical Faith and the Black American*. Wright describes his conversations with Evans as private Afrocentric tutorials in which they discussed specific passages from these texts and Wright's sermons.[3] Wright was a member of Transafrica, an African American foreign policy organization, and Trinity soon had Caribbean and African ministries. Wright's ministry started in Africa:

> We affirm African roots and use Africa as the starting point for understanding ourselves, understanding God, and understanding the world. We use Africa as the starting point for our music, our worship style, and our pedagogy. We understand Africa as the place where civilization began and the place where our story begins. We affirm that story, we embrace that story, and we tell that story. Our story is God's story. It is a story which contains a theology of resistance and refusal. It is the underground theology that has been a part of our story since the first European set foot on the Motherland, and it is the story that must be told.[4]

Such intense ecumenical study was second nature to Evans as the son of a minister. He had taught Sunday school, read all of the books in his father's library, attended religious conferences, and often written his own interpretations of Christianity and biblical passages.

The ideas regarding race and history in the texts Wright showed him changed Evans's art: For example, Diop's contention that Egyptian civilization was African was groundbreaking in 1951 when he first submitted his PhD

dissertation on this topic to the University of Paris, Sorbonne. When his work reached a wider audience in the 1960s, it still was "revolutionary" and very important to the Black Power and Black Arts Movements of the late 1960s and 1970s. The historical vignettes including Egyptian pyramids and black crusaders at the bottom of Evans's *Unashamedly Black* reflect Diop's assertions. Often quoting such poets as Aime Cesaire in *African Origin*, Diop places the Africanists of the twentieth century into a broader history of Afrocentric accomplishments. Beginning with Herodotus, Diop lists hundreds of references to blacks in Ancient history. He devoted much of the book to compiling evidence that the ancient Egyptian aristocracy was black and how white scholars had concealed this fact for centuries.[5] Not only were the polemical ideas eye-openers for Evans, but the concentration throughout Diop's text on what Frantz Fanon described as "the racial epidermal schema," the visibility of blackness in a postcolonial world, was especially influential.[6] This emphasis on the visuality of race caused Diop to frequently use art as evidence. For example, the caption for one sculpture reads, "Narmer (or Menes), typical Negro, first pharaoh of Egypt, who unified Upper and Lower Egypt for the first time. He is assuredly neither Aryan, Indo-European, nor Semitic, but unquestionably Black." Comparative examples were very effectively employed, such as one in which a hairstyle that shaped hair in a helmet-type form was shown being worn by a modern day Watusi and the Egyptian pharaoh Ramses II. This juxtaposition was accompanied by the following caption:

> Pharaoh Ramses II (yop), and a modern Watusi. The Watusi hair-do can be conceived only for woolly hair. The small circles on the Pharaoh's helmet represent frizzy hair (as noted by Denise Cappart in her article in *Reflet du Monde*, 1956).[7]

Evans's inclusion of the black South African struggle for freedom in this work makes it black nationalist and timely. Between 1985 and 1986 large-scale protests against apartheid increased abductions, murders, and violent clashes with police. The South African government declared a state of emergency twice. His depiction of marchers with fists in the air had become an iconic image in the news media. The racial conflict in South Africa was important to Trinity because Wright was the vice-chairperson of the Commission for Racial Justice and the congregation included two South African pastors who brought their activism concerning the conflict to the Chicago congregations.[8] The year before Evans painted *Unashamedly Black* local activist muralists Mitchell Caton and Nii Oti Zambezi had painted the now lost mural *Cry the*

Beloved Country—South Africa Exposed on the Chicago Defender Building at 24th and Michigan. In this mural, newspaper headlines, Dutch trading ships, skeletal miners, and Zulu warriors float over layers of boldly colored patterns that resemble tribal textiles and body adornment.

In an Afrocentric aesthetic, Caton often brought West and East African patterns into his murals as backdrops and visual accents to the layered narratives. *Time to Unite,* painted in 1976 by Caton, Calvin Jones, and Justine Devan at 41st and Drexel, features a collage of images of African American history, African mask, Kente and Ewe cloth patterns, and dancing drummers that are awash in an electrifying blue similar to the blues players on the far right. For Evans, James Cone's Black Liberation Theology girded Diop's history of a black African foundation for Western civilization. Historians like Diop, theologians like Cone, and artists like Evans sought to redeem blackness. As Cone writes in his support of segregation, "in order for the oppressed Blacks to regain their identity, they must affirm the very characteristic which the oppressor ridicules—Blackness. Until white America is able to accept the beauty of Blackness ("Black is beautiful, baby"), there can be no peace, no integration in the higher sense. Blacks must withdraw and form their own culture, their own way of life."[9] Very much like Diop, Evans chronicled blackness; he knew the passages in the Bible that proved the African presence in biblical history and he frequently would discuss this scripture with Wright and others.[10]

When Wright asked Evans to illustrate church materials, artistic and pastoral visions were married. Having been mentored by such prominent local religious leaders as Clarence Cobbs and Louis Farrakhan, Wright fully understood the role of publicity and media outreach.[11] By the mid-1980s his Sunday services were broadcast on the radio and the church published a weekly newspaper, *The Trinity Trumpet*, that gained a national audience.[12]

Like a modern day Apelles, Evans created the black family from the faces of his congregation. He wrote, "Who posed for the family? 4000 Trinitarians! I took a pair of eyes from there, a mouth from another, expressions and complexions from many, and put them together into a family that is happy and assured—and Black—and Christian."[13]

Papa Joe's Black (R)evolution

Evans was born on June 28, 1908, in Grand Rapids, Michigan, to Grace and Joseph Evans Sr. The family moved often because the elder Evans was a minister who pastored many churches in the Midwest. Having lived in Jewish, Italian, or racially mixed neighborhoods in Michigan, Pennsylvania, and Ohio,

Evans's first experience living in an all-black neighborhood was when his family moved to 41st and South Parkway in Chicago. Being the son of a pastor he often, understandably, recounted the ethnic make-up of a neighborhood in relation to its religion: "The Cleveland neighborhood was Italian. My playmates had names like Arbie, Dick, Mike, with last names Cavelli, Dibenzenzo. They were Catholic, and so I witnessed a religion that was observed with pomp and ceremony at Mass." Once in Chicago he was actually surprised when he experienced job and housing discrimination. For the rest of his life Chicago would be fixed in his mind as a city that taught him the most about racism.[14]

"Papa Joe," as Evans was affectionately called, created the image *Unashamedly Black and Unapologetically Christian* to commemorate Trinity United Church's twenty-fifth anniversary. In this painting, a brown-skinned Christ is a fifth member of this contemporary African American nuclear family. He extends the concept of the Trinity by composing it also of the light (upper), the family (middle), and black heritage (below). The small figures at the bottom represent slave ships and the first Christians, including black medieval crusaders. The latter puts an alternate spin on this imagery that normally features dark-skinned soldiers as Muslim crusaders fighting against fair-skinned European Christian soldiers. The scene in the lower right represents South Africans marching to freedom. Evans indicates that the "early morning light that bathes the five principal figures [in the center] indicates that we are somewhere in the development of freedom, equality and peace."[15] Evans divided the canvas into three tiers, conflating his three states of the black experience: family or community, struggle, and salvation with the Holy Trinity. Evans's journey as an African American Christian and imager of Christ reflects many of the conflicts and revelations inherent in black Christianity that African and American artists have explored for centuries.

Evans painted a number of murals in African American churches on the South Side of Chicago between 1948 and 1986. Though Evans worked for thirty-one years as a postal worker, he simultaneously pursued his artistic career. His political cartoons frequently appeared in *The Pioneer*, the local postal newsletter. He was even able to enroll in the American Academy of Art through the G.I. Bill. The artist outlined his philosophy of painting in relationship to his Christian faith in his unpublished biography, and I quote from him: "The Master paints and gives us the vision to enjoy that which He has created. The artist, with paint and brush, seeks to share his personal view." He even boasted of going to the Chicago Academy of Fine Arts, where the young artist Walt Disney tried to persuade him to move to Los Angeles and

pursue a career in animation, but Evans declined. His paintings and drawings reflect his knowledge of art historical traditions, such as a self-portrait from 1973 (figure 3.2) in which the artist poses in profile with a large pipe in homage to such Old Masters as Rembrandt. Evans was active in the arts scene. He published a few short stories in *Abbott's Monthly* (*The Defender's* predecessor) and served as a lead designer for the American Negro Exposition in 1940.

Evans painted his first significant religious works in his father's church, the Metropolitan Community Church in Chicago, located at 40th and South Park Way, which is now Martin Luther King Jr. Drive. These works were painted between 1948 and 1955. Only blocks from his father's church was the series of murals depicting the life of Christ by William E. Scott discussed in chapter 2. Scott represented a Jesus of different ethnicities ranging from white European to black African. Within the mural program, he painted many faces of Christ, presenting side by side a Christ for everyone—an all-inclusive, ever-changing vision of a God rather than a single historical truth.[16]

The muted pastel-colored palette and racial types of Evans's four panels in the Metropolitan Community Church reflected the influences of Scott and and the African American painter Tanner. Painted between 1948 and 1955, each panel is dedicated to a member or group of the church. In keeping with the community orientation of the church, most of the biblical subjects that

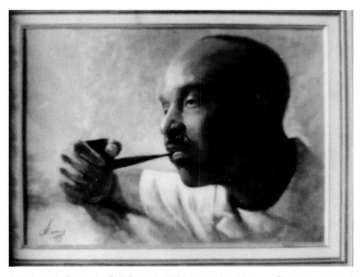

3.2 Joseph Evans Jr., *Self-Portrait*, 1973. Location unknown. Photo courtesy of author.

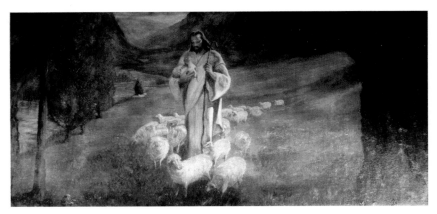

3.3 Joseph Evans Jr., *The Good Shepherd*, 1952. Metropolitan Community Church, Chicago. Photo courtesy of Jeanine Oleson.

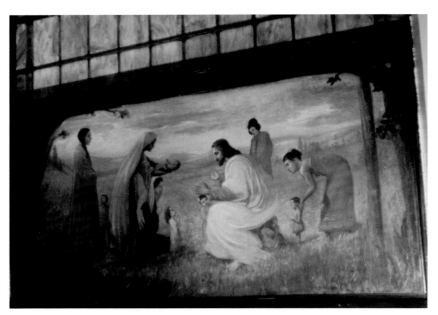

3.4 Joseph Evans Jr., *Christ and the Children*, 1952. Metropolitan Community Church, Chicago. Photo courtesy of Jeanine Oleson.

Evans painted for this series illustrate Christ's generosity toward others. *The Good Shepherd* (figure 3.3) and *Christ and the Children* (figure 3.4) reveal yet a third important influence on Evans's work, the imagery of the popular religious painter Warner Sallman (figure 3.5). As discussed earlier, Sallman's representations of Christ as a fair-skinned, brown-haired, and blue-eyed man are probably the most widely recognized religious images in the world. Evans also kept a framed Sallman image prominently displayed in his studio.[17] Sallman's influence on the visualization of Jesus, regardless of one's own religious beliefs, has most successfully been addressed in the work of David Morgan and Sally M. Promey.[18]

Evans's Christ figures in the series of oil paintings at Metropolitan are reminiscent of Sallman's work because of their erect poses in profile and their similar facial features and compositions. Here Evans's work appears merely derivative of this European American model. On the other hand, when one sees the broader nose, fuller lips, and darker skin tone of *The Good Shepherd* and one reads his own words about this imagery, it is clear that these paintings

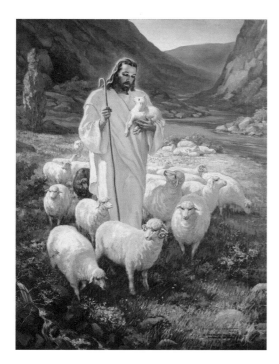

3.5 Warner Sallman, *The Lord Is My Shepherd*, ©1941 Warner Press, Inc., Anderson, Indiana. Used with permission.

spoke specifically to the congregation at the Metropolitan. An article in the *Chicago Defender* summarizes the artist's statement about the work:

> The five mothers are symbolic of the five races and all are young for they represent the painter's feeling that the races are young and face periods of richer development. The children, says Evans, represent the generations that shall inherit this troubled earth. The Christ is shown about to take one of the children into his arms. The setting is an open field filled with summer sunlight and vegetation to suggest that the winter of superstition and ignorance, prejudice and hate are gone and that the cooperation of all men will bring to the world a summertime of peace, the artist explains.[19]

The final panel clearly shows the presence of Christ in the congregants' lives. This painting was created in memory of Evans's mother and shows her in death meeting Jesus and a dark-skinned angel with dreadlocks. This work also plumbs canonical religious imagery, such as Renaissance and Baroque Assumption scenes that feature angels escorting the deceased up to heaven.

In this series, despite the aforementioned angel, Evans's representations of Christ follow the traditional European models used by Tanner and Scott;[20] however, in a smaller chapel in the Metropolitan, is *Christ in the Garden of Gethsemane* (figure 3.6), painted in a different style. This painting is clearly executed in his later style with its bold colors and decidedly "African" Jesus. A dark-skinned man with black hair kneels in prayer. His deep royal blue

3.6 Joseph Evans Jr., *Christ in the Garden of Gethsemene*, 1952. Metropolitan Community Church, Chicago. Photo courtesy of Jeanine Oleson.

tunic stands out against the lush and vibrant green and turquoise landscape and sky. Gone are the pastel colors of the earlier paintings in the front of the church. Evans painted this work between 1980 and 1989 over an older work from around 1950, the same time as the panels in the main chapel, that had suffered water damage. The artist had since left his father's church and joined the more Afrocentric congregation at Trinity in 1979. Also, at this time, Evans painted *The Baptism of Christ* at Pleasant Ridge Mount Baptist Church, located at Central and Adams, in the later style. These later works in which his Christ is clearly of African descent reflect a shift artistically, religiously, and politically. The transformation of Evans's images of Christ also held personal significance. Although he had not depicted Christ as a black man in a public church mural in the 1940s, Evans had done so in the playbill he designed (figure 3.7) for the Easter Sunday production of Willa Saunders Jones's *Passion Play* performed

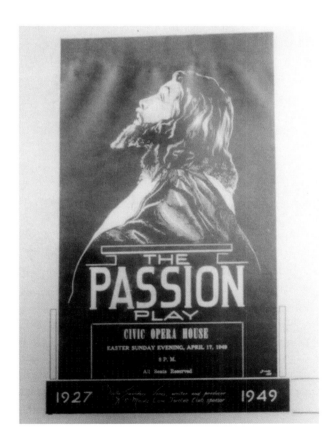

3.7 Joseph Evans Jr., playbill for *Passion Play*, performed at the Civic Opera House April 19, 1949. Mildred Evans collection, Chicago.

at the Civic Opera House on April 19, 1949. Normally only seen in African American churches since Jones wrote it in 1927, these productions at the Opera House beginning in 1946 were the most professional and the first version of the play to include a black Christ character.[21] To celebrate this racially provocative play by an African American woman, Evans filled the playbill's cover with the bust of a black man with long hair and a beard in profile looking up against a dark background. The word "Passion" stands out in the center in large white letters beneath a stark outline of the capital's ledge.

The Influence of the Black Arts Movement and the Muralist William Walker on Chicago

In addition to the commemorative painting, Evans created most of Trinity's graphic work and was the church's main photographer during his time as a member there. Having frequently worked as a graphic artist by creating advertising materials throughout his life, his superior draftsmanship is actually more evident in this work than in his paintings (figures 3.8 and 3.9). The austerity of the black-and-white page freed Evans from an often arduous struggle to reproduce nature. These drawings reveal a fresh modernist style that revels in both textures and angularity, sometimes at the same time. Whenever he was serving an African American audience, whether for Central Oil and Heating company or a leaflet on the Men's Week for Trinity, he often featured a handsome and dignified black Christ or another black male figure; "Black Is Beautiful" permeates these images, and it is here that the influence of yet another local phenomenon, the Black Arts Movement in Chicago is evident. This increased interest in including figures of African descent in his religious work was accompanied by the use of bolder colors. Evans not only embraced Afrocentric content, but this brighter palette reflected an "African" or "Black Aesthetic" as promoted by the Chicago-based artists coalition Afri-COBRA (Coalition of Black Revolutionary Artists; later, Coalition of Bad Relevant Artists). Their manifesto committed to making black art for black people. The initial members of this group of painters, printmakers, and fiber artists were Jeff Donaldson, Barbara Jones-Hogu, Wadsworth Jarrell, Jae Jarrell, and Gerald Williams; Walker was never a formal member but often visited their Visual Arts Workshop. They created a visual vocabulary of bright colors and patterns derived from East and West African textiles that attempted to shed European influences and make their form more consistent with the pro-black content of their work. Donaldson and others participated in the dissemination of many forms of public art, such as posters and murals, as their group was a

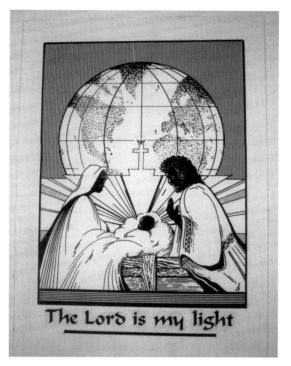

The Lord is my light

3.8 Joseph Evans Jr., *The Lord Is My Light*, pamphlet, ca. 1980. Trinity United Church of Christ, Illinois, Mildred Evans Collection, Chicago.

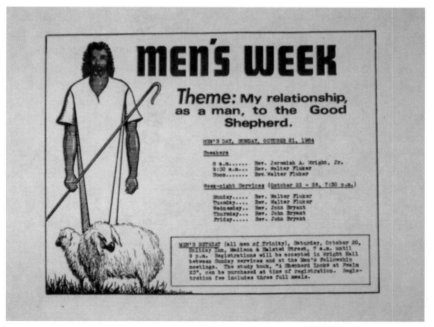

3.9 Joseph Evans Jr., *Men's Week*, pamphlet, ca. 1980. Trinity United Church of Christ, Chicago. Photo courtesy of author.

part of Black Arts Movement. Chicago was central to this national movement whose architects were, among others, Amiri Baraka, Larry Neal, Gwenolyn Brooks, and Haki Madhubuti, the latter two being Chicagoans.[22] This surge of black artistic expression beginning in the 1960s had both a visual and literary component in Chicago. Beginning with the famous *Wall of Respect* at 43rd and Langley Streets, erected by twenty-one members of the Chicago-based Organization for Black American Culture (OBAC) in 1967, muralists painted politically outspoken work all over the city of Chicago but predominantly on the South and West sides. Other artists, not officially affiliated with Afri-Cobra or OBAC, included Mitchell Caton, Justine Devan, Santi Isrowuthukal, Calvin Jones, Eugene Wade (Eda), William Walker, John Weber, and C. Siddha Sila. Weber created this work in direct response to the civil rights and poverty crisis facing the nation and the city of Chicago.[23]

Although Martin Luther King Jr.'s image was not on the *Wall of Respect* due to the more radical leanings of that community's members and some of the artists, he had moved to Chicago in 1966 to highlight racism in a major northern city during a campaign dubbed the Chicago Freedom Movement.[24] His presence in Chicago was a catalyst for community organizing and activism. With titles such as *Wall of Truth* (1969, figure 3.10, located across the street

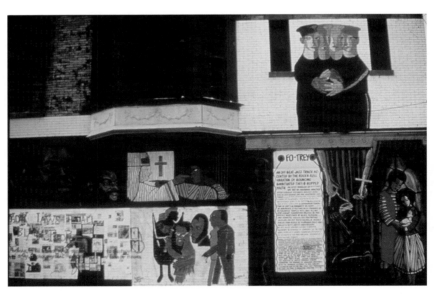

3.10 William Walker and Wade (Eda), *The Wall of Truth* (detail), 1969. 43rd and Langley Streets, Chicago (now lost). Photo courtesy of the William Walker Archive at the Chicago Public Art Group, Chicago.

from the *Wall of Respect*, 1967) and *Peace and Salvation/Wall of Understanding* (1970, at Locust and Orleans Avenues), the didactic imagery in the many murals that sprang up in the city celebrated African American historical role models such as King (see figure 3.13), Malcolm X, Frederick Douglass, and Harriet Tubman. These painters also provided morality tales about drugs, crime and prostitution that spoke directly to those living in the neighborhood around these murals, as seen in *Wall of Daydreaming/Man's Inhumanity to Man* (1975, figure 3.11, at 47th and Calumet) by Caton, Isrowuthukal, and Walker. The lead artists Caton and Walker painted pimps in luxury cars tied to the backs of suffering prostitutes, hooded KKK figures, and an ominous half-length portrait of a pimp with skulls for pupils surrounded by moneybags, chains, pills, and hypodermic needles. Like in most of this group's work, historical and contemporary lives merge. The bleeding bodies of King and John F. Kennedy lie on the checkerboard beneath the Green Line El that runs directly across the street from the mural. Chicago's skyline appears in the upper section of the mural.

Walker, the most prolific muralist from this period, with more than twenty murals in Chicago, also represented scenes of multiracial harmony in addition to his scathing indictments of heartless criminals or corrupt politicians.[25]

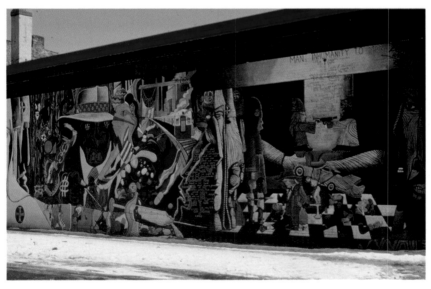

3.11 William Walker, Mitchell Caton, and Santi Isrowuthukal, *Wall of Daydreaming/Man's Inhumanity to Man*, 1975. Chicago. Photo courtesy of the Chicago Public Art Group, Chicago.

Childhood Is without Prejudice (1977, at 56th and Lake Park [56th Street Metra underpass]), is an example of Walker's milder and more optimistic work that often focused on a harmonious group of children representing different races. A signature device here is the way in which he cubistically melds the children's faces by making their features continuous—sharing eyes, cheeks, and skin. In 1970 Walker and Weber, a white Jewish American, founded the Chicago Mural Group, which is now known as the Chicago Public Art Group (CPAG). It was an interracial cooperative of a dozen men and women. The group went on to create more than seventy murals throughout the city in the following decade, many of which heralded African American people and history.[26]

With the funding secured from the city and other sources, Walker erected a large number of murals between 1974 and 1982. The majority of these murals are located within a few blocks of Evans's father's church at 40th and Martin Luther King Jr. Drive. This explosion of Afrocentric, worker-centric, social activist work that addressed raw issues of race, class, sexism, and poverty appealed to Evans's political and religious beliefs as it did for most of the South Side community. As Jeff Donaldson, one of the founders of both OBAC and Afri-COBRA stated about the *Wall of Respect*, "before the *Wall* was finished on August 24, 1967, it had become an instantaneous shrine to Black creativity, a rallying point for revolutionary rhetoric and calls to action, and a national symbol of the heroic Black struggle for liberation in America."[27] These murals were important in the community because they functioned as sites for cultural and political activity. During the painting of a mural, residents would often interact with the painters and sometimes even help out. The dedication ceremonies included music, speeches, and poetry readings with more than one hundred people. Other events such as drumming circles, concerts, and rallies occurred at these walls—they became open-air community centers as the poem that Don L. Lee, a.k.a. Haki Madhubuti, recited at the dedication of the *Wall of Respect,*

> A black creation,
> Black art, of the people,
> For the people,
> Art for people's sake
> Black people
> The mighty black wall.[28]

Making the black audience the subject, the main protagonist in their own history was at the heart of this movement. The muralists were working in the

Mexican mural tradition that focused on communities of working-class people versus the privileged few who historically were the patrons of painted portraits. These predominantly African American artists painted Chicago's South Side murals using "a vocabulary of 'vernacular' images, which were embedded in the common visual culture of an area—images that [were] immediately recognizable and charged with evocative power." Images that embraced empathetic realism were at the core of the black Christs that appeared in such neighborhood churches as Pilgrim and FCOD. All of these African American artists were community artists with similar goals. How Evans allowed his experience with the Trinity community to shape his work is aligned with the community mural practices that dominated his neighborhood starting at the end of the 1960s: "During a mural project, the artist m[et] the working class and its children as flesh-and-blood individuals, with their own culture and personal histories that intersected with the 'universal' history of 'great individuals' and 'great events' in fascinating ways."[29]

Christ, Nat Turner, Elijah Muhammad, and Other Black Revolutionaries

The impact, in terms of style and content, of the murals on the city's South Side is also apparent in specific aspects of Evans's work. Religion was not central but did appear in the work of OBAC artists. According to Sylvia Abernathy's design for *Wall of Respect*, an artist and photographer were assigned to each of the six sections: statesmen, sports, literature, theater, jazz, soul music, and religion, the latter was given to Walker and Robert Sengstacke.[30] In this section, Walker depicts Elijah Muhammad with arms outstretched leading a sea of Muslim followers in white suits and kufis. To the left is Wyatt Tee Walker, the pastor and civil rights activist close to Martin Luther King Jr. Next to him is Nat Turner preaching before a crowd holding signs that read "See, Listen, Learn."[31] Above the painting on the wall are two photographs, *Girls in Church* and *Spiritual Grace* by Sengstacke showing two forms of black worship featuring women: a revivalist hitting a tamborine (taken at a storefront church service two blocks from the *Wall*) and Muslim women (one is Muhammad's granddaughter) in white hijabs saying prayers; both photos were taken in Chicago.[32] There was also a storefront church next door to the *Wall*, and according to Eugene Wade, who repainted some of the wall in 1969, a cross and Bible were painted to the right of the *Wall* for that church in the same way standing silhouettes were painted in front of the newsstand to the left of the

mural.[33] Walker repainted this panel two more times before it was destroyed in 1971, and each version became increasingly less historically specific and more symbolic and colorful.[34]

Across the street Walker and Eda painted *The Wall of Truth* in 1969. In this mural, which is also no longer extant, Christianity is condemned (figure 3.10). A large wooden cross prominently hovers in front of a KKK member, and in another vignette a faceless figure holds a chain around the eyes of a praying black man in one hand while offering him a crucifix and a syringe with the other.[35] Walker had some previous experience with religious imagery because he had been commissioned to paint murals in two churches in Ohio while an art student in Columbus. Once he came to Chicago, he admired William Edouard Scott's work in the city, undoubtedly the murals at Pilgrim discussed in chapter 1, and he even tried to enlist him as a mentor.[36] In 1972 Walker began painting *All of Mankind* (figure 3.12) on the Strangers Home Missionary Baptist Church (originally called the San Marcello Mission) at Clybourn and Evergreen. Unfortunately, the church was sold before he could finish the interior and later tenants painted over it, but the exterior mural covers

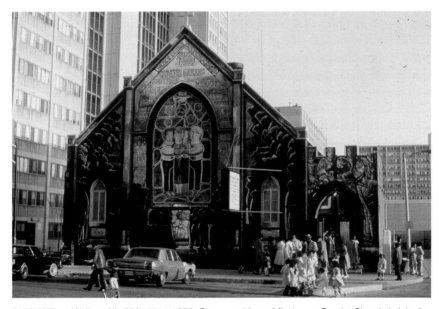

3.12 William Walker, *All of Mankind,* 1972. Strangers Home Missionary Baptist Church (originally called the San Marcello Mission), Chicago. Photo courtesy of The Chicago Public Art Group, Chicago.

the entire façade of the church with colossal figures that dissolve the surface of the building so successfully that the arched windows float among these figures.[37] The theme is harmony. A multiracial group of worshipers stand in the center with arms, hands, and faces linked or overlapping. The text reads "Why were they crucified?" and the names of historical figures like Gandhi, Malcolm X, Anne Frank, Martin Luther King Jr., and Jesus Christ are listed below. There are also references to the My Lai massacre and the Kent State shootings—all contemporary events about the Vietnam War. In these commissions, the pastor restricted or guided the artists very little. For example, for *All of Mankind* Father Dennis Kendricks commissioned Walker to make a mural cycle. His only guidelines were "something reflecting the love and unity of the community."[38] Cabrini-Green was hard hit by poverty, crime, and drug use in the 1970s; the church even had a drug rehabilitation program to reach out to the community. Walker's murals were part of the pastor's overall vision to bring pride and self-respect back to a neighborhood that felt abandoned by its mayor and its God. Approaching these murals as his own Sistine Chapel, Walker filled the interior of the church with tiers of figures from floor to ceiling. Images of such political figures as Malcolm X and Gandhi stand in for Christ, Moses, and traditional biblical characters. Symbolic pairs of white and black figures wrestling in lunettes (an explicit reference to Michelangelo's work in the Sistine ceiling) framed the central program that focused on groups of contemporary families and multigenerational figures in various scenes helping or guiding young children. Walker painted more than five hundred figures in these interior walls, and the majority were not explicitly biblical; however, they metaphorically represented Christian principles in the very specific contemporary context of a poor urban, black neighborhood. Filling a church with contemporary figures followed the African American biblical exegetical traditions found in each ministry in this book.

Making his art current and relevant to his audience was important to Walker. In 1970 Walker painted *Peace and Salvation/Wall of Understanding* at 872 N. Orleans in Cabrini-Green. For years after it was completed, he would return and repaint the lower section of the wall: "I felt whatever was newsworthy, meaningful, I would change that particular space. . . . I thought people should know about it. I would use that as . . . a chronicle or a newspaper."[39] He had begun a similar practice the year before on the *Wall of Truth*, which he and Eda painted across the street from the *Wall of Respect* at 43rd and Langley. Walker would routinely paste up actual pages from the newspaper about local and national events relevant to the African American community

in an area at the bottom that he labeled in bold letters "Black Laws for Black People."[40]

Chicago muralists also painted in Detroit at this time. A group of pastors who wanted their own inspirational wall in Detroit's impoverished African American ghetto commissioned the *Wall of Dignity* in 1968. Walker and Eda also painted murals for Saint Bernard's Catholic Church in Detroit in 1977 that depicted a black Moses asking the pharaoh to free his people and civil rights figures leading crowds as those seen in the *Wall of Respect*. Jeff Huebner, a mural critic and historian who is the authority on Walker and his work, believes that Walker probably became the most familiar with such visual manifestations of Black Liberation Theology as the black Christ and Mary while working in Detroit among the black and white pastors who brought him there to paint murals. Through this flurry of "Wall of . . ." activity, with the help of a few other painters, Eda and Walker successfully created a movement, the Black Mural Movement. Starting in the 1950s but propelled by the 1967 riots, Detroit was the site of much black activism and the birthplace of the Black Christian Nationalist movement that supported the idea of a black Christ: "Albert, founder and pastor of the Central Congregational Christian Church (1953), began preaching a series of sermons centered on the idea that Jesus was a black revolutionary messiah whose primary objective was to construct a black nation."[41]

A 1969 *Ebony* magazine article featured Cleage as the principal proponent of "dehonkifying" Jesus for black Christians with images of biblical figures of African descent. Cleage had been preaching about a black Christ since the 1950s, almost two decades before Cone published his work on Black Liberation Theology. It is significant that the Chicago muralists were in the midst of these debates. This group of religious leaders decided that Detroit needed its own wall of black heroes to heal the demoralized community there. According to Huebner, Walker and Eda painted the *Wall of Pride* in the neighborhood devastated by the riots and worked with two local artists, including Glanton Dowdell, who a few years earlier had painted the well-known black Madonna at the Central Congregational Christian Church; during that time in Detroit, Walker viewed that church mural and met Reverend Cleage.[42]

Religion was definitely not a central theme in the Black Arts Movement. In general, the literature and rhetoric of the Black Arts Movement considered Christianity yet another weapon of Eurocentric, racist, and colonialist domination, and Walker's images projected similar attitudes. As Larry Neal wrote in his polemical public declaration about the "Black Aesthetic" in "The Black Revolution" issue of *Ebony* in August 1969:

We have been praying to the wrong God. And who is God anyway but the awesomely beautiful forces of the Universe? . . . Your ancestors are the Gods who have actually walked this planet. Those who have tried to liberate us. Nat Turner, Harriet Tubman, Malcolm X, they are surely Gods. . . . We don't need any soulless Hebrew God. We need to see ourselves reflected in our religions. For prayer is poetry; and like poetry it acts to reinforce the group's vision of itself. . . . Like Black Art, Black religion should be about strengthening group unity and making radical change. . . . It is the task of the Black artist to place before his people images and references that go beyond merely reflecting the oppression and the conditions engendered by the oppression.[43]

Black Liberation Theology brought racial empowerment into a black religious experience that was solely focused on suffering. Devout black artists such as Evans sought to reconcile this alienation through the reclamation of racially appropriate images of biblical figures.

Walker often painted Martin Luther King Jr., Malcolm X, and Elijah Muhammad as a significant trinity of religious leaders.[44] In 1977 he painted *St. Martin Luther King* (figure 3.13) at 40th and Martin Luther King Jr. Drive.

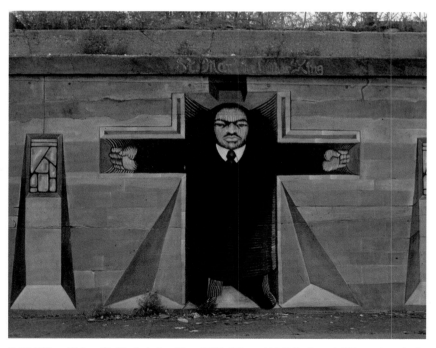

3.13 William Walker, *St. Martin Luther King*, 1977. 40th and MLK Boulevard, Chicago (now lost). Photo courtesy of William Walker Archive at the Chicago Public Art Group.

It features an image of King, his arms outstretched within a cross whose framed edges allude to a coffin. Walker uses a common trope seen after the assassination of the civil rights leader that conflated Christ and the suffering, sacrificed black leader. The community misunderstood this image, and many were offended by the portrayal of MLK hanging on the cross, although Walker was also adamant that he was *in* the cross and not on it. One passerby told him that her pastor thought it was sacrilegious; another resented that King stared straight into her tavern across the street. This image was the first time that Walker had used a single figure in a large mural. Walker allowed Siddha Sila Webber to paint the current mural, *Earth Is Not Our Home*, over it in 1981.[45]

Evans intertwines religious, political, and historical imagery in his work. By having a black Christ preside over vignettes depicting past and contemporary events, Evans made this Jesus in *Unashamedly Black* meaningful and relevant for Trinity's congregants in 1986—and today. He creates a narrative of racial struggle that is continuous with those of Christ as well as with other people of African descent. He included in his unpublished autobiography a list of "quotes that help to convey my thinking: #4. I do not criticise [*sic*] the Italian for painting Christ as an Italian. I do not criticize a German for painting Christ as a German. I do criticize the white church for painting Christ as an endorser of slavery, a proponent of racial superiority, and the anointer of anyone deemed palatable to Reagan."[46] These words are clearly an homage to the passage by Frederick Douglass:

> I love the religion of our blessed Savior. I love that religion which comes from above, in the wisdom of God which is first pure, then peaceable, gentle and easy to be entreated, full of mercy and good fruits, without partiality and without hypocrisy . . . I love the religion that is based upon glorious principle, of love to God and love to man; which makes its followers do unto others as they themselves would be done by. . . . It is because I love this religion that I hate the slaveholding, mind-darkening, the soul-destroying religion that exists in the southern states of America. Loving the one I must hate the other; holding on to one I must reject the other.[47]

This sentiment also appears in a specific suite of sermons that Wright cites as particularly important to Evans and their conversations about race and religion. In this 1980 four-part series entitled "The Challenge to the Black Church," Wright provides a list of woes facing the black Christian: "America with its Reaganism and racism (synonymous nouns), with its capitalism and

imperialism (synonymous sins), colonialism and consumerism (synonymous hypocrisies); . . . and its insecure inability to deal with anything African or Asian."[48]

The Stained Glass at Trinity

With the support of Wright, Evans established a strong art legacy at the church through an art program, scholarships, an artist-in-residency program, and regular exhibitions. Wright continued to support the representation of black people and black faith through art there. After Evans's death his successor and former student, Patrick Thompson, continued his artistic legacy by continuing these art programs and, with Wright, amassing a large collection of African and African American art. They also embarked on one of the most ambitious stained glass programs in an African American church in the United States. Wright visited many black churches around the country, and Seattle's Mount Zion Baptist Church, the largest black congregation in the state of Washington, made a great impression on him. The church, more than a century old, is adorned with stained glass windows the likes of which Wright had never seen before. They included numerous portraits of well-known figures from black history, religious and secular. Wright wanted such windows for Trinity in Chicago, and when he found out that the only African American in the United States with his own glass studio created them, he wanted them even more. He contacted Douglas Phillips (1922–1995) and began a creative dialogue that lasted a decade. Phillips had an active studio with many assistants that he opened in 1953 in Cleveland; he was a designer for General Electric who created, among many other innovations, the first lighting systems for interior, windowless stained glass installations. Also sponsored by GE, he designed the National Christmas Tree in the 1970s and '80s. He studied fine art in high school at John Huntington Polytechnic Institute and took classes at the Institute of Art in Cleveland. He then went to Syracuse University for his BFA, which he received in 1950.

Phillips and Reverend Wright corresponded for years, planning each figure and scene to represent black history and faith on these windows that cover the front and rear walls of the church. Despite having adorned hundreds of churches in his lifetime all over the country, Phillips considered the Trinity windows to be the most important project of his life, and although he was stricken suddenly with cancer, he continued to work on his designs until the very day he died in 1995.[49] His widow, Mona Phillips, installed the largest

program he had ever created after his death in 1996 (figure 3.14). In his book, *A Sankofa Moment: The History of the Trinity United Church of Christ*, Wright recalls how he wanted such an ambitious glass program for the very same reasons he first asked Evans to create race-positive images for the church in the 1970s:

> Because of my studies as an historian of religions, because of my work in the sacred music of Africans, because of my studies at the University of Chicago Divinity School and my knowledge of the history of Christianity, I knew that the white pictures were wrong. I wanted our children to grow up "Unashamedly Black and Unapologetically Christian," while not confusing their minds with what it meant to be Christian. . . . I wanted our stained glass windows to be a perpetual reminder to our toddlers, our youth, our young adults and our adult worshippers of every race of what biblical characters really looked like and what Jesus, the Word who became flesh, looked like once God took a human form in Northeast Africa in the first century of the Christian era![50]

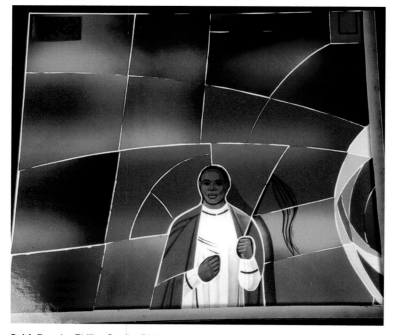

3.14 Douglas Phillips Studio, *Bishop*, stained glass, 1995. Trinity United Church of Christ. Photo courtesy of Elizabeth Sunday.

In the letters between Wright and Phillips, one understands the intellectual and spiritual bond these two men had.[51] Phillips painstakingly researched each figure, as evidenced in his meticulous files for the project that are categorized by historical era. These files contain photocopies from encyclopedias and texts on black and church history, in addition to Phillips's sketches based on images in these clippings (figure 3.15). Wright and the artist amended the list of sixty-six figures a number of times for various reasons, sometimes for historical balance and other times to emphasize specific types of the black presence, such as African rulers. The themes remained consistent: Africa and the Old Testament, the New Testament, Africa and the Early Church, and modern historical figures.[52] Wright also asked Phillips to send color sketches of each figure for approval, something he had never done before for a client. Normally, he would present a client with sketches and maquettes of a complete project, not individual figures.

3.15 Douglas Phillips, *Pope Multiades, Born in Africa in 314*, sketch, 1995. Trinity United Church of Christ. Photo courtesy of Elizabeth Sunday.

Phillips's stained glass is in more than two hundred institutions around the country and reaches viewers from different races and denominations, and he always saw the potential for his stained glass to transform attitudes:

> Today many churches want their messages expressed in symbols that would not, *could* not, have been used in the past. Our symbols have become less representational in some instances, in churches in which the spiritual identification is more individual. And we've found that our work can be both a mirror and a cause of social change. For instance, many members of a white church may be personally in favor of racial equality. But the concept takes on new reality and urgency for many when we design into our windows black and white people who thereby become part of the very physical fabric of the church building. Glass, unlike steel, will not rust or corrode. Its message can never be washed away. Once it's up there with the light shining through it, it is unaffected by time or by anything except the total destruction of the glass itself.[53]

No other African American church in Chicago surpasses the scale of Trinity's Afrocentric glazing, but the panel at New Mount Pilgrim Missionary Baptist Church also strives to be historically relevant to its black congregants.[54] Unlike Trinity's modern building, New Mount is in an older neo-Romanesque church, designed by Charles I. Wallace to seat 1,250 for the Saint Mel's Catholic Church in 1910. The Irish American community of Saint Mel's lived in that area west of downtown until the late 1960s.[55] Saint Mel's membership waned when whites left the neighborhood and black Protestants moved in. After being vacant for almost a decade, the building received the New Mount congregation in 1993. The majority of the earlier decoration remains, including large murals depicting Old and New Testament scenes. Pastor Marshall Elijah Hatch Sr. commissioned Tom Feelings (1933–2003) to make *Maafa Remembrance* (2000, figure 3.16), which connects powerful images of slave ships to a black Christ figure in a work that reflects a "theology of remembrance."[56] The muted pastel colors of the Feelings stained glass matches the palette of the rest of the church decoration, although the soaring image of the Christ body-as-slave-ship is jarring among the traditional iconography. In the tradition of Black Liberation Theology, Feelings conflates black suffering and that of Jesus through the Middle Passage, the harrowing journey enslaved Africans endured on the Atlantic Ocean between Africa and the Americas. As Cone writes about the potential for transcending oppression through faith: "But in the experience of the cross and the resurrection, we know not only that black suffering is wrong but it has been overcome in Jesus Christ."[57]

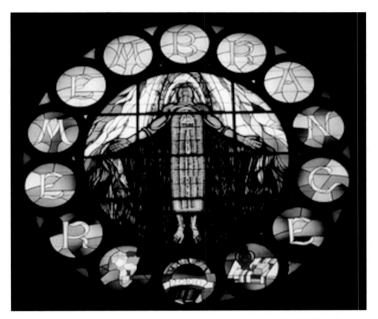

3.16 Tom Feelings, *Maafa Remembrance*, 2000. New Mount Baptist Church, Chicago. Photo courtesy of author.

Born in Brooklyn, New York, Tom Feelings had art instruction at an early age, and throughout his career as an illustrator he focused on the black subject. In 1958 he created the groundbreaking comic strip *Tommy Traveler in the World of Black History* for the *New York Age*, which followed a young African American boy meeting such historical figures as Crispus Attucks and Joe Louis while he traveled back in time. Feelings created work for numerous publications here and abroad, like *Look Magazine* and *The African Review Magazine*. In 1969 he illustrated Julius Lester's *To Be a Slave*, which became the first book by an African American to win the Newbery Honor Book Award. The artist's later books, such as *Moja Means One: A Swahili Counting Book* (1975), *Something in My Mind* (1978), and *Middle Passage* (1996), also made him well known in children's literature. Feelings used the slave ship from *Middle Passage* for *Maafa Remembrance*. His Christ crucified in a slave ship reflects the hybrid experience of the African American he strives to communicate in his work:

> When I am asked what kind of work I do, my answer is that I am a storyteller in picture form, who tries to reflect and interpret the lives and experiences of the people who gave me life. When I am asked who I am, I say I am an

African who was born in America. Both answers connect me specifically with my past and present. . . . [T]herefore I bring to my art a quality which is rooted in the culture of Africa . . . and expanded by the experience of being black in America.[58]

His powerful conflation of the cross and the slave ship present an image of black piety in line with other such images discussed in this book. On special holidays the arts are celebrated at New Mount Pilgrim Missionary as in the annual Maafa Christmas Pageant that "celebrat[es] the Birth of Jesus Christ in drama, fine arts, and song" during which there is a Nativity play and the display of drawings and paintings by congregants (mostly children) in which there are representations of black Christs and the Feelings's image.[59] As Gwendolyn Brooks wrote in "To the Diaspora":

CONCLUSION:

When you set out for Afrika
you did not know you were going.
Because
you did not know you were Afrika.
You did not know the Black continent
that had to be reached
was you.[60]

Wright's polemical political rhetoric became the center of a firestorm of criticism during Senator Barack Obama's presidential campaign because Obama had been a member of Trinity for more than two decades. The pastor's inflammatory comments on the terrorist attack of September 11, 2001, on AIDS, and on the U.S. government's overall negligence on the behalf of the black poor, addicts, and criminals shocked the mainstream media and its audience.[61] Wright's comments offered Obama an opportunity to address the "pro-black" doctrine of Trinity and the source of this polarity in his speech, "A More Perfect Union," given in Philadelphia on March 18, 2008. In that speech, Obama explains how central black affirmation and this image of a black Christ is to Trinity and to many African American churches while providing a context for his pastor's divisive remarks:

In my first book, *Dreams from My Father*, I described the experience of my first service at Trinity:

"People began to shout, to rise from their seats and clap and cry out, a forceful wind carrying the reverend's voice up into the rafters. . . . And

in that single note—hope!—I heard something else; at the foot of that cross, inside the thousands of churches across the city, I imagined the stories of ordinary black people merging with the stories of David and Goliath, Moses and Pharaoh, the Christians in the lion's den, Ezekiel's field of dry bones. Those stories—of survival, and freedom, and hope— became our story, my story; the blood that had spilled was our blood, the tears our tears; until this black church, on this bright day, seemed once more a vessel carrying the story of a people into future genera- tions and into a larger world. Our trials and triumphs became at once unique and universal, black and more than black; in chronicling our journey, the stories and songs gave us a means to reclaim memories that we didn't need to feel shame about . . . memories that all people might study and cherish—and with which we could start to rebuild."

That has been my experience at Trinity. Like other predominantly black churches across the country, Trinity embodies the black community in its entirety—the doctor and the welfare mom, the model student and the former gang-banger. Like other black churches, Trinity's services are full of raucous laughter and sometimes, bawdy humor. They are full of dancing, clapping, screaming and shouting that may seem jarring to the untrained ear. The church contains in full the kindness and cruelty, the fierce intelligence and the shocking ignorance, the struggles and successes, the love and yes, the bitterness and bias that make up the black experience in America.[62]

All of the art at Trinity was conceived and executed as Afrocentric art spe- cifically for the community at Trinity, and like the fruits of the Black Mural Movement, it offers a critical lens on tradition. The description of the role of such art fits well with Evans's murals: "Inevitably, community murals are controversial, for in a world of injustice, exploitation, war, and alienation, a formulation of values implies a criticism of that world and the projection of a possible alternative world. Community art becomes a form of symbolic social action and implies further action."[63] As writers, poets, filmmakers, and visual artists of color have proven, "seeing ourselves" is empowering in any context, be it religious or secular. Evans, Chisholm, and the pastors who commissioned their work understood this. A former Trinity pastor, Reverend Barbara Allen, summed up the impact of Evans's image on the church: "Papa Joe created Afro-centric images that seem so integral to our being, it's hard to even express what they mean to us. Simply, this is how we see Christ, but it was Papa Joe who captured the image for us."[64]

Sources such as Diop, Thomas, Wright's sermons, and Evans's own writ- ings help reconstruct the artist's shift from the more traditional European

representation of Christ to his final images in which he presents a complex iconography that embraces issues regarding black history, the Black Arts Movement, and Black Liberation Theology. Black public artists or artists communicating to black publics, like Evans, Walker, Phillips, and Feelings, used their imagery to reconcile European traditions (religious and artistic) and their own racial selves. Evans embraced the history around him and the Afrocentric zeitgeist of the Black Arts Movement. He lived within walking distance of earlier examples of black Christs at Pilgrim and FCOD, and by 1979, when he joined Trinity, Walker and his contemporaries had erected more than ten murals in that same neighborhood. In many ways Evans's murals function as a metaphorical "missing link" that connects the pro-black paintings in Bronzeville's churches in the first half of the twentieth century to the Black Mural Movement in its last quarter.

Father Tolton's Soldiers

Black Imagery in Three Catholic Churches

I am the good shepherd; I know my sheep and my sheep
know me—just as the Father knows me and I know the
Father—and I lay down my life for the sheep.

John 10:10 quoted for Saint Sabina Faith Community Church's
daily scripture for May 17, 2011

Chicago's Black Catholics

There are about thirty-nine Catholic parishes that serve predominantly African American communities in Chicago, however, Faith Community of Saint Sabina Church, Saint Elizabeth, and Holy Angels, like all of the other churches in this book, have pastoral leadership that makes a conscious effort and commitment to engage a visual culture for the spiritual benefit and racial uplift of their congregants. Unlike the black Protestant denominations, black Catholicism must address a two-thousand-year-old tradition of rituals and visual traditions. The American influences are also significant. As opposed to the other visual programs in this book, a common thread in the art programs in Sabina, Holy Angels, and Saint Elizabeth is the emphasis on the black presence in Catholic history. Although biblical figures and narratives still exist in the black Catholic imagery, important supporters of blacks, founders of black churches, and such black historical figures as Tolton, the first black priest, are also prominent. Legitimizing African American ownership of Catholicism through these connections is a clear leitmotif in all of these churches.

In Chicago, Saint Monica became the first black parish in 1924.[1] The archbishop of Chicago George W. Mundelein officially declared Saint Monica an all-black parish in 1917: "Because of the circumstances that do exist here in this city, I am convinced that our colored Catholics will feel themselves much more

comfortable far less inconvenienced and never at all embarrassed in a church that is credited to them."[2] Although the archbishop stated that this declaration did not, in turn, exclude African Americans from any other churches in the city, it did exclude all nonblack parishioners from Saint Monica. In a city so divided by race, his decree tacitly supported the exclusion of Chicago's black Catholics from predominantly white parishes, which many saw as a political blow after so much hard work on the behalf of these black parishioners.

At the end of the nineteenth century, there were roughly 200,000 African American Catholics out of a total population of 7 million.[3] Many of Chicago's black Catholics from the nineteenth century had migrated from New Orleans, which had a significant and unique mix of a strong Catholic tradition and a large slave and a free black population due to the French influences there. Catholic slave owners and Louisiana migrants in Maryland created the second concentrated area of black Catholics in the country. The earliest black Catholics in Chicago worshiped in the basement of Old Saint Mary's Church when it was located at 9th Street and Wabash in the 1870s. This church, now at 1500 S. Michigan, is the first and oldest Catholic parish in the Archdiocese of Chicago, having been established in 1833.[4] In 1893 Saint Monica was built after a decade-long fundraising campaign led by the Augustine Society, a group of the city's black Catholics who did charity work for African Americans and through these efforts increased the black Catholic population. Saint Monica's has an important place in the history of black Catholics. Father Augustine Tolton, the first African American Catholic priest in the United States, had his first assignment at Saint Monica's. Tolton was one of only four priests of African descent to serve in the United States. In 1862, when he was eight years old, Tolton escaped slavery in Missouri to Illinois with his mother and siblings soon after his father had joined the Union army. Father Peter McGirr, pastor of Saint Peter's Catholic Church in Quincy, Illinois, took Tolton in where he then went on to attend that church's Catholic school and become an altar boy. Due to segregation he had to complete his ecclesiastical studies in Rome. His return to Illinois was covered in the national press and occurred with much fanfare as thousands of onlookers, both black and white, followed his flower-draped carriage to Saint Peter's, where he gave his first Mass. Tragically, Tolton died in 1897, only four years after leading his historic congregation of black Catholics at the newly built Saint Monica.[5]

The experience of black Catholics in the United States "has been an experience of alternating tension between the pull of universalism and the demands of racial particularism."[6] With roughly 1.2 million black Catholics in the United

States today, a good number foreign born, their significance has remained small within the history of African American religion. Although Latin American Catholics around the world have embraced liberation theologies, black Catholics have been consistently more conservative. One early exception is the Federated Colored Catholics, which Thomas Wyatt Turner founded in 1917. This organization had a strong commitment to racial equality, both inside and outside the Catholic Church. During the civil rights era, according to the theological historian Albert J. Raboteau, black Catholics experienced "a crisis of identity. . . . In the midst of celebrations of black pride and rediscoveries of black culture, some wondered where black Catholics fit? Were they not, after all, blacks in a white church, a church that still exhibited strains of racism? Had not African American culture been overwhelmingly Protestant?"[7] And despite the existence of black parishes in many cities across the United States, most were still pastored by white priests. In response to these concerns, activist groups like Black Catholics Clergy Caucus and National Black Sisters Conference appeared. In the following decades, American Catholics also examined the universality of Catholicism abroad, especially, the promotion of African and Asian clergy and sought to encourage such perceived equality at home. Even today, foreign priests frequently pastor churches that are predominantly black or Latino.[8] The hybrid type of worship, a combination of Catholic liturgy and black Protestant traditions, that one experiences in the majority of black Catholic churches today was not common a century ago, and it reflects the ways in which pastors have addressed the cultural specificity of their congregants. Some theologians attribute how black Catholic churches addressed the "sterility of liturgical rites" with ethnically diverse practices and décor to the Second Vatican Council's call for more flexibility coupled with the radicalization of the Black Power movement.[9]

Saint Sabina's Visual Ministry

Saint Sabina is known for its controversial social activist pastor, Michael Pfleger. Pfleger, who is white, was installed at Sabina in 1975 when the church's neighborhood of Auburn-Gresham was transitioning from predominantly Irish to African American. Through his decades of social activism, Pfleger has become a renowned civil rights leader on the national and international stage. It was during this time that he strategically drew media attention as he protested such injustices as prostitution and gun violence that are endemic to all poor, urban communities in the United States.[10] Throughout the entire

building, there is a consistent visual campaign to affirm blackness and educate all viewers about black history.

When one approaches the church, a bronze public sculpture by Sabina's official sculptor and decorator Jerzy S. Kenar (figure 4.1) is the first thing one sees. Kenar is a Polish immigrant who makes liturgical art for churches around the country and has his own gallery in Chicago.[11] In the sculpture an older African American child proudly wears a graduation cap and gown while a younger girl looks at her with admiration. This work is more reminiscent of something one would find in a public park than in front of a church. Inside Saint Sabina, banners and signage in black nationalist colors of red, black, and green are present, and there is another pair of Kenar's figures in which one child is pointing a gun at another. Near the sculpture stands a wooden cross wrapped in police tape and news headlines about local victims of violence (figure 4.2).

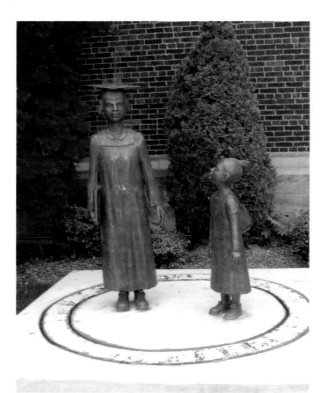

4.1 Jerzy Kenar, *Graduation*, bronze, ca. 1990. Faith Community of Saint Sabina, Chicago. Photo courtesy of Isadore Glover Jr.

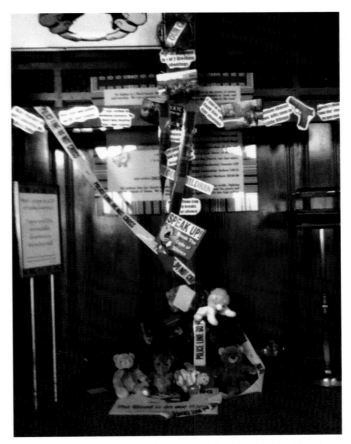

4.2 *Anti-violence Cross*, 2011. Faith Community of Saint Sabina Church, Chicago. Photo courtesy of author.

One has to pass this display to enter the chapel. Inside, the traditional 1930s neogothic interior blends with more recent Afrocentric elements like the altar and baptismal font (figure 4.3) that Kenar carved in wood to look like African drums. Behind the altar is a Holy Family group in wood. Kenar has made numerous such groups for churches, yet this is the only one depicting African Americans representing Joseph, Mary, and the Christ child. During services the prevalence of African-inspired textiles such as Kente cloth among the choir, band members, and dancers (who perform African-inspired dances while the choir sings) provide an environment that recognizes and promotes black cultures.

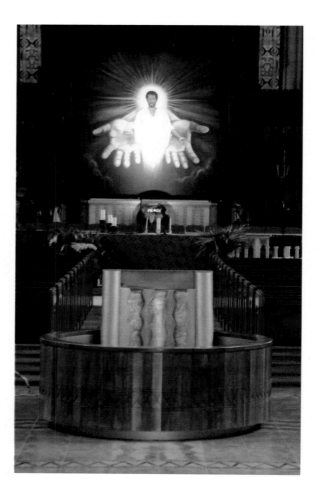

4.3 Jerzy Kenar, *Baptismal Font*, mixed metals and wood, ca. 1990. Faith Community of Saint Sabina Church, Chicago. Photo courtesy of Isadore Glover Jr.

There are seven murals and several pieces of decorative art and sculpture at Saint Sabina. All of the murals are painted directly onto the church's walls. The main image in the apse of the church is by the Mexican-born Father Fernando Arizti (1933–2006), and four others in minor chapels and the basement, the site of the weekly African market, are by Dr. Samuel Akainyah (b. 1953). All of these visual elements radiate from the central image of the church titled *For God So Loved the World* (figure 4.4), by Arizti, which shows the black Christ with outstretched hands in the apse of the church.[12] Pfleger knew of the Mexican-born Arizti and his work because Arizti's images were often featured in Josephite journals, and he had seen some of Arizti's paintings when

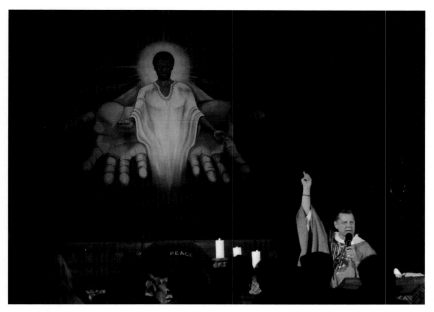

4.4 Fernando Arizti, *For God So Loved the World*, 2009. Faith Community of Saint Sabina Church, Chicago. Photo courtesy of Isadore Glover Jr.

the artist worked in Chicago. The Josephites are a religious order dedicated to serving African Americans and making the Bible a text relevant to them. Arizti's painting of a black Joseph coddling Christ as a black toddler appears on the cover of the first edition of a Catholic Bible for African Americans, subtitled "God's Family Album."

Arizti's images appear in churches around the world. A small painting of Joseph with the infant Christ is in Saint Brigid Catholic Church in Los Angeles, where he was the associate pastor after he left Chicago. Soon after he painted that image Arizti went to Saint Anthony's in Accra, Ghana, where he painted another black Jesus. He then joined a mission in Benin City, Nigeria, where he painted other Afrocentric compositions before he died in 2006 in a car accident at the age of seventy-two.[13] The most ambitious, and one of his last completed works, was a risen black Christ offering the keys of the kingdom to Saint Peter among men and women dancing and playing native instruments dressed in the native costumes of various tribes of Nigeria. This mural is in the interior of Saint Peter's Catholic Chuch in Okoh, Nigeria. According to his friend and fellow missionary in Benin, Gerald Arman, Arizti, inspired by

the civil rights movement, fought for inclusion through his ministry and art making in both the United States and abroad. He served Latino and African American congregations in cities like Chicago and Los Angeles, and while in Nigeria he often created masses that used only traditional local music or special masses for specific groups in a community like the taxi drivers in Benin City.[14]

According to Dr. Kimberly M. Lymore, the assistant pastor, before Arizti painted his mural for Sabina he met with parishioners and asked them how they viewed Christ and how they wanted him to portray a Christ that was "warm and inviting as well as strong." He spent many weeks painting the mural in the church's community center, the Ark, where he was open to talking with anyone who wanted to ask him about the mural. Similarly to how Chisholm at Quinn and Evans at Trinity included portraits of congregants, Arizti modeled the hands that are reaching out after the hands of a church maintenance worker, Michael Pettigrew.[15] Although there was some negative reaction to the image of a black Christ by people *outside* the church, the reaction of the church members during the unveiling of the mural was overwhelmingly positive, as recounted in the *Chicago Sun Times*:

> The unveiling of Arizti's work was a great time of rejoicing for the Community of St. Sabina. Unveiled to the music of the current gospel tune by the same title, the event seemed to beget love, for after the dedication service . . . those present, blacks, whites, Hispanics, clergymen laymen, seniors and children alike, flooded the aisles, embracing one another and loving one another. It was a great scene to witness, men hugging men, women hugging women, men hugging children—everybody hugging everybody.[16]

There are also a number of murals in the community center that have been created by student groups, one by a group from Howard University and another by two Saint Sabina students. A series of portrait heads of famous black figures (2010) is in the lunchroom, while the other mural fills the back wall of the main entrance to the Ark. This 2005 mural by Paul Benton combines colorful silhouetted images of children playing sports and instruments with images of Christ carrying the cross and angels blowing horns. Akainyah created a social activist context for Christ in his series of murals painted at Sabina between 1981 and 1984. The Ghananian-born Akainyah received his BFA from the School of the Art Institute of Chicago in 1979 and went on to get a master's degree in diplomacy and international law from the University of Chicago soon after. Throughout the 1980s and '90s he combined these two fields by creating politically engaged paintings about issues from apartheid in

South Africa to gang violence in the United States, for both private and public spaces. Akainyah has also been a humanities professor at Kennedy-King Community College since 1998. In 1999 the city of Chicago so appreciated and admired the activist artist that it declared February 15 Samuel Akainyah Day and named him the official artist for the National Democratic Convention. The artist also owns a gallery in the city where he sells his artwork.[17]

In a side chapel, Akainyah paints Martin Luther King Jr. and Gandhi at the table of the Last Supper. Across from this mural is Christ washing Peter's feet. Both figures are dark-skinned men wearing white tunics. In the lower level, Akainyah paints an African market scene with women carrying baskets (figure 4.5). Each Sunday there is an open market where congregants sell food

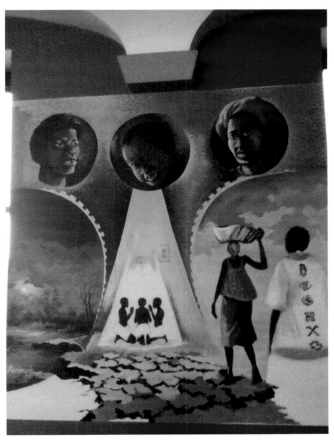

4.5 Samuel Akainyah, *African Market*, mural, 1982. Faith Community of Saint Sabina Church, Chicago. Photo courtesy of Isadore Glover Jr.

and wares in the basement of the church. In both of these paintings, the artist adds very subtle collage elements, such as attaching an actual man's striped shirt to the figure in the lower right to bridge the gap between the mural on the wall and the space in which the viewer stands. Akainyah's paintings with African themes also adorn private areas of the church such as the dining room.

Pastor Pfleger, Protest, and the Black Graphic Body

Even in areas with very limited public access the political message is clear, and these elements create an environment in the buildings that reinforces the mission of Saint Sabina for the church staff on a daily basis. In the hallway of the second floor where the pastor's private rooms are located, Pfleger has created a gallery to the joys and sorrows of the African diaspora. Spotlights highlight East and West African sculpture on the floor and walls; photographs of Pfleger with such famous guests as Harry Belafonte, Maya Angelou, Louis Farrakhan, Cornel West, and Jeremiah Wright Jr. appear on another wall, while reminders of the history of oppression, such as a slave auction, line another. All of these black activists have spoken at Sabina, and some like West and Wright visit often. To the right of the hall's entrance, framed reproductions of "Colored Only" signs around a collage of photographs of Malcolm X and Martin Luther King Jr. (figure 4.6) begin and end this display.

Elizabeth Abel has examined the multifaceted role that segregation signs have played in our visual culture in her book *Sign of the Times*. The reclamation and assertion of a black presence is important in this hallway. As Abel writes, "making signs entailed negotiating between public and private, class and race, self-authorization and self-exposure on both sides of the color line."[18] As with his ecclesiastical garments with African embellishments (figure 4.7), southern black preaching style, use of black vernacular speech, and the neon "Jesus" sign that hangs above the altar, this display in the pastor's rooms aims to bridge the gap between "the written and somatic racial signs" of his ministry.[19] This hallway of history is a liminal space for the pastor because it is the foyer for both his private living areas and where he receives friends, family, and VIP visitors to the church. One can read this space as both personal and public. Like Pfleger's militant protest marches and sit-ins in the public sphere, this homage to black history and the photographs of him with prominent blacks associate him with a civil rights legacy and legitimize him as a black activist within Sabina's community. The pastor's visual empathy on display blackens his whiteness, making him what his friend Cornel West calls him,

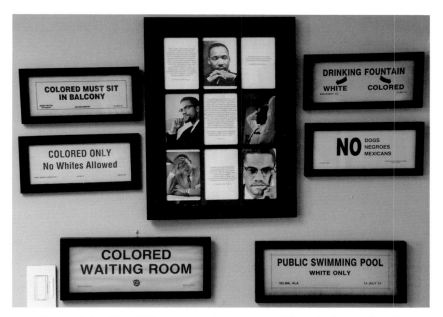

4.6 Hallway in Father Michael Pfleger's private living quarters, 2011. Faith Community of Saint Sabina Church, Chicago. Photo courtesy of author.

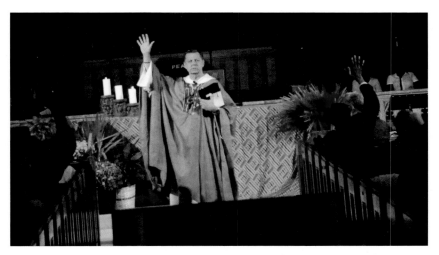

4.7 Pfleger during service in main chapel. Faith Community of Saint Sabina Church, Chicago. Photo courtesy of Isadore Glover Jr.

"an honorary black brother."[20] The Afrocentric and historically informed (and informing) imagery throughout Sabina and Pfleger have a symbiotic relationship; his actions outside activate what fills the interior and vice versa.

In the past, the physical presence of such segregation signs as "Whites Only" and "No Negroes, Mexicans or Dogs" as displayed in the pastor's hallway gave "race a graphic body."[21] These written words could represent and deny black bodies and their bodily needs and wants. Pfleger's countergraffiti campaign against alcohol and tobacco ads on the South Side reveals how the pastor understood the power and influence of the graphic body in the public sphere. The "booze and butts" billboards that use sex to peddle fortified wines and nicotine inundate poor black and Latino neighborhoods with raced graphic bodies, the attractive brown and black models with whom viewers empathize and desire to emulate. Beginning in 1988 Pfleger argued to the billboard companies, to the media, and later in court during his trial for vandalism that these images were like "twenty-four-hour [drug] pushers. A kid could not come out of his house to go to school without getting hit by the images . . . [that were] whetting the appetites of our children."[22] When his legal efforts failed, Pfleger with a couple of congregants started obliterating the billboards with red house paint during weekly night raids. Responding with the anarchist tactics of the graffiti taggers so prevalent in his neighborhood, the pastor bombed up to thirty billboards per night until July 10, 1990, when he was arrested. His tag was no name or character, just red spray paint that covered the product and brand name in the offending advertisements. This vandalism eventually cost one company more than $100,000 in damages. These vigilante efforts brought national attention to the damaging visual pollution ubiquitous throughout most socially vulnerable urban neighborhoods. Pfleger consistently adopts cultural forms that serve as racialized graphic bodies familiar to his congregants in order to "do God's work" in that community. Pfleger performs acts widely considered black and urban like "bombing" billboards and getting jailed for it. Through such empathetic gestures, he "marks out" or masks his own white identity to better represent his congregants and their concerns.[23] On March 25, 2012, Pfleger donned a white hoodie at the pulpit as he spoke about the killing of Trayvon Martin. Pfleger continued to be an activist from the pulpit regarding the police shootings in Ferguson, North Charleston, Baltimore, and around the nation.

Pfleger's words and images go hand in hand. He talks to black publics and publicly performs black talk. He instructs congregants to recite statements and declarations to their neighbors during his sermons, which is a common practice in various Protestant church traditions. At Sabina the words of the white pastor are literally communicated via black voices to the black congregants

in real time. In the center of Saint Sabina's lobby are two sculptures everyone must pass to enter the chapel. One is a wooden image by Kenar of one child pointing a handgun at another. Next to it is a wooden cross covered in ribbons, police tape, photographs, and newspaper headlines. It was originally part of the Good Friday service on April 22, 2011.[24] In the webcast of this service Pfleger stands at the pulpit dressed in a dark suit with a purple striped bowtie in the style of Louis Farrakhan. Behind him is a wooden cross. He explains the cross in his sermon's introduction:

> This cross, you may have noticed, is not an ordinary cross but unfortunately all too real. I believe the killing of our children is today's crucifixion. I believe there is a genocide going on, not just in Chicago but across the nation.
>
> I need you to cry out to God to protect our children. Cry out to him, call on him. Plead the blood over our children. We have the power to bind and to loose.

The camera pans over the headlines about teen shootings, "Stop the Violence" slogans, and photocopies of guns. Stuffed teddy bears and a red cellophane balloon conflate commemorating Christ's death on the cross with the popular forms of memorializing violent or sudden deaths, such as shootings and car accidents, on the sites of those deaths. The spontaneous ad hoc memorials referenced at Sabina, as Erika Doss explains in *Memorial Mania*, show how "the material culture of grief at sites like Columbine embodies the faith that Americans place in *things* to negotiate complex moments and events, such as traumatic death."[25] As he had done with the thirty-five pine caskets, each representing a child killed by gun violence in 2007, that were carried through the Auburn-Gresham neighborhood and left on display on Sabina's grounds, Pfleger uses powerful props to visualize his message for peace.[26] Calling for everyone to light blue lights in honor of Martin Luther King Jr.'s birthday or erecting a memorial wall of mourning for mothers of murdered children are all events covered in the media and often televised. Pfleger, like Cobbs decades earlier at FCOD and like today's televangelists, deploys visuality to the greatest empathetic effects. The sermons and activist gestures concerning the violence and disenfranchisement of Sabina's neighborhood connect its congregation in real time with real issues on a daily basis.

Saint Elizabeth's Mosaics

In 1990 Saint Elizabeth's Catholic Church, located at 50 East 41st Street and the Mother Church of the black Catholic Church of the Archdiocese of

Chicago hired Ildiko Repasi to repair the heavily damaged mosaics that adorned two exterior walls of the church (figures 4.8 and 4.9). She had to conform to the spirit of those older compositions, which focused on figures in Catholic Church history relevant to black Catholics, and her images are very straightforward. They are like a visual listing of these figures important to the history of black Catholicism and to Saint Elizabeth's. Each six-by-fourteen-foot mosaic is made of brightly colored ceramic tiles. Ghanaian adinkra symbols appear throughout. The focus on history does not deter Repasi from using the race of figures symbolically. The Michigan Avenue section highlights Father Augustine Tolton, the first African American Catholic priest in the United States, whose first assignment was in Chicago at Saint Monica's.

The 41st Street section pictures an African American woman as the symbol of Saint Elizabeth, the "mother" church of Chicago's black Catholics. Repasi, who is originally from Hungary, had extensive experience with ceramics, having recently received her BFA from the School of the Art Institute of

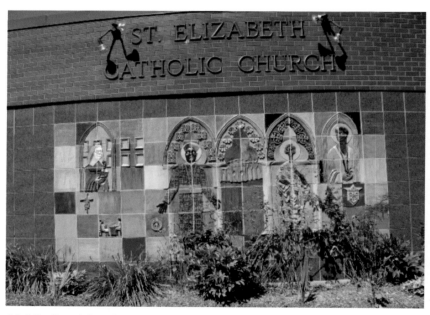

4.8 Ildiko Repasi, *Saint Elizabeth's History*, Michigan Ave. side, mosaic, 1991. Saint Elizabeth's Catholic Church, Chicago. Photo courtesy of author.

Chicago and apprenticed in Europe.[27] Because Repasi was a white artist creating black imagery, she had to meet frequently with board members—the church members had wanted a black artist once the project went from repairs to an original work of art. Repasi recalls, "I had to make loads of proposals and presentations to the board etc. Somewhere in between I met Margaret [Burroughs] and she certainly supported me. . . . For the project I got the history of the church and some guidelines to follow. I had to use African motives [*sic*] and lots of colors."[28] In a twist of fate—or as Repasi calls it "a comedy of errors" or a "higher will"—the artist, now a "non-denominational agnostic," was raised Catholic by her mother, who was a former nun, and Saint Elizabeth was a Hungarian-born saint. Saint Elizabeth's had served Catholics in this neighborhood since 1881 but eventually merged with Saint Monica's, Chicago's first black parish, in 1924. Saint Elizabeth Church, like the Protestant churches on the South Side, recognized the unmet needs for social services in the area and established a number of outreach organizations in the 1930s, such as the Regina House for Women housed in the former

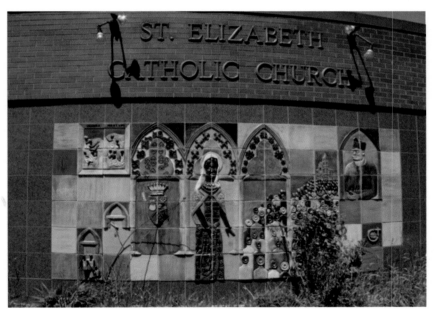

4.9 Ildiko Repasi, *Saint Elizabeth's History*, 41st St. side, mosaic, 1991. Saint Elizabeth Catholic Church, Chicago. Photo courtesy of author.

John G. Shedd mansion at 3812 S. Michigan in 1936, the Catholic Center for Black Families at 2643 W. Fulton in 1936, and the Friendship House at 4233 S. Indiana in 1937.

Saint Monica's, designed and built exclusively by African American crafts-people, appears in the mosaic. Father Tolton stands within the arch with arms outstretched in a welcoming gesture. Beside him is a replica of Saint Monica's (once located at 36th and Dearborn) with its signature two towers. The African American woman next to the building symbolizes the role of Saint Monica as the first "mother" for Chicago's black Catholics. This black mother also alludes to a black Madonna, who, like the black Christ, is absent in the mosaics but can be symbolically present in these figures. The other woman in the Michigan Avenue mosaic is Mother Katharine Drexel, the white nun who established Saint Monica's school in 1913. Repasi depicts her holding an African American child in the upper left of the mosaic. The school served two hundred students that first year, and by 1924, when Saint Monica and Saint Elizabeth merged, there were almost a thousand students. The enrollment for 2009 was 266, and it was one of the few remaining Catholic schools in the city.[29] Below Sister Drexel's image is that of a crucifixion and a teacher with her students.

The bust of a black man across from Sister Drexel in the upper right is Saint Peter Claver (1580–1654). Repasi erroneously represents Claver as of African descent. He was a Spanish priest who ministered to enslaved Afri-cans, primarily at the Middle Passage port in Cartegena, Columbia, where slavers brought hundreds of slaves every month. The priest declared himself "a slave of the Negro slaves," feeding them and tending to the ill his entire life. During his life he baptized more than three hundred thousand blacks. Pope Leo XIII canonized Claver on January 15, 1888.[30] The "Africanized" Claver in the mosaic more truthfully represents his significance in the history of black Catholics, according to Repasi: "Claver's skin color was a representational issue, and of course, one can dig into a deeper meaning, which, from a spiri-tual, philosophical [and] transcendental point of view is reasonable." In the same way that Pfleger reflects the culture of his congregants in dress, speech, and politics at Sabina, Repasi blackens the Spanish Claver by changing him from a Hispanic European to a black man. The coat of arms below this figure is that of the Knights of Peter Claver, founded in 1909 in Mobile, Alabama, by a group of African American priests and laymen. This organization is the oldest African American lay order.[31]

In the 41st Street mosaic there is another symbolic black female figure, representing the church. Alongside her, a stream of figures sweep toward

the neogothic structure that was the original Saint Elizabeth and is now a community center and school gym. The basketball players in the bottom left also represent a former community center, the Shield House, which stood at 41st and Michigan for many years. In the upper left the Uganda martyrs also refer back to the old Saint Elizabeth Church. In the right is the bust of Father Joseph Eckert, who brought Saint Monica's congregation to Saint Elizabeth. The Ugandan martyrs in the mosaic allude to two mural-size portraits of Claver and the Ugandan Martyrs that adorned the old church.[32]

Black and Abstract at Holy Angels

The Holy Angels Catholic Church began as a small congregation of twenty Irish immigrants in 1880. Later, the church was on the brink of closure when white flight sent most of its members farther south or to the suburbs in the 1930s and '40s, and a solid African American membership helped rebuild the church's congregation and its focus. Father George Clements became its first black pastor in 1969. Although the original neogothic church burned in 1986, it moved into a new building on the same site in 1991, and some stained glass panels salvaged from the original building stand in the foyer. Currently the school has about 150 students.

The church's website once had antique maps of Africa for its wallpaper, and it offers numerous links to historical information about black Catholicism, such as lists of black saints and popes. There is also a link with an extensive global civil rights history. Only a few artworks adorn the church's stark contemporary interior. Like Sabina, community-based campaigns against gun violence and to advocate self-respect among the black congregants are cornerstones of this church's ministry. The current pastor, Andrew C. Smith Jr., is a former Chicago police officer who brings his own local experiences of hardship and perseverance to the pulpit and sets an example for youth in the neighborhood.

The central focus of the church is the mural by Englebert Mveng (figure 4.10), who was a visiting pastor at Holy Angels in 1991. A handful of smaller paintings of black biblical figures line the sidewalls near the altar. This mural has a scholarly specificity that reveals its creator's detailed knowledge of the Bible as a priest. Each diamond-shaped section represents a moment in biblical history in which an angel has intervened (see pp. 159–60). Mveng combines African and Catholic forms. The rosette found in traditional Catholic stained glass conforms to the shape of the top diamond. The church's website provides

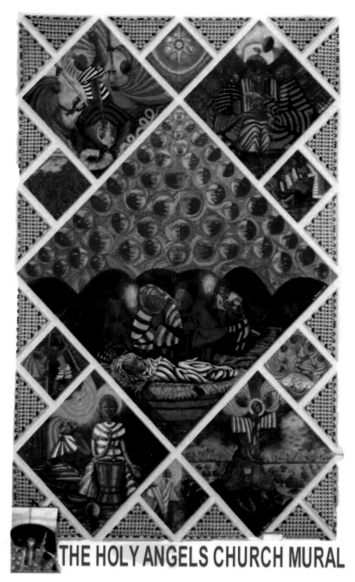

THE HOLY ANGELS CHURCH MURAL

4.10 Englebert Mveng, Holy Angels mural, 1991. Holy Angels Church, Chicago. Photo courtesy of author.

Mveng's exegetical guide explaining each scene; they vary from the Book of Revelations to the Life of Christ, from Genesis to the apocryphal Book of Tobit:

1. From Revelations: (Warriors and fighters)

St. Michael the Archangel is shown as he thrusts his sword into the mouth of the Serpent-Dragon, Satan (in Hebrew this means accuser) casting him down from heaven. The serpent was protesting God sending him onto earth in the form of man. This is in contrast to the multitude of Angels who sang and celebrated his birth to Mary and Joseph.[33]

The figures are all black; Mary is "a common Nigerian woman." Their garments and the patterns in the backgrounds allude to African textiles in their bright, saturated, contrasting colors and geometric grids. In one scene Mveng makes a direct link between the biblical scene and contemporary events:

3. Acts of the Apostles: (Ch.6) (Liberators)

Peter was banished to prison by King Herod and the Lord sent an angel in the middle of the night . . . who told him to get up and as he did his shackles broke and he walked past the sleeping guards. The artist thought that in light of Nelson Mandela's recent release from Prison, he would make the face on Peter closely resemble Mandela's (which it does).[34]

These angelic interventions highlight the presence of God in everyday life. Interactions with the divine are not only for the afterlife, and the biblical past becomes integrated into contemporary life. These strategies are similar to those used by Dorsey in his fusion of profane and sacred lyrics, as discussed in chapter 1. Mveng's imagery is also reminiscent of the Bible quilts Harriet Powers created between 1886 and 1898, in which she placed scenes from the Bible next to representations of natural phenomena that had occurred in her lifetime.[35] Sadly, Mveng was murdered in 1995 when he returned to Cameroon. Many believe his death was the result of his efforts on behalf of the poor there.

In 1991 Richard Hunt created liturgical sculptures for the altar. His large metal dove (figure 4.11) hangs in the foyer. Like most of Hunt's work, it is made out of various metals, some reclaimed from cars and other machinery. The abstract piece is discernible as a bird, as large curved sheets of steel suggest wings in flight. The artist has twisted heavy rods together, creating a delicate cage for the bird's plumed halo. Hunt, an internationally exhibited artist who is based in Chicago attended the School of the Art Institute of Chicago in the 1950s, and soon after, the museum acquired his sculpture *Hero Construction* (1958). In 1953 Hunt saw the work of such modernist masters as Julio Gonzalez,

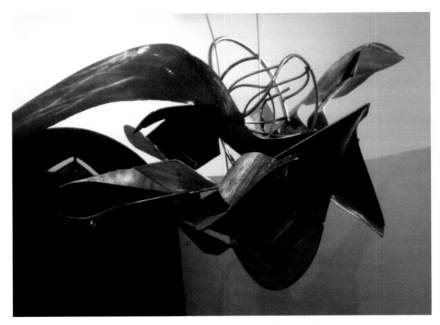

4.11 Richard Hunt, *Dove*, steel, 1991. Holy Angels Church, Chicago. Photo courtesy of author.

Pablo Picasso, and David Smith in the exhibition *Sculpture of the Twentieth Century* at the Art Institute. Because of this experience Hunt desired to transcend the stubborn materiality of the metals through direct-metal welding. His work sometimes looks like drawings in steel. He enjoys the challenge of shaping artificial materials into natural forms in order "to develop the kind of forms Nature might create if only heat and steel were available to her."[36] Flight has been a recurring theme in Hunt's work. Here, the dove is the Holy Spirit. Flight represents freedom for Hunt:

> I would say my own use of winged forms in the early '50s is based on mythological themes, like Icarus and Winged Victory. It's about, on the one hand, trying to achieve victory or freedom internally. It's also about investigating ideas of personal and collective freedom. My use of these forms has roots and resonances in the African-American experience and is also a universal symbol. People have always seen birds flying and wished they could fly.[37]

Next to the altar stands Hunt's crucifixion in which the Christ figure on a steel cross is a twisted rectangular block of shining steel with a crown of thorns. The violence implied in the welding itself communicates suffering as deftly as

his metal dove appears to take flight. Hunt has undertaken several commis-
sions for churches and synagogues, such as the welded bronze cross at Saint
Matthew United Methodist Church at 1000 N. Orleans in Chicago. Other
such work is located outside of the city, in such suburbs as Kankakee and
Lisle, Illinois. Hunt's engagement with these projects reflects some of his own
upbringing: "I have a religious background," Hunt said. "I'm not particularly
practicing a religion, but as I said, I have a religious background, and I call
on that when I am doing religious work."[38]

A more recent acquisition is a very intimate series of stained glass win-
dows, each measuring slightly over one square foot, that line the left side of
the church in recessed niches. The bold colors and abstracted shapes of the
Stations of the Cross imagery bridge the austerity of Hunt's monochromatic
steel sculptures and the rainbow palette of Mveng's paintings. Challenging
empathetic realism, the artwork at Holy Angels offers its congregants the most
abstracted examples of liturgical imagery that this author has encountered in
African American churches in the city. However, these works are peripheral to
Mveng's large Afrocentric mural, which clearly establishes the racial orienta-
tion of the church through highly representational imagery. The prevalence
of translucent brown skin in the stained glass figures and the small painting
of a black Christ on the wall behind Hunt's crucifixion mediate the abstrac-
tion, making Holy Angels one of the most visually and theologically coherent
spaces discussed in this book.

CHAPTER **5**

Urban Street Faith

Murals, T-shirts, and Devout Graffiti

Yea, he made me a king to rule in his image.
Earth is my kingdom—ain't no limits.

Excerpt from "Bold as a Lion" by muralist and rapper Damon
Lamar Reed

Can You Feel Me? The Public Art Ministries of Damon Lamar Reed

Damon Lamar Reed, a native of Phoenix, Arizona, considers his art and music making to be a part of his comprehensive arts ministry. Reed received a BFA from the School of the Art Institute of Chicago, where he met the artist Bernard Williams (b. 1964). Reed started working seriously with murals when he apprenticed under Williams at the Chicago Public Art Group (CPAG) in the late 1990s. At that time, Williams had become the lead restorer for important 1970s murals by William Walker and Mitchell Caton in the city, some of which are discussed in chapter 3.[1] He was also painting murals of his own design on the South and West Sides. And more importantly for Reed, Williams was also working with churches at the time. He restored Jones's First Church of Deliverance (FCOD) mural discussed in chapter 2, and in 1996 Saint Edmund's Episcopal Church commissioned Bernard Williams to paint three images of black figures from the Bible to adorn the apse of the church, located at 61st Street and Michigan Avenue. Working over several months, Williams and the church members agreed on Simon the Cyrenian (of Cyrene), Hagar, and the Eunuch (figures 5.1 and 5.2). The murals helped integrate more Afrocentric imagery into the church, which had housed the Greek Orthodox congregation of Saint Constantine until 1948, when Saint Edmund's Church acquired it.[2] Williams's murals accompany thirty-three stained glass windows representing important black religious and political

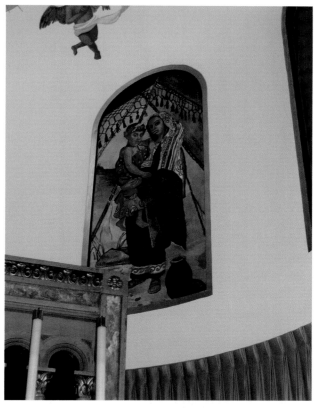

5.1 Bernard Williams, *Hagar*, 1996. Saint Edmund's Episcopal Church, Chicago. Photo courtesy of Jeanine Oleson.

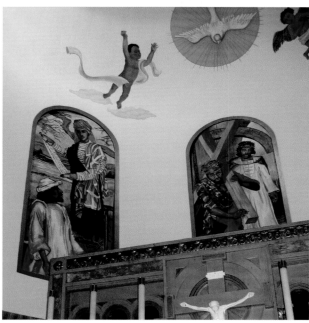

5.2 Bernard Williams, *Eunuch* and *Simon the Cyrenian*, 1996. Saint Edmund's Episcopal Church, Chicago. Photo courtesy of Jeanine Oleson.

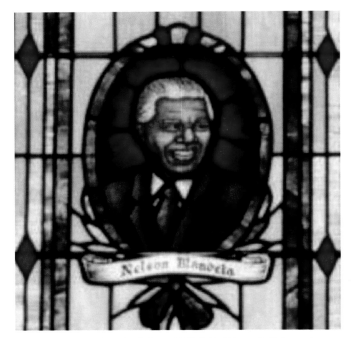

5.3 *Nelson Mandela*, stained glass, 1992. Saint Edmund's Episcopal Church, Chicago. Photo courtesy of the Saint Edmund's Episcopal Church, Chicago, IL.

figures, from Saint Cyprian to Rosa Parks and Nelson Mandela (figure 5.3) to Reverend Absalom Jones, that were installed the same year as the murals.[3]

Inspired by Old Masters like Caravaggio since he was in high school, Williams used the Art Institute's rich collection as a resource for the paintings at Saint Edmund's and painted from live models dressed in costumes. The content was also as important to him:

> It was really fun to kind of think about being commissioned by people who did have this interest in the black presence in the Bible because during my whole four years in college I was a total Bible scholar. I was in this Christian campus group. It was real close to Jews for Jesus. It was heavily evangelical.
>
> I eventually left it but it was really beautiful though. There were some beautiful experiences. . . . And for my own spirituality. It was a real shaping for me.[4]

There are large Bible scenes that a Greek artist copied from Italian Baroque works, adding Greek titles between 1935 and 1937. In the foyer photo portraits of Tolliver and other former pastors hang among the painted Greek Orthodox

icons of the four evangelists. Williams's black figures inject a black presence into the original Greek Orthodox décor that provides sites of self-recognition and empathy among the older imagery.

Working within an existing space and acknowledging one's audience either in a church or on a busy street corner were skills Williams imparted to Reed. The younger painter soon became an active member of the Chicago Public Art Group, gaining recognition as a lead artist on restorations and original commissions in the city. In 2003 the world-renowned painter and MacArthur Fellow Kerry James Marshall invited Reed to exhibit with him in *One True Thing: Meditations on a Black Aesthetic* at the Museum of Contemporary Art in Chicago.[5] Reed creates murals, T-shirts, and rap music that reflect his devout Christian principles.[6] Many of his images include a youthful, black Christ on the cross, often with arms open to the viewer (figure 5.4). Images

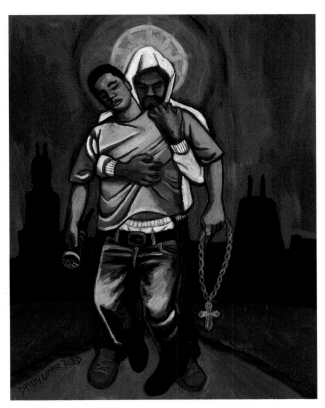

5.4 Damon Lamar Reed, *Forgiven*, T-shirt design, oil on canvas, 2009. Photo courtesy of the artist.

of young people of all races but especially African Americans dominate his work because he wants to speak to his generation of young people:

> I get inspiration from a number of sources: The Bible, old photographs from family albums, songs with a message that align with my beliefs, my own lyrics (which I have started to incorporate into my paintings), and everyday life. My aim is to show the world that this "Hip-Hop" generation is not completely lost. In my paintings I uplift people, showing them there is a way out of the darkness. If one person or child can look at one of my creations or at my life as an example and decide to empower him or herself, then I have made my mark on the world.[7]

Reed's consumers are predominantly African American and Latino and below the age of thirty. Reed is an active participant in Reverend Phil Jackson's hip-hop services, called the House Covenant Church, in the Lawndale neighborhood of Chicago, which targets young inner-city Christians. It is the youth ministry of Lawndale Community Church. These services feature rapping, emceeing, and graffiti writing as spiritual acts performed in real time for and with the congregation. I attended one service in which a breakdancer performed after he discussed how Christ had brought him to dancing after recovering from debilitating sclerosis. The connection between his performance and his testimony of faith was seamless: Christ healed him and he danced. As with the open mike portion of the services, the audience had the opportunity to breakdance also at the end of the evening.

Like the empathetic realism seen in works by Scott, Dorsey, Jones, Arizti, and others discussed earlier, Reed's work deploys this spiritual tool through the language of a hip-hop aesthetic to young people. He has created two large murals for this congregation. One is a large bricolage mosaic on the back of the main church, and the other is located down the street and consists of four painted sections on the front of the Firehouse Community Arts Center created for Lawndale Community Church (figure 5.5). Like the sculptural program on a Renaissance cathedral, the paintings on the façade of the old firehouse show the main "hip-hop" arts surrounding a biblical passage from Isaiah. Reed has pared down his figures to a limited palette of bold colors and shapes. The DJ scratching LP's, the lanky rapper with his mouth obscured by the microphone and the breakdancer suspended upside down on one hand pulsed with color. They have features and skin tones of African, Latino, and Asian racial types. Above the active bodies of these two boys and a girl presides the only figure Reed represents with a close-up profile, a young black

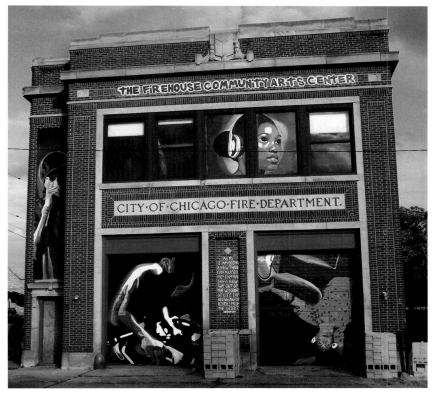

5.5 Damon Lamar Reed, *Mural*, 2009. Firehouse Community Arts Center, Ogden amd Hamlin, Chicago. Photo courtsey of artist.

woman wearing DJ headphones who looks heavenward. In the context of this ministry, she hovers at this apex like a fly black Madonna, a devout diva. The text below her reads:

And Yo! I'm doing a new thang. Can you feel me?
I'm making a new way out of the wilderness of life.
I am bringing out rivers from the desert.

This passage is from Isaiah 43:19. The King James version is:

Behold, I will do a new thing; now it shall spring forth;
shall ye not know it? I will even make a way in the wilderness,
and rivers in the desert.

The colloquial or urban vernacular translation of the text here in Reed's mural reflects the way in which Pastor Phil gives his sermons. Jackson uses the informality of hip-hop speech and cultural forms to reach a demographic that he feels traditional churches are losing. He believes "one of the most influential cultural forces today can be 'spiritually hijacked' for purposes of building God's kingdom here on earth—especially in our urban centers, where youth and their families face many difficult barriers and challenges."[8] Unlike the blues, gospel, or soul music, which have some ties to religious musical expressions and the church, hip hop has the challenge of being tethered to many vices of secular life: sexual promiscuity, crime, greed, and selfish consumerism, among others. In their book, *The Hip-Hop Church*, Pastor Phil and Efrem Smith present "holy hip hop" culture as an opportunity to create a wide-reaching spiritual movement among contemporary black and Latino youth across the nation and even the world: "It is possible to create an alternative culture while living in a larger culture. . . . Holy Hip Hop is about artists and ministers that live in a culture but have a different 'diet,' choices that lead to a healthier outcome. There are ministries all over the world that model this movement of hip hop, and the outcome of their alternative culture is transformed lives."[9]

Smith and Jackson's text is historical and instructional. Drawing on the primary studies by other popular religious scholars such as Anthony B. Pinn and Michael Eric Dyson, these two young pastors present steps on how an urban church can create a hip-hop youth ministry. "The House" in Chicago is their model. Reed's hip-hop images on the firehouse are the main elements set forth in *The Hip-Hop Church*. The emcees are "Theolyricists"; the step dance team and "One Voice" rappers provide another praise element within a service structured like any traditional one. Each team has a leader who functions as a deacon of that group of youth by leading prayer sessions and nurturing individual skills.[10] More traditional prayer leaders also provide counseling before the service and throughout the week. The services at "The House" include the Media Shout, which utilizes projected images, the ministry's logo, and questions relevant to each particular service. This barrage of "eye candy," according to Smith and Jackson, appeals to the visual sensibilities of their audience. Moving against church stereotypes, these services comprise multiple presentations from readings to slam poetry, none lasting more than fifteen minutes. Reed's murals adorn the Firehouse Community Arts Center, an integral part of the arts ministry just down the street. In the Lawndale neighborhood on the west side of Chicago, Reed and his mentor

Pastor Phil promote a hip-hop ministry that targets an at-risk youth audience that is never static. To create a culture of hip hop that praises God, there must be instruction. "The House" sponsors classes that teach a holistic set of skills from emceeing and graffiti making to social justice and entrepreneurship. Reed's work in the neighborhood follows the role the visual arts play in this movement according to Pastor Phil: "Find out through your network who in your neighborhood can tag, graffiti or bomb. Get them on board to teach their skill to other young people on the block. If you can, find a building in your community—even an abandoned building—and get permission to tag a meaningful message on it that the whole block would like and be thankful for."[11]

In a smaller painting (figure 5.6), Reed paints a rapper in the foreground with Christ bearing the cross behind him; their arms mirror each other, the

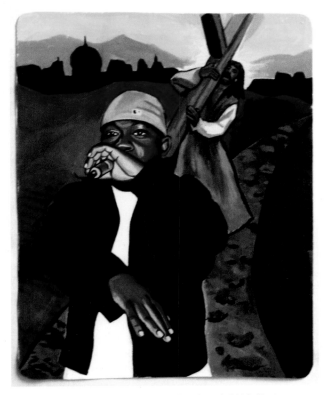

5.6 Damon Lamar Reed, *Listen Up!*, oil on board, 2009. Photo courtesy of artist.

wordsmith holding his mike, the black Christ his cross. This work could illustrate Reed's lyrics to his rap song "Bold as a Lion":

> I tell the storm, calm down, I know that I'm heard
> I don't have to think twice, I believe in His word
> He made me a king; I got to be bold
> He made me a kingdom, it's got to be gold, I'm bold
>
> Chorus:
> I'm as bold as a lion,
> I Fear no man.
> Bold as a lion,
> Mic in my hand.
> Bold as a lion.
> You got to understand,
> I'm as bold as a lion.

Another painting (figure 5.7) shows a young man with a cornrowed hairstyle taking the bleeding body of a brown Christ with dreadlocks down from a

5.7 Damon Lamar Reed, *At the Cross*, oil on board, 2000. Photo courtesy of artist.

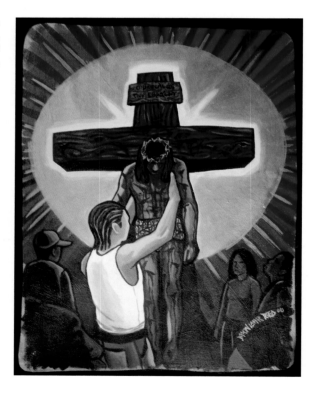

glowing cross. The cropped head of one man and shoulder of another in the foreground make the viewer part of this crowd of contemporary spectators who wear baseball caps and jeans at the crucifixion. Many of Reed's paintings focus on a single black man, often a self-portrait, in a plain white T-shirt wearing a cross around his neck. The centrality of the devout man in the white T-shirt often reads as a Christ figure, especially when others pray and lift up their hands around him. In the mosaic *Change Makers* (figures 5.8 and 5.9) outside Lawndale Community Church at Central Park and Ogden, a dove hovers about this central figure while he empties bottles of water over

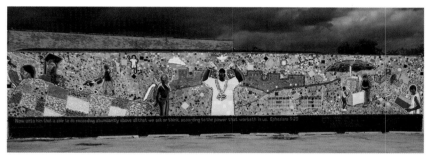

5.8 Damon Lamar Reed and Moses X. Ball, *Change Makers*, 2008. Lawndale Community Church, Ogden and Central Park, Chicago. Photo courtesy of the artist.

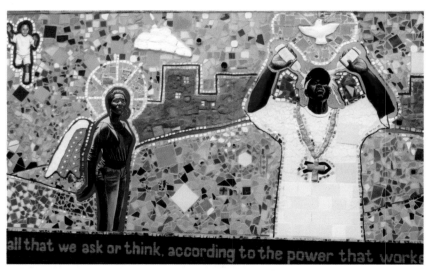

5.9 Damon Lamar Reed and Moses X. Ball, *Change Makers* (detail).

his head, creating a halo while also alluding to baptism. In his work, Reed represents his own struggle to lead a Christian life in the *imitatio christi*—in the imitation of Christ.

> Yea, he made me a king to rule in his image
> Earth is my kingdom ain't no limits
> He gave me dominion, subdue it and replenish it
> Be fruitful and multiply, it's all up in Genesis.

Reed also did a series of paintings, heavily influenced by his mentor Marshall, that are bust-length portraits of black men with doves above their heads or wearing white wings against a background of colorful abstract drips (figure

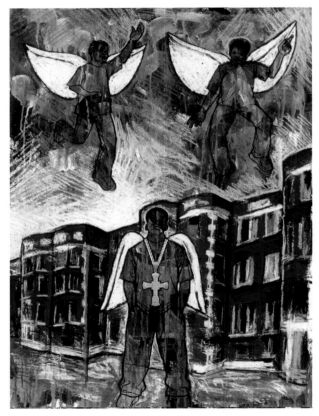

5.10 Damon Lamar Reed, *Don't Let Nothing Hold You Down*, oil on canvas, 2006. Photo courtesy of artist.

5.10). Marshall did a similar series in the 1990s of portraits of black youth with halos. In one such image the man has wings and stands in the middle of a city street while two other black male teens float above him. According to Reed, "the angel can't fly because he's rocking too much ice. It's basically about materialism in the culture. I'm all for having nice things, but don't make the things more important than the One who gave you the things."[12]

In keeping with this multimedia approach that has been common among all of the churches in this book, Reed's outreach to his community also introduces the T-shirt as public art. Like the conflations of the black Christ and the pastor at Pilgrim and FCOD, Reed's work merges the painted image of Jesus with that of a real black body, the one within the T-shirt (figure 5.11). Reed makes the figure fill the entire "frame" of the shirt: the head nears the

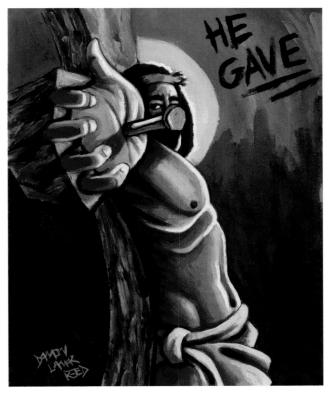

5.11 Damon Lamar Reed, *He Gave*, T-shirt design, oil on canvas, 2007. Photo courtesy of artist.

edge of the collar, and the outstretched arms reach toward the sleeves. Here the empathetic realism of those earlier visual forms of the black Christ goes even further. As the painted figures of Reverend Cobbs and Christ reflected the gestures of the actual Cobbs during services, the silkscreened body of Christ on the shirt masks or melds with the body of its wearer.

The political power of something that can carry the didactic message of a mural or poster but be portable, removed, concealed, and distributed is not at all new. Wearing T-shirts depicting political leaders or sporting slogans has been a powerful subversive practice for most of the twentieth and twenty-first centuries. During the height of protest against racial apartheid in South Africa, that government even banned T-shirts that depicted the radical leader, later martyr, Steve Biko. Distributors were jailed and some were killed.[13] During presidential election years in the United States, there are always incidents over controversial shirts and bumper stickers. Schools often ban certain types of messages, logos, and even styles of T-shirts, recognizing the potential political power of clothing. In the last decade, the extra large "white T," an iconic cultural item in hip-hop culture, has made spray can artists consider the body as a "wall" for celebrations of and memorials to musicians, rappers, or loved ones as in the ubiquitous RIP compositions that feature a painted or digital photo portrait, often with graffiti embellishments. The prevalence of body tattoos as memorials to dead friends and relatives among young people in distressed urban areas is another example of the ways in which the body can carry meaning that underscores both the vulnerability and visibility of black and brown bodies in U.S. cities. RIP tattoo memorials and the prevalence of crosses, Virgin Marys, and images of the crucified Christ in the body art lexicon are worth mentioning here. Pastor Phil has a large tattoo that he refers to often in sermons, pointing to his own body as a text to be read and recited. The Latin phrase "coram deo," in the presence of God, inked onto his forearm is a testament to his commitment to Christ's teachings and an omnipresent reminder of Christ's sacrifice. Jackson makes the tattoo a public display of empathetic realism to his congregation. This mark on his black body reminds him of the suffering Christ endured on his body, fusing the two; Christ as text is inscribed *into* Phil's flesh as the Word of God *became* flesh in the body of Jesus.[14] Morgan has traced the way in which religious groups have embraced the latest popular art forms from wood engravings to the internet to reach the largest audiences possible.[15] These aesthetic vehicles are just more public languages.

The aesthetic of Reed's religious T-shirts also alludes to street art and another type of public art that I call "devout graffiti." Though rare and fugitive,

instances of street art with religious themes in Chicago exist. "Jesus Saves" simply scrawled on a wall appears infrequently, but a handful of detailed paintings of the Jesus figure taken from the traditional Sallman imagery appear in street art on legal walls in predominantly Latin American neighborhoods on the South and West Sides. The street artist BSAVES erected a cardboard crucifix (figure 5.12) at Grand and Milwaukee in June 2011. "Father forgive them for they know not what they do" in blues, greens, oranges, and yellows and in different sizes fill the background. More legible reiterations of this text are written over this surface in silver marker. The crucifix form, slightly smaller than life size, is traditional in all other ways, from the "INRI" above the head represented by a jagged and abstracted bleeding crown to the

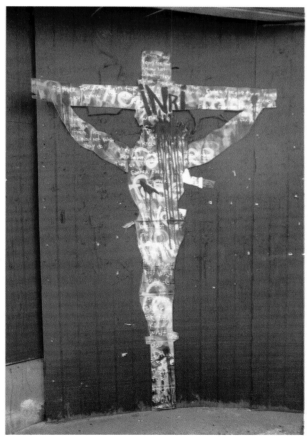

5.12 BSAVES, *Crucifixion with Graffiti Prayer*, aerosol paint on cardboard, 2011. Photo courtesy of author.

rectangular shape of the footrest below the silhouette of Christ's bent knees on the cross. Red sprays mark the nailed hands and feet and pierced side. Although this temporary installation lasted less than a week, it sat nailed on an abandoned building that juts out in the center of the southern end and apex of a major intersection where three major streets, Grand, Milwaukee, and Halsted, converge. Due to previous graffiti, this vacant building has been painted a dark oxblood brown, providing a contrasting background for the crucifix. The brightly painted crucifix made the area look like an altar. This particular corridor is a "gallery" of sorts for street art, with large preprinted images adhered to walls with wheat paste alongside stenciled and traditional graffiti tags. The painted *Gallery*—murals depicting flowers, shells, and other such imagery from 1971— is faded but still impressive along the underpass at Grand. These elder statesmen of the nascent years of the Mural Movement preside over a corridor now known for its temporary wheat-pasted street artworks. It is also an ad hoc exhibition site for a persistent wood collagist who frequently attaches three-dimensional pieces on the buildings on this corner. The remnants of a wheat-pasted stencil of a lurching zombie and a whimsical four-foot-long caterpillar-like creature appeared on streets adjacent to it. This ephemeral installation is not a complete anomaly in street art. The graffiti artist whose tag is JESUS SAVES has been writing this phrase mainly throughout Manhattan and the surrounding boroughs since 1995 (figure 5.13). He calls it a "graffiti ministry": "As I write it on the walls, it preaches for me 24/7, it is a message I leave behind for many people to see it and realize that salvation is found through Jesus Christ not through church, religion or being a goody goody."[16]

5.13 JESUS SAVES, graffiti, aerosol paint, undated. New York.

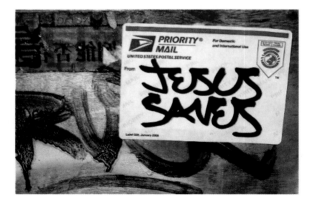

Like these tags, the cardboard crucifix also preached 24/7—until it was removed, of course. The very prominent position of the crucifix at the center of a busy intersection made it more visible than all of the other street art located there, but it also made it the most vulnerable. It did not even last a week. Like Reed's T-shirts that may be glimpsed momentarily by others as the wearer walks by, this temporary icon reached a large audience, an audience not necessarily expecting to see an evangelical message at a stoplight. The images discussed throughout this book have been effective and spiritually transformative because of their immediacy—their visceral effect upon their viewers as they reach into their world one way or another. They are real, of this world, and they are empathetic through their cultural specificity. Cone articulates the importance of the relevance of the many facets of Christ to contemporary people: "While the *wasness* Of Jesus is Christology's point of departure, thereby establishing Christ inseparable relationship with the historical Jesus, the *isness* of Jesus relates his past history to his present involvement in our struggle."[17] The black Christ embracing a family in the slave ship's hold, attended by rappers, on the pulpit as the preacher in real time or painted on the wall, "bombing" billboards to obliterate addictive cigarette ads or to write JESUS SAVES, each engages publics, in most cases, black urban publics, who respond to the empathetic realism of these gestures. And the graphic body of the black Christ will continue to adopt new visual forms to satisfy the changing spiritual and racial needs of its followers.

Where the Black Christ Suffers and the Politics of Black Tragic Space in Chicago

On January 7, 2006, Pilgrim Baptist Church, discussed in chapter 1, burned to the ground. Luckily, no lives were lost, but a set of premier early-twentieth-century murals, a historic landmark, and many primary documents concerning the birth of gospel music were. It took me nine months to even visit the ruins. Eventually, I had to reconcile how these now invisible objects would fit into a book I wanted to have a small but significant tour component. Could there be a tour of something that no longer existed? In stepping back and seeing this loss in a much larger historical context, I decided, indeed it could. People motivated by the power of memory visit invisible or lost monuments all the time. "Tragic tourism" is a profitable industry worldwide based on the desire of many to stand where something significant occurred lifetimes before. As Kenneth E. Foote wrote in his introduction to *Shadowed Ground*: "Instead of remembering exactly what was, we make the past intelligible in the light of present circumstances. This issue lies at the heart of understanding how these places change. The sites have been inscribed with messages that speak to the way individuals, groups, and entire societies wish to interpret their past. When "read" carefully, these places also yield insight into how societies come to terms with violence and tragedy."[1] In her book *Memorial Mania*, Erika Doss examines the American voracious appetite for memorials and "tragic tourism": "Palpable desires for visceral experience—for intensified modes of sensation that may permit empathetic response, encourage ideological attachment, and, especially, confirm our own reality—draw people to the spaces and places of tragic death."[2]

These lost murals, this ruined piece of historic architecture, are part of a lineage of "tragic Black spaces" in Chicago that also connect to other such sites across the country and across history. Pilgrim Baptist Church was a racial trope about African American history in which absence and loss play a large role. As the suffering Christ connects across centuries to the suffering of today's oppressed for the viewers discussed in this book, local black tragedy instantly connects, politically and psychically, to world sites and oppression. It is this tethering of sorrow, this chain of micro to macro links, that foregrounds this semiotic relationship between black selfhood and tragedy. In the black Christian context, significant to this book, tragedy and suffering have "use": "Black Christian eschatology is anchored in the tragic realism of the Old Testament wisdom literature and the proclamation of a coming kingdom by Jesus Christ [and] focuses on praxis against suffering, not reflection upon it, personal and collective resistance to suffering, not a distancing from it. And ultimately, with the aid of divine intervention, suffering is overcome."[3] The struggle of colonialized peoples to fill the real and constructed negative spaces in order to exist against their own physical and cultural erasure is what the African American philosopher Lewis R. Gordon has mapped out as black existentialism.[4] In *Passing O*, Karla F. C. Holloway argues that "African Americans particular vulnerability to an untimely death in the United States intimately affects how black culture both represents itself and is represented."[5]

Multiple meanings of loss converge in the fire at Pilgrim and the blackened brick shell it left behind. The first and most immediate association for its black congregants is with other black church fires as symbols of racial intimidation. In a seventeen-month period in 1995–96 various assailants set twenty-five fires in African American churches in seven southern states.[6] Eventually, police arrested members affiliated with a white supremacist hate group. The recurrent images of steeples aflame during those months reminded many of the 1963 Birmingham church bombing that martyred four little black girls for the civil rights movement. Of course, in a broader civic context, a devastating fire in Chicago also alludes to the Great Fire of 1871 that killed three hundred people and destroyed four square miles. This calamity defined the city as it spurred new development that brought Chicago prosperity and international recognition. The city's history was marred by yet another major fire, the tragedy at the Iroquois Theater in 1903, when more than six hundred people were killed in the most deadly single-building fire in U.S. history. All of these tragic sites are marked with monuments in the city. When the congregants at Pilgrim vowed to rebuild they were reiterating a Chicago tradition. This perseverance

also displays African American perseverance; the call and response between devastating blow and defiant resilience is expected and relentless.[7]

I have written elsewhere concerning how much the black history narrative focuses upon the ownership and the policing of black pain and black representation.[8] African Americans, like all oppressed peoples, live in a historical legacy that is often engulfed in the social discourses of tragedy and victimization. It is notable that in 1993 the American Girl doll company, whose mission is to create historically grounded dolls with which little girls can identify, introduced its first and only African American doll, Addy, a runaway slave.[9] This addition highlighted the fact that while European American girls were allowed to develop relationships with dolls who personified other types of historical hardship—from pioneer daughters to poor Irish servants—none of them was escaping enslavement. Black girls had to become slaves in order to identify with the American Girl doll that physically looked like them. As this rather flagrant example demonstrates, to be visibly black in the United States is to wear the legacy of victimization beginning in childhood. The common occurrence of elaborate enslavement recreations in African American history museums underscores this emphasis on the experiential component. Whether one enters an actual holding pen, meticulously rebuilt timber by timber, as one does in Cincinnati at the National Underground Railroad Freedom Center, or one peers into the recreated lower deck of a slave ship fitted with mannequins painted with vomit and other misery as one can do at the Griot Museum of Black History in Saint Louis. Transporting visitors back to a site of degradation and horror is the cornerstone of such institutions that celebrate black American heritage.

It is of little wonder then that younger African Americans sometimes shun Black History Month, because it can be a never-ending litany of suffering and perseverance. The sound-bite history provided in schools each year still centers on the Underground Railroad, MLK, and Rosa Parks, with a handful of sports figures such as Hank Aaron, thrown in for good measure. The loss of Pilgrim created another site of black tragedy for the city. Official civic plaques and ad hoc memorials crafted of plastic wreaths mark numerous such areas in Bronzeville that often show how spaces and borders, actual and symbolic, make up large parts of Chicago's black histories. There is the "invisible" line of segregation over which a young African American boy swam on a sultry July day in 1919 at the 29th Street beach and drowned after being hit by rocks thrown by whites. This event and attempts to desegregate the beach that day sparked one of the Red Summer's deadliest riots that killed thirty-eight,

injured more than five hundred, and destroyed homes and businesses in a week of unrest. A plaque marks the site at the beach where the violation of something unmarked but "known" caused so much destruction. More recently, in 2003, fifteen hundred people stampeded at the E2 nightclub at 2347 S. Michigan Avenue, killing twenty-one and injuring more than fifty young people. The violation of fire codes and response team misconduct concerning this incident made the club a symbol of the civic indifference toward the city's black residents.

The best-known of such local places of black suffering in the city is where police killed Fred Hampton, leader of the Chicago chapter of the Black Panther Party on December 4, 1969. Hampton and a number of other Panthers lived in a low-income apartment at 2337 W. Monroe Street. Hampton's slogan was "You can kill the revolutionary but you cannot kill the revolution," and on the day of the raid twenty-one-year-old Hampton and his roommate, Mark Clark, were killed when Chicago police officers sent ninety-nine rounds of ammunition into their home. Others, including Hampton's pregnant girlfriend, were also present but survived. Soon after the murders Black Panther members, in an eyewitness campaign to counter the reports in the mainstream media, conducted tours of the physical evidence in the apartment that contradicted the police accounts of the raid. People lined up for hours in the bitter Chicago cold to view the bullet-riddled walls and hardened pools of blood on the mattress and floors. The hail of bullets that rained down on Hampton and his girlfriend in their bed that morning violated the black domestic sphere. Historically, the black church and black home are the sole sanctuaries from racial oppression and violence. The black home is where humanity is protected and restored. As bell hooks writes about personal photographs in the black home: "The walls and walls of images in southern black homes were sites of resistance. . . . These walls were a space where, in the midst of segregation, the hardship of apartheid, dehumanization could be countered."[10]

Hampton's apartment operates as a locus of civil rights martyrdom similar to the Lorraine Motel in Memphis, Tennessee, where Martin Luther King Jr. was assassinated.[11] In 2009 a conference about the Black Panthers held at the University of Chicago to commemorate Hampton's death culminated with a rally at the site on the fortieth anniversary of Hampton's and Clark's deaths. Although an upscale condo now stands where the infamous crime scene once did, proclamations by survivors of the 1969 raid and the fervor of the crowd successfully reactivated this politically charged space of protest and memory during the rally there forty years later. Hampton's apartment was in a Chicago

ghetto where the Panthers, in a tradition associated with black churches like Pilgrim, provided free meals, health care, and Afro-centric history and politics lessons for its residents, filling the void left by institutional discrimination that prevented access to affordable food, doctors, and an uncompromised education.[12]

The charred building strewn with debris that now stands where Pilgrim Baptist Church once did also resonates as a standard image from the black ghetto, which is often presented as filled with the negative spaces of empty lots and abandoned buildings. These images of decay in which black and brown people are often invisible or solitary are ubiquitous in our visual culture, from the midcentury photographs by Roy Decarava to any current news slideshows about urban blight. The devastation left by Hurricane Katrina in 2005 and the 2010 earthquake in Haiti has become the most iconic representation of the devastated black urban space for our contemporary culture. These images also harness grief. As Erika Doss writes: "Grief's effective potential in America lies in its ability to mobilize social and political action, and to orchestrate productive change. It is hardly surprising that grief has an expanded presence in contemporary America; because its performative power can challenge and overturn established national norms, grief is both highly appealing and highly threatening."[13]

In Chicago, the razing of Cabrini-Green, a Chicago Housing Authority public housing development on Chicago's North Side, was bordered by Evergreen Avenue on the north, Sedgwick Street on the east, Chicago Avenue on the south, and Halsted Street on the west. At its peak, Cabrini-Green was home to fifteen thousand people living in mid- and high-rise apartment buildings. Over the years, gang violence and neglect created terrible conditions for the residents, and the name "Cabrini-Green" became synonymous with the problems associated with public housing throughout the United States. The endangered 1973 *All of Mankind* mural by William Walker, discussed in chapter 3, is on the Strangers Home Missionary Baptist Church, once a central church and community center for Cabrini. In 2011 wrecking crews demolished the last remaining building.[14] The entire neighborhood is still in the process of being redeveloped into a combination of high-rise buildings and row houses, with the stated goal of creating a mixed-income neighborhood, with some units reserved for public housing tenants. Controversy regarding the implementation of these plans has arisen because they displaced the majority of former low-income residents, forcing many to leave the city completely. As David Theo Goldberg has written, "Danger remains largely, if not solely, a condition of color and the evidence of its effect is inarguable: African-Americans rarely

enjoy the benefit of space, as they are historically and routinely rendered visu-
ally transparent, peripheral, part of the landscape, ready to be moved, cleared
and discarded for spatial use and improvement or 'to remove danger.'"[15] Like
Cabrini other black neighborhoods in Chicago struggle against erasure from
blight and gentrification. In some ways, the migrating populations of these
neighborhoods highlight two important themes addressed in the visual cul-
ture of black faith in this book: first, the integral role of black suffering in
the activation of empathy; and second, the diverse and shifting publics for
its imagery. Black Chicagoans' relationship to the city, namely, Bronzeville, is
fraught with these complex issues of ownership, displacement, and tragedy,
making the church fulfill many needs regarding refuge and racial affirma-
tion, as I have discussed here. I have brought together empathetic realism
and tragic space in this concluding section because they are conflated inside
and outside of these places of worship. The following section of tours with
maps that adhere to the book's themes enable the reader to visualize or actu-
ally experience the site-specific relationships that permeate everything in this
text.

APPENDIX I

Tours and Maps

Tour 1: Church Murals, Mosaics, and Glass

This selection of sites provides a broad overview of large-scale murals, stained glass, and mosaics inside churches, as well as outdoor sites in between in historic Bronzeville, which stretches from 26th to 67th and from the Dan Ryan Expressway east to the Illinois Central Railroad tracks on the west. While the churches, all of which are discussed in the main text, structure this tour, artworks of interest nearby are listed. Also, works of art by some of the church artists or works that influenced them are on this tour. In 1994 the City of Chicago's Bronzeville Public Art Project commissioned more than twenty artists to create sculptures for the main thoroughfares that surround the churches in this book, so many of these sculptures are included here also.

A. Proctor Chisholm, *Christ and Mary in Heaven*, mural, 1904, in Quinn AME Church, 2401 S. Wabash Ave.

B. Alison Saar's *Monument to the Great Northern Migration*, sculpture, 1996, MLK Blvd and 26th St.

C. William E. Scott, *Life of Christ series*, murals, 1936–37, Pilgrim Baptist Church, 3300 S. Indiana Ave. (lost).

D. Mitchell Caton et al., murals and sculptures, Donnelley Art Garden, 3947 S. Michigan Ave.

E. William Walker, *Meat Packers Mural*, 4859 S. Wabash Ave.

F. Richard Hunt's *Crucifixion and Altar Dove*, 1991; and Father Englebert Mveng, *Passages from the Bible*, murals, 1990 (see pp. 159–60), and *Stations of the Cross*, stained glass, Holy Angels Church, 607 E. Oakwood Blvd.

G. Ildiko Repasi, *Black Martyrs and Church Fathers*, mosaics, 1995, Saint Elizabeth Catholic Church exterior, 50 E. 41st St.

H. Frederick Jones, *Neighborhood People Flocking to the Lord* and *Reverend Cobb at the Altar*, First Church of Deliverance, 4301 S. Wabash Ave.

I. Al Sadiq Mosque, 4448 S. Wabash Ave.

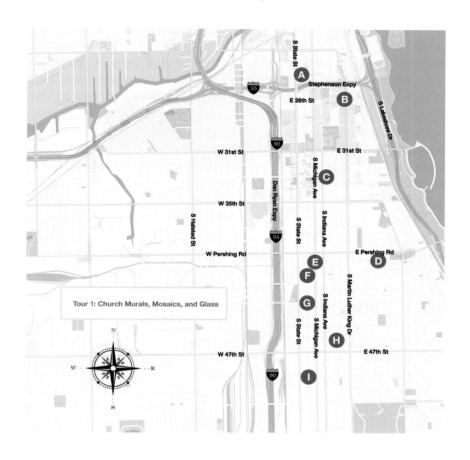

Tour 1: Church Murals, Mosaics, and Glass

Tour 2: Church Murals, Mosaics, and Glass (Further South)

This tour continues the previous tour by moving further south beyond Bronzeville. Bernard Williams's work discussed in chapter 4 is a focal point of this tour. Other works by Williams, by his contemporaries such as Kiela Smith, and works by William Walker that Williams restored are included. All of these artists have worked with the Chicago Public Arts Group, a central nonprofit agency that has supported murals and mosaics since 1964. A mural by Walker is in every tour, which attests to how large his legacy looms over the history of public art in the city. Trinity United Church, whose official artist Joseph Evans Jr., is the focus of chapter 3 and whose stained glass is discussed in chapter 4, is located on the South Side. The DuSable Museum is included because it is the first African American history museum, founded in 1961, and houses examples of work by such artists in this book as William E. Scott and Frederick Jones, in addition to many other important African American artists. Across the street from Trinity is the Carter Woodson Library, a branch of the Chicago Public Library system that houses the largest archive of African American primary documents in the United States and examples of twentieth-century African American art, namely, Richard Hunt's *Jacob's Ladder*.

 A. Bernard Williams, *Feed Your Children the Truth*, E. 50th St. and S. Cottage Grove Ave.

 B. Bernard Williams, *Hagar, Simon and the Eunuch*, mural, 1997, Saint Edmund's Episcopal Church, and *Black Leaders*, stained glass, 1996, 6105 S. Michigan Ave.

 C. DuSable Museum of African American Heritage, 740 E. 56th Pl.

 D. Reverend Fernando Arizti, *For God So Loved the World*, 1984, and many sculptures, ca. 2000 by Jerzy S. Kenar, in Saint Sabina Catholic Church, 1210 W. 78th Pl.

 E. Joseph Evans, *Unashamedly Black, Unapologetically Christian*, painting, 1986, and *African Presence*, stained glass, Trinity United Church, 421 W. 95th St.

 F. Richard Hunt, *Jacob's Ladder*, sculpture, 1977, Carter Woodson Library lobby, 9525 S. Halsted St.

 G. Bernard Williams, *Forces of Pullman*, mural, 1995, Pullman Branch Library, children's reading room, 11001 S. Indiana Ave.

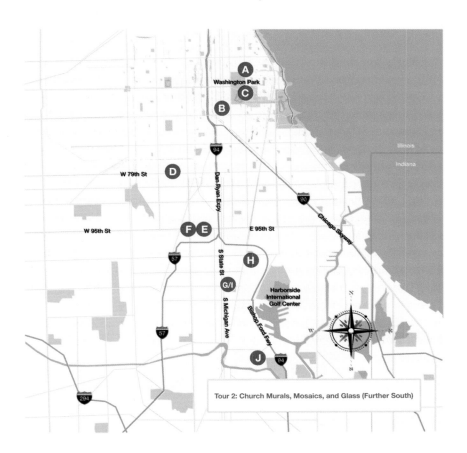

Tour 2: Church Murals, Mosaics, and Glass (Further South)

H. Phil Schuster and Rene Townsend, *Pullman Porter Sculpture*, 1995, E. 104th St. and S. Maryland Ave.

I. Nina Smoot-Cain and Kiela Smith, *Come Journey through Corridors of Treasures*, mosaic, 1995, Pullman Branch Library, adult reading room, 11001 S. Indiana Ave.

J. William Walker, *Reaching Children/Touching People*, mural, 1980, Altgeld Gardens and Chicago Youth Center, 975 E. 132nd St.

Tour 3: William E. Scott's Bronzeville Murals

The first half of chapter 2 discusses Scott's mural activity and his own determination to be a positive "race" painter in the 1930s and '40s. The tour includes one example of Scott's early work on the North Side. However, the rest of the sites are in Bronzeville. The South Side Community Art Center is located one block west of Pilgrim Baptist Church. It has been an integral part of the lives of African American artists in Chicago since its opening in 1941. It is the only art center sponsored by the Works Progress Administration that still exists. Scott and most of the artists in this book exhibited there or used its facilities at some point in their careers. Works by many of the city's artists are in its collection. Two murals from the Black Mural Movement appear at the end of this tour to show how the mural tradition started by such early painters as Scott in the first half of the twentieth century in Bronzeville experienced a strong and even more democratic revival in the latter half.

A. William E. Scott, *Dock Scene*, mural in Lane Tech High School, 2501 W. Addison St.

B. William E. Scott, *Life of Christ* series, Pilgrim Baptist Church, 3300 S. Indiana St. (lost).

C. South Side Community Art Center, 3831 S. Michigan Ave.

D. William E. Scott, *African American Advancement*, Wabash YMCA, 3763 S. Wabash Ave.

E. William E. Scott, *Constructive Recreation, the Vital Force of Character Building*, mural, 1915, Davis Square Park Fieldhouse, 4430 S. Marshfield Ave.

F. Jeff Donaldson, William Walker, Robert Sengstacke, Eugene Eda, et al., *Wall of Respect* site, 1967, E. 43rd St. and S. Langley Ave. (lost).

G. William Walker, Mitchell Caton, and Santi Isrowuthukal, *Wall of Daydreaming and Man's Inhumanity to Man*, mural, 1975 (restored 2001), E. 47th St. and S. Calumet Ave.

H. Mitchell Caton, Calvin Jones, and Justine Devan, *Time to Unite*, mural, 1976 (restored 2003), E. 41st St. and S. Drexel Blvd.

I. DuSable Museum of African American Heritage, 740 E. 56th Pl.

J. William E. Scott, *Du Sable Trading with Indians at Fort Dearborn* and *Meeting of Frederick Douglass and Abraham Lincoln*, murals, John D. Shoop Elementary, 1140 S. Bishop St.

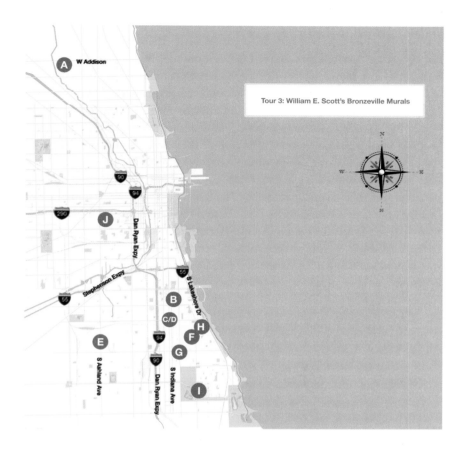

Tour 3: William E. Scott's Bronzeville Murals

Tour 4: History of Loss and Black Tragic Spaces

On January 7, 2006, Pilgrim Baptist Church caught fire. Luckily, no lives were lost, but a set of premier early-twentieth-century murals by William E. Scott, a historic landmark, and many primary documents concerning the birth of gospel music were destroyed. I had to reconcile how these now invisible objects would fit into this guidebook section. This tour considers Pilgrim's loss in a much larger historical context that explores the role of tragic black spaces in the city's African American communities on the West and South Sides. This role of tragedy in the formation of African American identity in Chicago is discussed further in the conclusion. The burned site at Pilgrim folds into a lineage of loss that includes the 1871 fire and the 1919 South Beach riots that were sparked by the drowning of a black youth who swam into the white area of the lakefront. Within walking distance of Pilgrim are Leonard Crunelle's monument to those lost in World War I and the now empty lot where the *Wall of Respect*, a touchstone for the Black Arts Movement once stood.

A. Egon Weiner, *Pillar of Fire*, 1961 marking ground zero for 1871 Chicago Fire, 137 E. DeKoven St. at S. Jefferson St.

B. E2 Nightclub, 2347 S. Michigan Ave.

C. Former *Chicago Defender* Building, 2400 S. Michigan Ave.

D. Site of lost Pilgrim Baptist Church, 3300 S. Indiana St.

E. Leonard Crunelle, *Victory Monument*, 1927, E. 35th St. and S. Martin Luther King Jr. Drive.

F. South Side Community Art Center, 3831 S. Michigan Ave.

G. Jeff Donaldson, William Walker, Robert Sengstacke, Eugene Eda, et al., *Wall of Respect* site, 1967, E. 43rd St. and S. Langley Ave. (lost).

H. Mitchell Caton, Calvin Jones, and Justine Devan, *Time to Unite*, mural, 1976 (restored 2003), E. 41st St. and S. Drexel Blvd.

I. 29th Street Beach, 1919 Race Riot site.

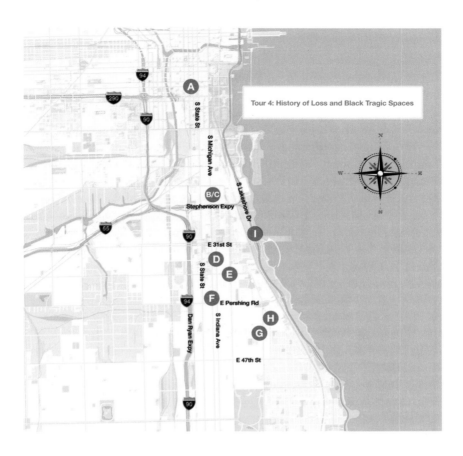

Tour 4: History of Loss and Black Tragic Spaces

Tour 5: History of Loss Sites (Further North)

This tour carries the previous tour of tragic space north. This tour includes the site of the low-income home Martin Luther King Jr. briefly lived in in 1966 with his young family in order to bring attention to the substandard living conditions for Chicago's black residents. West of here is the site of the 1969 murder of the city's Black Panther leader Fred Hampton, which still garners its share of tragic tourism. Not far is Tom Feelings's powerful stained glass program that depicts the Middle Passage within New Mount Pilgrim Missionary Baptist Church. This neighborhood has been caught between gentrification and blight for decades. Therefore, other stunning examples of public art appear amid empty lots and rising condominiums, including mosaics by Olivia Gude, Dzine, and Damon Lamar Reed, and William Walker's mural on the exterior of one of the only remaining buildings in the now abandoned and razed Cabrini-Green public housing neighborhood. The art works in this tour highlight the struggle that the residents have waged to assert positive and affirming elements within a web of tragic spaces.

A. MLK Chicago home, 1550 S. Hamlin Ave.

B. Eugene Eda, *Black Heroes*, mural, 1967, Malcolm X College, 1900 W. Van Buren St.

C. Nina Smoot-Cain and John Yancey, *Pyramids of Power*, mosaics, 1988, Henry Booth House, 2328 S. Dearborn St.

D. Site of Fred Hampton murder, 2337 W. Monroe St.

E. Tom Feelings, *Maafa Remembrance Glass*, 2000, New Mount Pilgrim Missionary Baptist Church, 4301 W. Washington Blvd.

F. Olivia Gude and Dzine, *Still Deferred, Still Dreaming*, mosaic, 1993, W. Washington Blvd. and N. Sacramento Blvd.

G. Joseph Evans Jr., *Baptism of Christ*, mural, ca. 1980, New Mount Pleasant Missionary Church, 4104 W. Roosevelt Rd.

H. Site of Cabrini-Green Housing Projects, 1230 N. Burling St. (lost).

I. William Walker, *All of Mankind*, mural, 1972–73, Strangers Home Missionary Baptist Church, 617 W. Evergreen Ave.

J. Damon Lamar Reed and Moses X. Ball, *Change Makers*, mural, bricolage and mosaic, 2005, Lawndale Community Church, S. Central Park Ave. and W. Ogden Ave.

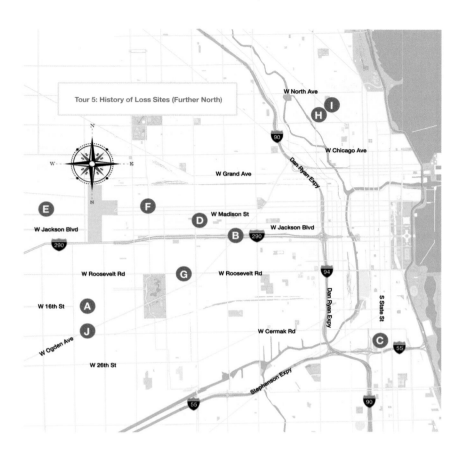

Tour 6: Joseph Evans Jr., Church Painter

"To me, it was obvious that Christ could not be the conception of Sallman or Metro, Goldwyn, or Meyer. It was obvious, also, that those who made this declaration had to be persons with whom I could share this faith." In 1986 Joseph W. Evans wrote these words in the explanatory pamphlet for his illustration of the motto of the Trinity United Church of Christ: "Unashamedly Black and Unapologetically Christian." Evans's image of a Jesus with dark brown skin and tightly curled black hair, his arms outstretched behind a smiling African American family was his vision of being black and Christian. In 1979 he joined Trinity United Church, where its pastor, Jeremiah A. Wright Jr., promoted Black Liberation Theology. Evans became the primary designer for all of Trinity's materials. Evans was locally known as a portraitist and exhibited his paintings frequently in the city. He also painted murals in other churches. Chapter 3 places Evans's art within the Black Liberation Theology Movement and the Black Arts Movement, including the representation of religion in the murals by Walker and other key muralists from the 1970s and '80s. Other murals associated with the Black Arts Mural Group are also included here. A mural by Bernard Williams, whose church work is in chapter 4, is worth noting because Williams is the second generation of this movement and has been the lead restorer on the majority of Walker's murals.

A. Joseph Evans Jr., *Baptism of Christ*, mural, ca. 1985, New Mount Pleasant Missionary Church, 4104 W. Roosevelt Rd.

B. Damon Lamar Reed, *Connections*, Chicago Christian Industrial League, 2006, S. California Ave. and W. Roosevelt Rd.

C. Proctor Chisholm, *Christ and Mary in Heaven*, mural, 1904, Quinn Chapel AME Church, 2401 S Wabash Ave.

D. Joseph Evans Jr., *Christ Parables Series*, 1948–55, and *Christ in the Garden* (repainted in 1980s), Metropolitan Community Church, 4610 S. Prairie Ave.

E. Mitchell Caton and Calvin Jones, *Another Time's Voice Remembers My Passion's Humanity*, 1979 (restored 1993), and Marcus Akinlana, Nyame Brown, Juan Chavez, et al., *The Great Migration*, 1995, murals, Donnelley Art Garden, 3947 S. Michigan Ave.

F. William Walker, *History of the Packinghouse Worker*, mural, 1974 (restored 1998), 4859 S. Wabash Ave.

G. Damon Lamar Reed, *Birth of a Hero*, Donoghue Charter School, 707 E. 37th St.

H. Justine Devan, *Black Women Emerging*, mural, 1977 (restored 2001), 4120 S. Cottage Grove Ave.

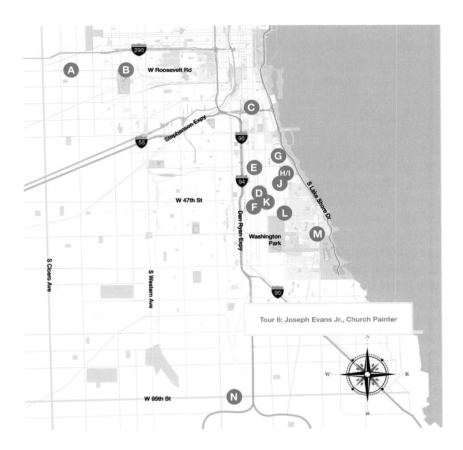

I. Mitchell Caton, Calvin Jones, and Justine Devan, *Time to Unite*, mural, 1976 (restored 2003), E. 41st St. and S. Drexel Blvd.

J. Jeff Donaldson, William Walker, Robert Sengstacke, Eugene Eda, et al., *Wall of Respect* site, 1967, E. 43rd St. and S. Langley Ave. (lost).

K. William Walker, Mitchell Caton, and Santi Isrowuthukal, *Wall of Daydreaming and Man's Inhumanity to Man*, mural, 1975 (restored 2001), E. 47th St. and S. Calumet Ave.

L. Bernard Williams, *Feed Your Children the Truth*, mural, 1994, E. 50th St. and S. Cottage Grove Ave.

M. William Walker, *Childhood Is without Prejudice*, mural, 1977, Metra viaduct at E. 56th St. and S. Stony Island Ave.

N. Joseph Evans Jr., *Unashamedly Black, Unapologetically Christian*, painting, 1986, and *African Presence*, stained glass, Trinity United Church, 421 W. 95th St.

APPENDIX **II**

Daily Scripture Emails from Saint Sabina

One can receive daily Saint Sabina emails with scripture. These emails sometimes clearly refer to current events, such as selections that mentioned floodwaters and salvation during the catastrophic flooding in the southern states and downstate Illinois in May 2011. During Pastor Pfleger's various suspensions when the archdiocese has decided his outspoken behavior in the media has warranted reprimand, the daily scripture selections allude to a congregation in crisis and their pastor's victimization. During his suspension immediately after Easter Holy Week in April 2011, the daily scriptures took on dual meanings as Pfleger's conflict with Cardinal Francis George is conflated with the Resurrection narrative. Two days after the suspension this selection from John 20:26–28 was posted: "A week later his disciples were in the house again, and Thomas was with them. Though the doors were locked, Jesus came and stood among them and said, 'Peace be with you!' Then he said to Thomas, 'Put your finger here; see my hands. Reach out your hand and put it into my side. Stop doubting and believe.' Thomas said to him, 'My Lord and my God!'" Another post on May 17, just days before Pfleger was reinstated, was: "I am the good shepherd; I know my sheep and my sheep know me—just as the Father knows me and I know the Father—and I lay down my life for the sheep" (John 10:10). Rhetorically, Pfleger became the black Christ who is so visually present in the visual culture at Sabina. That Christ is maligned by outsiders yet always empathetic to his followers as he aligns himself with and in defense of their blackness.

Jeremiah 1:9–10

9 Then the LORD reached out his hand and touched my mouth and said to me, "I have put my words in your mouth. 10 See, today I appoint you over nations and kingdoms to uproot and tear down, to destroy and overthrow, to build and to plant."

Daily Scripture email 5/20/11

Psalm 116:1–2 (New International Version)

1 I love the LORD, for he heard my voice;
he heard my cry for mercy.
2 Because he turned his ear to me,
I will call on him as long as I live.

Daily Scripture email 5/19/11

Psalm 124:2–4 (New International Version)

2 if the LORD had not been on our side
when people attacked us,
3 they would have swallowed us alive
when their anger flared against us;
4 the flood would have engulfed us,
the torrent would have swept over us,

Daily Scripture email 5/18/11

John 10:14–15 (New International Version)

14 "I am the good shepherd; I know my sheep and my sheep know me—
15 just as the Father knows me and I know the Father—and I lay down my
life for the sheep.

Daily Scripture email 5/17/11

John 10:10 (New International Version)

10 The thief comes only to steal and kill and destroy; I have come that they
may have life, and have it to the full.

Daily Scripture email 5/16/11

John 21:15 (New International Version, ©2011)

Jesus Reinstates Peter

15 When they had finished eating, Jesus said to Simon Peter, "Simon son of
John, do you love me more than these?"

"Yes, Lord," he said, "you know that I love you."

Jesus said, "Feed my lambs."

Daily Scripture email 5/11/11

John 20:26–28 (New International Version, ©2011)

Luke 24:36 (New International Version, ©2011)

Jesus Appears to the Disciples

36 While they were still talking about this, Jesus himself stood among them and said to them, "Peace be with you."

Daily Scripture email 4/28/11, the day after he had been suspended by Cardinal George

John 20:26–28 (New International Version, ©2011)

26 A week later his disciples were in the house again, and Thomas was with them. Though the doors were locked, Jesus came and stood among them and said, "Peace be with you!" 27 Then he said to Thomas, "Put your finger here; see my hands. Reach out your hand and put it into my side. Stop doubting and believe."
28 Thomas said to him, "My Lord and my God!"

Daily Scripture email 4/29/11

Luke 24:5–6 (New International Version, ©2011)

5 In their fright the women bowed down with their faces to the ground, but the men said to them, "Why do you look for the living among the dead? 6 He is not here; he has risen! Remember how he told you, while he was still with you in Galilee:

Daily Scripture email 5/2/11

For the next week, most of the Daily Scripture selections continued to be from those biblical passages pertaining to the resurrection that focus on Jesus proving his identity through his body. Disciples and others view or touch him and his wounds.

Luke 24:25–26 (New International Version, ©2011)

25 He said to them, "How foolish you are, and how slow to believe all that the prophets have spoken! 26 Did not the Messiah have to suffer these things and then enter his glory?"

Daily Scripture email 5/6/11

26 A week later his disciples were in the house again, and Thomas was with them. Though the doors were locked, Jesus came and stood among them and said, "Peace be with you!" 27 Then he said to Thomas, "Put your finger here; see my hands. Reach out your hand and put it into my side. Stop doubting and believe."
28 Thomas said to him, "My Lord and my God!"

Daily Scripture email 4/29/11

APPENDIX **III**

Explanations for Scenes in Mural at Holy Angels Catholic Church

Mveng's mural depicts various biblical scenes. The explanations below are based on his comments about each panel. His original, more detailed descriptions appear online at http://www.holyangels.com/node/5.

1. From Revelations: Warriors and Fighters

Saint Michael the Archangel thrusts his sword into the mouth of the Serpent-Dragon, Satan.

2. Book of Daniel: Deliverers

Three Jewish men, Meshach, Shadrach, and Abednego, are thrown into the fire by King Nebuchadnezzar. They prayed for deliverance, and an angel (the yellow figure) was sent to protect them from the fire.

3. Acts of the Apostles: Liberators

Peter was banished to prison by King Herod, and the Lord sent an angel in the middle of the night to free him. The artist painter Peter to closely resemble Nelson Mandela in acknowledgment of Mandela's recent release from prison.

4. The Annunication: Preparers of the Way

The Virgin Mary appears as a common Nigerian woman in her village hut. The archangel Gabriel appears to her and says, "Hail, Mary, full of grace; the Lord is with thee."

5. Resurrection and Ascension: Announcers of the Good News

On Easter morning the angels appeared to announce the good news of Christ's resurrection and Ascension into heaven. Christ is victorious over death as he steps out of the tomb, showing the wound in his hand to "doubting Thomas."

6. Agony in the Garden: Comforters and Consolers

The apostles slept as Christ prayed. The chalice refers to Luke 22:42: "Father, if you are willing, take this cup from me; yet not my will but thine be done."

7. Book of Revelation: Protectors

On Judgment Day four angels went to the four corners of the earth and grabbed the winds to destroy it. A fifth angel arose and said, "Those who have been sealed as the servants of our God shall be saved."

8. Genesis: Messengers

Abraham and Sarah, who were both in their nineties, had always wanted to have children but had none. Mysterious travelers told them that Sarah would bear a child, whom they should name Isaac.

9. Book of Tobit: Healers

Tobit was blind, and the archangel Raphael told his son and his wife to take the gall from a fish and place it over his eyes. When they did, scales dropped from his eyes and he could see again.

10. Star of Bethlehem at the Birth of Jesus (*top and center*)

A multitude of angels sing and celebrate the birth of Christ. There are forty-nine faces because of the verse "you shall forgive and love seven [*sic*] times seven." The infant Jesus is in the common surroundings of the average family of the day.

Notes

Introduction. Visualizing Christ Our Redeemer, Man Our Brother

1. Street religion is not new or just Black in Chicago and elsewhere. In 2005 efflorescence on the concrete in the Fullerton exit underpass off the Kennedy Expressway formed the shape of the Virgin Mary, creating an international media frenzy that brought (and still brings) Catholics and nonreligious gawkers from all over to view this makeshift shrine. These manifestations of faith have a rich history going back centuries from Veronica's hankerchief to the Virgin of Quadalupe to the Potato Chip Virgin of Los Angeles.

2. James H. Cone, *God of the Oppressed* (New York: Seabury Press, 1975), 18.

3. *Echo*, Summer–Fall 2010, 16.

4. Audiorecordings were once available at Minister Popcorn's MySpace page, http://www.myspace.com/ministerpopcorn (last accessed January 20, 2010).

5. I am aware that my use of the terms "European" and "African" throughout this book could be problematic because not all Africans have these traits and not all Europeans have oppositional traits. However, for the artists in this study, such physical markers were essential to their sociopolitical and artistic visualizations of different races and ethnicities and the didactic messages they wished to communicate. Nuance is not a staple of mural-making history.

6. Barack Obama, *Dreams from My Father: A Story of Race and Inheritance* (1995; New York: Crown, 2004), 294. It should also be noted that Obama read this excerpt in the groundbreaking speech on race, "A More Perfect Union," that he gave in response to Wright's remarks at the Constitution Center in Philadelphia, March 18, 2008.

7. For more see Peter C. Murray, *Methodists and the Crucible of Race, 1930–75* (Columbia: University of Missouri Press, 2004).

8. Stephen W. Angell and Anthony B. Pinn, eds., *Social Protest Thought in the African Methodist Episcopal Church, 1862–1939* (Knoxville: University of Tennessee Press, 2000), 144. For more on the AME church's early history and the shaping of its theology, see Albert J. Raboteau, "Richard Allen and the African Church Movement,"

in *A Fire in the Bones: Reflections on African-American Religious History* (Boston: Beacon Press, 1995), 79–102.

9. All church info from *Quinn Chapel, AME Church: Centennial Celebration, 1847–1947* (Chicago: Quinn AME Chapel, 1947), unpag.

10. Kymberly N. Pinder, "'Our Father God; Our Brother Christ or Are We Bastard Kin?': Images of the Suffering Christ in African American Painting, 1924–45," *African American Review* vol. 3, no. 2 (1997), 223–33.

11. Major J. Jones, *Color of God: The Concept of God in Afro-American Thought* (Macon, Ga.: Mercer University Press, 1987), 38.

12. For more, see Yvonne Chireau and Nathaniel Deutsch, eds., *Black Zion: African American Religious Encounters with Judaism* (New York: Oxford University Press, 2000); Arthur Huff Fauset, *Black Gods of the Metropolis: Negro Religious Cults of the Urban North* (1944; Philadelphia: University of Pennsylvania Press, 2000); and William R. Jones, *Is God a White Racist? A Preamble to Black Theology* (1973; Boston: Beacon Press, 1997).

13. Also, significant is the political use of the capital B in Black in many passages quoted in this text. It is yet another strategy of asserting a positive racial identity, much like the work in this book.

14. *Negro World*, September 6, 1924, 4.

15. W. E. B. Du Bois, *Darkwater: Voices from Within the Veil* (1920; New York: Schocken, 1969), 27.

16. Alex Poinsett, "The Quest for a Black Christ," *Ebony*, March 1969, 170ff.

17. The political tug-of-war over the color of Christ's public body in Detroit continued. The face and hands of the sculpture of a white Christ at Detroit's Sacred Heart Seminary were painted black during the riots. Soon after, anonymous whites restored them to their original color, and then they were painted black again, as they are now to acknowledge the seminary's commitment to the local community and to commemorate the original painting and its political significance (Poinsett, "The Quest for a Black Christ," 170). For more on the history of Cleage and the black Jesus in Detroit see Saint Cecilia's website at http://www.stceciliadetroit.org/ (last accessed March 5, 2011); Jennifer Lynn Strychasz, "Jesus Is Black: Race and Christianity in Black American Church Art, 1968–1986" (PhD diss., University of Maryland, 2003), 113ff; and Angela D. Dillard, *Faith in the City: Preaching Radical Social Change in Detroit* (2007; Ann Arbor: University of Michigan Press, 2010), 237ff.

18. Anthony B. Pinn, *Why Lord?: Suffering and Evil in Black Theology* (New York: Continuum International, 2006), 29. Although I address some of gospel's history in chapter 1, an extensive discussion of the political nature of black sacred music is beyond the scope of this book. For more on this music history see Jon Michael Spencer, *Protest and Praise: Sacred Music of Black Religion* (Augsburg Fortress, 1990); and James H. Cone, *The Cross and the Lynching Tree* (Maryknoll, N.Y.: Orbis, 2011).

19. Excerpt from "God is a Negro" (1898), in Edwin S. Redkey, ed., *Respect Black: The Writings and Speeches of Henry McNeal Turner* (New York: Arno, 1971), 176.

20. For more on the black Christ in the work of these modernists, see Pinder, "'Our Father God,'"; Kymberly Pinder, "Deep Waters: Rebirth, Transcendence, and Abstraction in Romare Bearden's *Passion of Christ Series*," in *Romare Bearden: American Modernist*, ed. Ruth Fine and Jacqueline Francis, 143–65 (Washington, D.C.: National Gallery of Art, 2011); Richard J. Powell, "'In My Family of Primitiveness and Tradition': William H. Johnson's *Jesus and Three Marys*," *American Art* 5, no. 4 (1991): 20–33.

21. David Morgan, "'Would Jesus Have Sat for a Portrait?': The Likeness of Christ and the Popular Reception of Sallman's Art," in *Icons of American Protestantism: The Art of Warner Sallman*, ed. David Morgan (New Haven: Yale University Press, 1996) 193.

22. Cone, *The Cross and the Lynching Tree*, 160.

23. He does cite one that appeared in December 1916 issue of *The Crisis* (ibid., 103).

24. For more on these exhibitions and a brief history of lynching imagery see Dora Apel, *Imagery of Lynching: Black Men, White Women, and the Mob* (New Brunswick, N.J.: Rutgers University Press, 2003).

25. Countee Cullen, *Black Christ and Other Poems* (New York: Harper, 1929), 33.

26. See Anna O'Marley, ed. *Henry Ossawa Tanner: Modern Spirit* (Berkeley: University of California, 2012).

27. Kinshasha Conwill, "In Search of an 'Authentic' Vision: Decoding the Appeal of the Self-Taught African-American Artist," *American Art* 5, no. 4 (1991): 4. See also Conwill's more recent work on this subject in *Testimony: Vernacular Art of the African American South: The Ronald and June Shelp Collection* (New York: Abrams, 2001). Other recent work on African American self-taught artists includes the two volumes of *Souls Grown Deep: African American Vernacular Art*, which was edited by the collectors Paul and William Arnett and is exclusively about their massive collection of black outsider art (Tinwood Books, 2000–2001); and Carol Crown, ed., *Coming Home!: Self-Taught Artists, the Bible, and the American South* (Memphis: Art Museum of the University of Memphis; Jackson: University of Mississippi Press, 2004).

28. Tom Finkelpearl, *Dialogues in Public Art* (Cambridge: MIT Press, 2000), x.

29. Artist's statement on his website: http://www.richardhunt.us (last accessed June 27, 2009)

30. Malcolm Miles, *Art, Space and the City: Public Art and Urban Futures* (London: Routledge, 1997), 85.

31. John Pitman Weber, "Politics and Practice of Community Public Art: Whose Murals Get Saved?," paper presented at Mural Painting and Conservation in the Americas, a two-day symposium sponsored by the Getty Research Institute and the Getty Conservation Institute, May 16–17, 2003, at the Getty Center in Los Angeles, 9.

32. Sally M. Promey, "The Public Display of Religion," in *The Visual Culture of American Religions*, ed. David Morgan and Sally M. Promey (Berkeley: University of California Press, 2001), 32–33.

33. Houston A. Baker, "Critical Memory and the Black Public Sphere," in *The Black Public Sphere: A Public Culture Book*, ed. Black Public Sphere Collective (Chicago: University of Chicago Press, 1995), 8. Baker is responding to the section on the types of representative publicness in Jürgen Habermas, *The Structural Transformation of the Public Sphere. An Inquiry into a Category of Bourgeois Society*, trans. Thomas Burger (Cambridge: MIT Press, 1991), 5–14.

34. Rebecca S. Chopp, "Reimagining Public Discourse," in *Black Faith and Public Talk: Critical Essays on James H. Cone's Black Theology and Black Power*, ed. Dwight N. Hopkins (Waco, Tex.: Baylor University, 2007), 152. Erika Doss's scholarship on public art has also been helpful in understanding the relationship between public art such as murals and monuments and various raced and gendered publics. Her article "Between Modernity and the 'Real Thing': Maynard Dixon's Mural for the Bureau of Indian Affairs," *American Art*, 28, no. 3 (2004): 8–31, articulates much about racial politics, audiences, and empathy.

35. Craig L. Wilkins, *The Aesthetics of Equity: Notes on Race, Space, Architecture and Music* (Minneapolis: University of Minnesota Press, 2007), 108–9.

36. Sally M. Promey, "The 'Return' of Religion in the Scholarship of American Art," *Art Bulletin*, 85, no. 3 (2003): 581.

37. David Morgan, preface to *Visual Piety: A History and Theory of Popular Religious Images* (Berkeley: University of California Press, 1999), xv.

38. Anthony B. Pinn, *Noise and Spirit: The Religious and Spiritual Sensibilities of Rap Music* (New York: New York University Press, 2003); St. Clair Drake and Horace Cayton, *Black Metropolis: A Study of Negro Life in a Northern City* (1945; Chicago: University of Chicago Press, 1993); Wallace D. Best, *Passionately Human, No Less Divine: Religion and Culture in Black Chicago, 1915–1952* (Princeton: Princeton University Press, 2005); Dave Jordano, *Articles of Faith: African American Community Churches in Chicago* (Chicago: Center for American Places at Columbia College, 2009).

39. The limited resources for these small congregations make the type of large-scale murals, mosaics, and stained glass that appear in the churches in my study simply prohibitive.

40. Historically, storefront pastors have been "socially and politically conservative and at times unabashedly anti-scientific and antimodern." Best, *Passionately Human*, 60.

41. Eva Cockcroft, John Pittman Weber, and James D. Cockcroft, *Toward a People's Art: The Contemporary Mural Movement* (1977; Albuquerque: University of New Mexico Press, 1998); Mary Gray, *A Guide to Chicago's Murals* (Chicago: University of

Chicago Press, 2001); Olivia Gude and Jeff Huebner, *Urban Art Chicago: A Guide to Community Murals, Mosaics, and Sculptures* (Chicago: Ivan R. Dee, 2000); Heather Becker, *Art for the People: The Rediscovery and Preservation of WPA-Era Murals in Chicago's Public Schools, 1904–1943* (San Francisco: Chronicle Books, 2002); Robin Dunitz and John Prigoff, eds., *Walls of Heritage, Walls of Pride: African American Murals* (San Francisco: Pomegranate Communications, 2000); Janet Braun-Reinitz, Amy Goodman, and Jane Weissman, *On the Wall: Four Decades of Community Murals in New York City* (Jackson: University of Mississippi Press, 2009).

42. David Morgan and Sally Promey, eds., *The Visual Culture of American Religions* (Berkeley: University of California Press, 2001). See also Sally Promey, "The 'Return' of Religion in the Scholarship of American Art," *Art Bulletin* 85, no. 3 (2003): 581–603; James Elkins and David Morgan, eds., *Re-Enchantment* (New York: Routledge, 2008); and James Elkins, *On the Strange Place of Religion in Contemporary Art* (New York: Routlege, 2004). Promey directed Jennifer Lynn Strychasz's dissertation, "Jesus Is Black." Strychasz's study like mine also focuses on specific churches, their black imagery, and their relationship to Black Theology but during a shorter time period. The First Church of Deliverance that I discuss in chapter 2 is the only Chicago church whose murals are mentioned briefly in the context of another church because its imagery predates her parameters. Strychasz discusses Chicago in the context of the Wall of Respect and murals by William Walker and Eugene Eda in Detroit, which I cover in depth in my chapter 3.

43. Edward J. Blum and Paul Harvey, *The Color of Christ: The Son of God and the Saga of Race in America* (Chapel Hill: University of North Carolina Press, 2012).

44. Bill Walker quoted in David Conrad, "Community Murals as Democratic Art and Education," *Journal of Aesthetic Education* 29, no. 1 (1995): 99.

45. For more on rap and religion see Anthony B. Pinn, *Noise and Spirit: The Religious and Spiritual Sensibilities of Rap Music* (New York: New York University Press, 2003).

46. Vito Acconci, "Public Space in Private Time," in *Art and the Public Sphere*, ed. W. J. T. Mitchell (1990; Chicago: University of Chicago Press, 1992), 173.

47. Dwight N. Hopkins, *Heart and Head: Black Theology—Past, Present and Future* (New York: Palgrave, 2002), 165–66.

48. Chopp, "Reimagining Public Discourse," 154. Elena Peña discusses a similar local relationship between racial and spiritual affirmation through the brown-skinned Madonna of Guadalupe in "Guadalupan Sacred Space Production and Mobilization in a Chicago Suburb," *American Quarterly* 60, no. 3 (2008): 721–47.

49. Cornel West, "Subversive Joy and Revolutionary Patience in Black Christianity," in *The Cornel West Reader* (New York: Civitas), 436.

50. David Freedberg, *The Power of Images: Studies in the History and Theory of Response* (Chicago: University of Chicago Press, 1989), 200.

51. Albert J. Raboteau, "Relating Race and Religion: Four Historical Models," in *Uncommon Faithfulness: The Black Catholic Experience*, ed. Shawn Copeland (Maryknoll, N.Y.: Orbis), 13.

Chapter 1. Painting the Gospel Blues: Race, Empathy, and Religion at Pilgrim Baptist Church

This chapter on Pilgrim Baptist Church was completed during a residency at the Georgia O'Keeffe Museum and Research Center in Santa Fe, New Mexico, where I received invaluable feedback from the staff and fellows there in the summer of 2007. I would also like to thank Cynthia Mills, editor at *American Art* for her help in shaping the article version of this chapter that appeared in its Fall 2011 issue (volume 23, no. 3, 76–99); Kate Dumbleton for research assistance; and my colleague Shawn Michelle Smith for taking the time to work miracles on some of the pre-digital images reproduced here.

1. William L. C. Bynum, interview by the author on May 20, 2007.

2. Henry Louis Gates Jr. and Cornel West, *The African-American Century: How Black Americans Have Shaped Our Country* (New York: Free Press, 2000), 82.

3. Jacqueline Goggin, *Carter G. Woodson: A Life in Black History* (Baton Rouge: Louisiana State University Press, 1993), 83ff.

4. Quoted in Randall K. Burkett, *Black Redemption: Churchmen Speak for the Garvey Movement* (Philadelphia: Temple University Press, 1978), 118. Two years later the Fourth International Convention closed with celebration of a Blessed Black Man of Sorrows and the Blessed Black Mary. For more on this topic see the introduction to this book.

5. Randall K. Burkett, "The Baptist Church in Years of Crisis: J. C. Austin and Pilgrim Baptist Church, 1926–1950," in *African-American Religion: Interpretive Essays in History and Culture*, ed. Timothy E. Fulop and Albert J. Raboteau (New York: Routledge, 1997), 333n13. All biographical information is from this essay and Burkett, *Black Redemption*, 113–20.

6. On the history of the church as a source for social services and refuge from white hostility and racism, see E. Franklin Frazier, *The Negro Church in America* (1963; New York: Schocken, 1974), 50–51.

7. Burkett, "The Baptist Church," 318, 328.

8. Quoted in ibid., 329.

9. Michael W. Harris, *The Rise of Gospel Blues: The Music of Thomas Andrew Dorsey in the Urban Church* (New York: Oxford University Press, 1992); and Robert Darden, *People Get Ready! A New History of Black Gospel Music* (New York: Continuum International, 2004), 164ff. Jackson also opened Mahalia's Beauty Salon near Pilgrim in 1939. Darden, *People Get Ready*, 215.

10. Dorsey quoted in Harris, *The Rise of Gospel Blues*, 197.

11. Wallace D. Best, *Passionately Human, No Less Divine: Religion and Culture in Black Chicago, 1915–1952* (Princeton, N.J.: Princeton University Press, 2005), 97, 106. On the performed sermon, see Gerald L. Davis, *I Got the Word in Me and I Can Sing It, You Know: A Study of the Performed African-American Sermon* (Philadelphia: University of Pennsylvania Press, 1987).

12. Harris, *The Rise of Gospel Blues*, 154. Harris also notes that Dorsey often elevated the tessitura at the end of refrains and especially in final verses, which means higher notes were sung at these points to simulate the ways in which black preachers ended sermons in a crescendo (233–34).

13. Ibid., 165.

14. Ibid., 130–34.

15. Rosa Henderson, "Deep River Blues," lyrics available at http://www.lyricsbay .com/deep_river_blues_lyrics-rosa_henderson.html (accessed July 13, 2015).

16. Mother McCollum, an early evangelical guitarist based in Chicago, was famed for her song "Jesus Is My Aer-O-plane," a prime example of how this fusion of everyday modern life and Christian messages could incorporate contemporary technology. Best, *Passionately Human*, 110.

17. On the rebuilding of Pilgrim, see Rebuild Pilgrim Baptist Church, http:// rebuildpilgrim.org (last accessed July 15, 2015) Although murals are not mentioned on this website, church trustee Cynthia Jones confirmed in an interview with me that there are plans to have murals installed in the new building. Whether they will allude to Scott's murals has not been determined. Email correspondence, November 30, 2010, and interview, December 2, 2010.

18. For more on Chicago's African American churches and class and assimilation see Best, *Passionately Human*.

19. For more on this topic, see my article "'Our Father, God; Our Brother, Christ; or Are We Bastard Kin?': Images of Christ in African American Painting," *African American Review* 31, no. 2 (1997): 223–33.

20. "Noted Painter of Murals and Haitian Scenes to Hold Exhibit in Library," *Chicago Sunday Tribune*, March 27, 1949, pt. 3.

21. St. Clair Drake and Horace R. Cayton, *Black Metropolis: A Study of Negro Life in a Northern City* (1945; Chicago: University of Chicago Press, 1993), 395.

22. The sources for all biographical information about Scott unless stated otherwise are Peter J. Roberts, "William Eduoard Scott: Some Aspects of His Life and Work" (PhD diss., Emory University, 1980); Harriet G. Warkel, "Image and Identity: The Art of William E. Scott, John W. Hardrick, and Hale A. Woodruff," in *A Shared Heritage: Art by Four African Americans*, ed. William Edward Taylor and Harriet G. Warkel (Indianapolis: Indianapolis Museum of Art, 1996), 17–76; and Rachel Berenson Perry, "The Paintings of William Edouard Scott," *American Art Review* 19, no. 2 (2007): 146–51. The latter compiles the didactic information provided for the exhibition *Our*

Own Artist: The Paintings of William Edouard Scott, on view at the Indiana State Museum, Indianapolis, February 3–June 3, 2007.

23. Charles Dawson, unpublished autobiography, Archives of American Art, 220, Smithsonian Institution, Washington, D.C.

24. According to Scott's Art Institute transcript, he attended the school until June 1909 when he took his final class, which was in mural decoration. Scott and his Art Institute classmates Gordon Stevenson and Margaret Hittle each painted a series about labor in the city for a competition. Each winning mural was installed in Lane. Scott's transcript cites this award and the $50 he also received with it. For more on Scott's murals in schools and field houses, see Heather Becker, *Art for the People: The Rediscovery and Preservation of Progressive and WPA-Era Murals in the Chicago Public Schools, 1904–1943* (San Francisco: Chronicle Books, 2002), 65, 67, 218–19; and Mary L. Gray, *A Guide to Chicago's Murals* (Chicago: University of Chicago Press, 2001), 370–71, 230–31, 124–25. See also, for a brief mention, Michael Harris, "Urban Totems: The Communal Spirit of Black Murals," in *Walls of Heritage, Walls of Pride: African American Murals*, ed. Robin J. Dunitz and James Prigoff (San Francisco: Pomegranate Communications, 2000), 24–43.

25. Alain Locke, *The Negro in Art* (New York: Hacker Art Books, 1968), 131. There were two Chicago Art Leagues. The first was founded by a group of white art students in the 1880s and the other in the 1920s by such black students as Harper, Farrow, Scott, and Charles Dawson. Roberts, appendix to "William Eduoard Scott"; Joyntyle Theresa Robinson and Wendy Greenhouse, *The Art of Archibald Motley, Jr.* (Chicago: Chicago Historical Society, 1991), 163.

26. Margaret T. Burroughs, "The Four Artists," in Taylor and Warkel, *A Shared Heritage*, 13; and Theresa Leininger Miller, *New Negro Artists in Paris: African American Painters and Sculptors in the City of Light, 1922–34* (New Brunswick, N.J.: Rutgers University Press, 2001), 143.

27. Joan Wallace, interview by Peter J. Roberts, December 20, 1979, in unpublished recordings at the Indianapolis Museum of Art.

28. As quoted in Francis Holbrook, "A Group of Negro Artists," *Opportunity: Journal of Negro Life*, 1, no. 7 (1923): 212.

29. For more on this skewed representation of Tanner's and other African American artists' work, see Kymberly Pinder, "Black Representation and Western Survey Textbooks," *Art Bulletin* 81, no. 3 (1999): 533–37; and Kirsten Pai Buick, *Child of Fire: Mary Edmonia Lewis and the Problem of Art History's Black and Indian Subject* (Durham, N.C.: Duke University, 2010).

30. For more on Tanner's religious works see Kymberly N. Pinder, "'Our Father God; Our Brother Christ or Are We Bastard Kin?': Images of the Suffering Christ in African American Painting, 1924–45," *African American Review* vol. 3, no. 2 (1997), 223–33; Jennifer Harper, "The Early Religious Paintings of Henry Ossawa Tanner: A Study of the Influences of Church, Family, and Era," *American Art* 6, no. 4 (1992):

68–85; and Alan C. Braddock, "Painting the World's Christ: Tanner, Hybridity, and the Blood of the Holy Land," *Nineteenth-Century Art Worldwide* 3, no. 2 (2004): http://www.19thc-artworldwide.org/autumn04/67-autumn04/autumn04article/298 -painting-the-worlds-christ-tanner-hybridity-and-the-blood-of-the-holy-land (accessed August 20, 2015).

31. Tanner exhibited this painting in February 1913; an American visiting his studio that summer also mentions it being there, and it was on view at the Paris Salon in 1914. Dewey F. Mosby, *Henry Ossawa Tanner* (Philadelphia: Philadelphia Museum of Art, 1991), 47; and Marcia Mathews, *Henry Ossawa Tanner. American Artist* (Chicago: University of Chicago Press, 1969), 148–49.

32. Tanner made a number of religious canvases that included his wife, Jessie, as a model for Mary and his young son as Christ; see Braddock, "Painting the World's Christ." Between 1910 and 1913 Tanner exhibited some of these religious works in Chicago. In February 1913 *Christ at the Home of Lazarus* was at the Thurber Art Galleries, and in April *Jesus Learning to Read* was at the Art Institute of Chicago. Mosby, *Henry Ossawa Tanner*, 46–47.

33. Cited in "Decorates Burdsal City Hospital Wing," *Indianapolis Star*, October 31, 1915, 21.

34. Cinnamon Catlin-Legutko, "The Art of Healing: The Wishard Art Collection," in *The Art of Healing: The Wishard Art Collection* (Indianapolis: Indianapolis Historical Society, 2004), 33. Other significant religious works by Scott were a set of murals, now lost, in First Presbyterian Church, and *Pope Pius XII and Two Bishops* (1953). The latter commemorated the Catholic Church's consecration of the first African bishops. Some biographical sources cite thirty murals in Chicago and Indianapolis churches, but most are not extant. Warkel, "Image and Identity," 37.

35. Edward J. Blum and Paul Harvey, *The Color of Christ: The Son of God and the Saga of Race in America* (Chapel Hill: University of North Carolina Press, 2012).

36. Quoted in Braddock, "Painting the World's Christ," 8.

37. Kirstin Schwain, *Signs of Grace: Religion and American Art in the Gilded Age* (Ithaca: Cornell University Press, 2008), 56. Ironically, Tanner himself had served as such an "authentic" biblical type while a student at the Pennsylvania Academy of the Fine Arts. Ellwood C. Parry includes a quotation regarding a "negro attached to the Academy" who posed as an Arab in 1883 in his "Thomas Eakins's 'Naked Series' Reconsidered: Another Look at the Standing Nude Photographs Made for the Use of Eakins's Students," *American Art Journal* 20, no. 2 (1988): 60. Tanner attended the Pennsylvania Academy of the Fine Arts between 1879 and 1885 and was the only African American during those years. Mosby, *Henry Ossawa Tanner*, 58–59.

38. For more on color politics regarding skin tone and racial identification in the United States, see F. James Davis, *Who Is Black? One Nation's Definition* (University Park: Pennsylvania State University Press, 1991).

39. Mara A'Lynn Stuart, current CEO and great-niece of original owner of Stuart Mortuary, interview by the author, December 15, 2006, and email correspondence, July 9, 2011.

40. Joan Wallace, interview by the author, July 6, 2010.

41. An oil of another version of this composition entitled *Carrying the True Cross* is in the DuSable Museum of African American History in Chicago. It is an almost exact replica of the Nolan Funeral Home image, but the composition is tighter, reversed, and includes fewer bystanders. This work with two other biblical scenes features a European American Christ figure.

42. "The Cross of Calvary," *Chicago Defender*, May 12, 1934, 3.

43. *Negro World*, August 27, 1921, 3. For more on Garvey, see Randall K. Burkett, *Garveyism as a Religious Movement: The Institutionalization of a Black Civil Religion* (Metuchen, N.J.: Scarecrow, 1978); Burkett, "Religious Ethos of the UNIA," in *African American Religious Thought: An Anthology*, ed. Cornel West and Eddie S. Glaude Jr. (Louisville: Westminster John Knox, 2003), 550–71; and Tony Martin, *Literary Garveyism: Garvey, Black Arts and the Harlem Renaissance* (Dover, Mass.: Majority Press, 1983).

44. Quoted in *Negro Journal of Religion* 3, no. 1 (1937): 12.

45. "Unveil Mural by W. E. Scott at Wabash 'Y,'" *Chicago Defender*, July 4, 1936, 12. Arthur knew Scott through his Rosenwald award and helped him exhibit his Haiti paintings once he was back in the States.

46. For more, see Stanley Warren, *The Senate Avenue YMCA: For African American Men and Boys; Indianapolis, Indiana, 1913–1959* (Virginia Beach: Donning, 2005); and Davarian L. Baldwin, *Chicago's New Negroes: Modernity, the Great Migration and Black Urban Life* (Chapel Hill: University of North Carolina Press, 2007), 207–17.

47. Baldwin, *Chicago's New Negroes*, 207.

48. Paul Healy, "Negro Exhibit Coming to Life in Oil, Colors," *Chicago Tribune*, June 23, 1940, pt. 3, 3.

49. For more, see Robert Allerton Parker, *The Incredible Messiah: The Deification of Father Divine* (Boston: Little, Brown and Co., 1937).

50. For more on the cultivation of the "New Negro" in Chicago's history, see Baldwin, *Chicago's New Negroes*.

51. Quoted in *Negro Journal of Religion* 3, no. 1 (1937): 12.

52. The auditorium format of the church was designed to increase the performative aspects of worship that many denominations had adopted from popular theater in the second half of the nineteenth century. See Jeanne Halgren Kilde, *When Church Became Theatre: The Transformation of Evangelical Architecture and Worship in Nineteenth-Century America* (New York: Oxford University Press, 2005), 112–44, for more on this phenomenon.

53. This "performance" of Christ resurrected as a black man was not new; such charismatic pastors as Father Divine (George J. Baker) claimed to be Christ on earth. In 1941 Austin visited Father Divine and his Peace Mission to learn how he

"fill[ed] some need of the masses." Many black Baptist church leaders criticized him for the trip because Divine had claimed to be God incarnate since 1912. Burkett, "The Baptist Church," 336n34. For more on the tableau vivant as a particular and enduring form of visual piety see Schwain, *Signs of Grace*, 71ff; and Morgan, preface to *Visual Piety*, 345.

54. "Jesus' Idea of Royalty," *Negro Journal of Religion* 1, no. 1 (1935): 9.

55. Anthony B. Pinn, *Why Lord? Suffering and Evil in Black Theology* (New York: Continuum International, 1999), 66–67. Pinn addresses this subject in many of his other books on the black church; see his *The Black Church in the Post–Civil Rights Era* (Maryknoll, N.Y.: Orbis, 2002).

56. Best, *Passionately Human*, 103.

57. Thomas A. Dorsey, "Precious Lord, Take My Hand," in Harris, *The Rise of Gospel Blues*, 234–35.

58. Burkett, *Black Redemption*, 120.

59. Paul Oliver, *Songsters and Saints: Vocal Traditions on Race Records*, (Cambridge: University of Cambridge Press, 1984), 153; and Harris, *The Rise of Gospel Blues*, 234–35.

Chapter 2. Come unto me all ye that labour and are heavy laden: First Church of Deliverance and Its Media Ministry

1. Most of the biographical information about Cobbs can be found on the FCOD website, http://www.firstchurchofdeliverance.org/Our_Church.htm (September 18, 2013); statistical information about Spiritualist and storefront churches is from St. Clair Drake and Horace R. Cayton, *Black Metropolis: A Study of Negro Life in a Northern City* (1945; Chicago: University of Chicago Press, 1993), unless otherwise cited.

2. Drake and Cayton, *Black Metropolis*, 642.

3. Wallace D. Best, *Passionately Human, No Less Divine: Religion and Culture in Black Chicago, 1915–1952* (Princeton, N.J.: Princeton University Press, 2005), 115, 41.

4. The very first radio ministry was in 1921 by another Chicago pastor, Paul Rader.

5. Jonathan L. Walton, *Watch This!: The Ethics and Aesthetics of Black Televangelism* (New York: New York University Press, 2009). For more on the history of the relationship between religion and mass consumerist media forms, see Leigh Eric Schmidt, *Consumer Rites: The Buying and Selling of American Holidays* (Princeton, N.J.: Princeton University Press, 1995).

6. Joseph P. Washington, *Black Sects and Cults* (Boston: Beacon, 1967), 114.

7. Drake and Horace R. Cayton, *Black Metropolis*, 642–46.

8. FCOD newsletter, July 4, 1948. Chicago History Museum Archives.

9. Congregant quoted in *First Church of Deliverance Preliminary Staff Summary of Information submitted to the Commission on Chicago Landmarks by the Department of Planning and Development on July 6, 1994*, 11, in Vivian G. Harsh Research Collection, Chicago Public Library.

10. "Top Radio Ministers," *Ebony*, July 1949, 56.

11. The church coffers paid for two of the largest funerals ever seen in Chicago when the pastor's mother, Luella Williams, and the great Cobbs himself died in 1965 and 1979, respectively. Five thousand people attended Williams's funeral, which included 13 flower cars, 52 limousines, and 175 private automobiles in the funeral procession. *Chicago Defender,* January 18, 1965, 12.

12. Meredith Taussig and Timothy Barton, *First Church of Deliverance: 4315 S. Wabash Avenue: Preliminary Staff Survey Summary of Information* (Chicago: Commission on Chicago Landmarks and Chicago Department of Planning and Development, 1994), 2.

13. All biographical information regarding Bailey herein is from Mikael David Kriz, "Walter T. Bailey and the African American Patron" (MA thesis, University of Illinois at Urbana-Champaign Graduate College, 2002). Also see www2.arch.uiuc.edu/africanamericanalumniresearch/SWFS/BAILEYinfo.swf (last accessed January 10, 2006).

14. Kriz, "Walter T. Bailey and the African American Patron," 29.

15. Ibid., 39.

16. Enameling is a difficult art form. Audio tapes owned by muralist William Walker include an extensive conversation held on June 21, 1974, between Walker and Jones about how to do enameling and build a kiln. See William Walker Archive at the Chicago Public Art Group.

17. Frederick D. Jones, interview by Arlene E. Williams, Archive of American Art, 7, Art Institute of Chicago, Ryerson and Burnham Libraries; hereafter Jones, AAA interview.

18. See *Washington, D.C. Government Charwoman*, photograph, Library of Congress, Farm Security Administration/Office of War Information Black-and-White Negatives, http://www.loc.gov/pictures/resource/cph.3b27020/?co=fsa memory.loc.gov/ammem/fsahtml/fachap07.html (last accessed July 16, 2015).

19. Tom Seibel, "Artist Returns 46 Yrs. Later to Add Finishing Touch to Mural," *Sun Times*, March 7, 1992, 17. Also in this article, Jones mentions that originally Cobbs asked two artists from the Center to paint the two murals, but Jones ended up doing most of the work alone. He also tells of how the congregants called him the "Michelangelo of First Church of Deliverance" because he painted using a scaffold in the foyer.

20. Ibid.

21. Jones, AAA interview, 10–11. For more on Woodruff's mural see Stephanie Mayer Heydt, *Rising Up: Hale Woodruff's Murals at Talladega College* (Seattle: University of Washington Press, 2012).

22. Pat Higgins, "At 74, Artist Puts His Heart, Soul into Painting," *Chicago Tribune*, May 20, 1987, http://articles.chicagotribune.com/1987-05-20/news/8702070454_1_paintings-harrison-jones-fred-jones (last accessed August 23, 2015).

23. Jones, AAA interview, 13.

24. Ibid., 15.

25. Ibid., 17–18.

26. Don L. Lee, introduction to *The Black Experience in the Arts*, exhibition catalog, Wright Art Center at Beloit College, February 8–March 1, 1970, Beloit, Wis., unpaginated.

27. Jones, AAA interview, 5.

28. Most of the biographical information about Cobbs can be found on the FCOD website, http://www.firstchurchofdeliverance.org/Our_Church.htm (accessed September 18, 2013), and statistical information about Spiritualist and storefront churches is from Drake and Cayton, *Black Metropolis*, unless otherwise cited.

29. "Policy" was the term for illegal lottery. For more on its history in Chicago see Nathan Thompson, *Kings: The True Story of Chicago's Policy Kings and Numbers Racketeers* (Chicago: Bronzeville Press, 2006).

30. Drake and Cayton, *Black Metropolis*, fig. 32, p. 601.

31. Cobbs was one of the leading pastors of "Ministers for Daley" in 1971 who pressured Daley to put an African American on the ticket. Daley did place Joe Bertrand as candidate for city treasurer. Cobbs and others in this group of Daley supporters frequently spoke in the press and elsewhere in defense of Daley as an ally of the city's black communities. Many believe that the great influence these church leaders had on their congregations helped the mayor secure the majority of the black vote and his historic fifth term in that year's election. (*Chicago Defender*, March 16, 1971, 1–3, and March 27, 1971, 1.) This support was controversial since Daley was also integral to the creation of certain housing legislation, the Dan Ryan expressway, and the expansion of the University of Illinois campus that enabled discriminatory practices and racial segregation to continue both in the city and in the suburbs. Ironically, the social services that FCOD provided were in direct response to the Daley's administration's failure to help Chicago's African Americans prosper and assimilate into the larger society. Jones states in his 1988 interview that Daley's attempts to curry favor with Cobbs and other African American community leaders had a long history and the mayor had helped fund the renovations and murals at FCOD to secure Cobbs's support. Jones, AAA interview, 59.

32. Best, *Passionately Human, No Less Divine*, 188–89. Cobbs was embroiled in a highly publicized libel suit against the *Chicago Defender* in the winter of 1939 concerning articles written about Cobb being involved with criminals and immoral behavior by association such as visiting such individuals in jail and at the hospital. Defensive comments in the press and in his sermons, such as "I am full man. Don't believe any gossip you hear circulated about me" strongly suggest that these rumors pertained to his sexuality. He eventually dropped the $250, 000 lawsuit with a lengthy "truce" and admonishment in the *Defender*. *Chicago Defender*, December 9, 1939, 9.

33. The following description of such efforts by FCOD appeared in an editorial by William N. Bowie, which was in response to some published criticism of Cobbs and those with whom he associated: "Further, he has purchased the buildings situated on the site covering nearly the entire block at the Southwest corner of 43rd street and Wabash ave., as his protest and contribution to vitiate exorbitant rent exacted of the common herd. The fallen, unfortunate, and unwed female has never been refused substantial succour. She has never been referred to a charitable agency when immediate need was merited; but a substantial pecuniary assistance out of the pockets of Rev. Cobbs has been the answer." *Chicago Defender*, January 25, 1947, 14.

34. "Rev. Clarence H. Cobbs Closes Ninth Anniversary Celebration at the Noted Institution," *Chicago Defender*, June 4, 1938, 23.

35. Jones, AAA interview, 45.

36. This particular view of Chicago's skyline is a classed view. The Gold Coast, located just blocks north of downtown is historically the city's wealthiest district. This distant view of downtown that Jones depicts is specifically seen from such working-class neighborhoods as Bronzeville, Bridgeport, Pilsen, and the Back of the Yards, to name a few.

37. For more on Morris see Bernice Johnson Reagon, ed., *We'll Understand It Better By and By: Pioneering African American Gospel Composers* (Washington, D.C.: Smithsonian Institution Press, 1992), 309ff.

38. Smith's program *The Glorious Church of the Air* was also on multiple stations: WIND, WSBC and WGES. For more on Smith see Best, *Passionately Human*, 147ff.

39. Washington, *Black Sects and Cults*, 115.

Chapter 3. Black Liberation Theology, Black Power, and the Black Arts Movement at Trinity United Church of Christ

1. James Cone, *Black Theology of Liberation* (New York: Lippincott, 1970), 43–44.

2. Teo Wvilet, *The Way of the Black Messiah: The Hermeneutical Challenge of Black Theology as a Theology of Liberation* (London: SCM Canterbury, 1987); and Benjamin Mays, *The Negro's God as Reflected in His Literature* (1938; New York: Russell and Russell, 1968).

3. Reverend Jeremiah Wright, phone interview with the author, June 10, 2000. For more on the history of Trinity, see Jeremiah Wright Jr., *A Sankofa Moment: The History of Trinity United Church of Christ* (Dallas: Saint Paul Press, 2010).

4. Jeremiah A. Wright Jr., "An Underground Theology," in *Black Faith and Public Talk: Critical Essays on James H. Cone's Black Theology and Black Power*, ed. Dwight N. Hopkins (Waco, Tex.: Baylor University Press, 2007), 101.

5. Three decades later Martin Bernal would create a firestorm of controversy by asserting similar claims in his two volumes of *Black Athena : The Afroasiatic Roots*

of Classical Civilization (New Brunswick: Rutgers University Press, 1987). This book sparked an extensive decades-long debate and subsequent publications to both refute and support its assertions; see, for example, Mary R. Lefkowitz, *Not Out of Africa: How Afrocentrism Became an Excuse to Teach Myth as History* (New York: Basic Books, 1996). Defending or indicting the validity, scientific or otherwise, of Diop's or Bernal's theses would only be tangential here, for the influence of this type of scholarship on this pastor and, in turn, how he presented it to his congregants are what is relevant to my discussion.

6. Frantz Fanon, *Black Skin, White Masks* (1952; New York: Grove, 1967), 112.

7. Cheikh Anta Diop, *The African Origin of Civilization,* trans. Mercer Cook (Chicago: Lawrence Hill Books, 1974), figs. 5 and 11.

8. Wright, *Sankofa Moment,* 78ff.

9. Cone, *Black Theology of Liberation,* 18.

10. Patrick Thompson, the artist Evans trained to take over his studio at Trinity Church, phone interview by the author, May 12, 2000.

11. In *Sankofa Moment,* Wright's connection to Cobbs is important because he felt an affinity with him. Wright even cites a prophetic statement that Cobbs made during his sermon as part of a weeklong dedication program for Trinity's larger facilities in 1978: "The Lord will give you as far as you can see!" as a statement that galvanized him and his staff to commit to the most ambitious ministry they could conceive of (104). Throughout this text, Wright refers to Cobbs and how Trinity's successes continued to fulfill his prophecy. As discussed in the previous chapter, Cobbs was the first African American minister to televise his sermons. Wright first created media outreach with his "Tape Ministry" in the 1970s, during which specific "Tape Ministers" in the congregation would record Sunday sermons and then take the cassette tapes to the homes of the sick and disabled who could not attend (175–76).

12. Wright, *Sankofa Moment,* 194–96.

13. Quoted in Marci Whitney-Schenck, "Unashamedly Black and Unapologetically Christian," *Christianity and the Arts* 1, no. 1 (1994): 25–26.

14. Joseph M. Evans, unpublished autobiography, possibly written between 1979 and 1986. All biographical information in this text is from this autobiography owned by his widow, Mildred Evans of Chicago, unless otherwise noted.

15. Artist quoted in text of informational pamphlet published for painting's dedication.

16. For more on Scott's murals see chapter 1 in this book; Harriet G. Warkel, "Image and Identity: The Art of William E. Scott, John W. Hardrick, and Hale A. Woodruff," and Edmund Barry Gaither, "The Mural Tradition," both in *A Shared Heritage: Art by Four African Americans,* ed. William E. Taylor and Harriet G. Warkel (Indianapolis: Indianapolis Museum of Art, 1996), 17–76, 123–46; and Peter J. Roberts, "William Edouard Scott: Some Aspects of His Life and Work" (MA thesis, Emory University, 1985).

17. I had the privilege of spending time in Evans's studio, which, according to his widow, was exactly as he had left it. The Sallman image hung in between Evans's own portrait and landscape paintings. The bookshelf in the studio was filled with Afrocentric and Christian literature as well as art history books, including such titles as *Lessons from History, A Celebration of Blackness, Black Families in White America, Doing What Is Christian, Is the Kingdom of God Realism?,* and *Atlas of the Bible.* The entire ensemble of the artist's creative and intellectual environment reflected all of the resources, some conflicting, that informed his art and his life that is seen so consistently in it.

18. Sallman's influence on our visualization of Jesus has most successfully been addressed in David Morgan, ed., *Icons of American Protestantism: The Art of Warner Sallman* (New Haven: Yale University Press, 1996). Morgan is the leading scholar in the field of popular religious iconography and its cultural meanings and uses. For more, see David Morgan and Sally Promey, *The Visual Culture of American Religions* (Berkeley: University of California Press, 2001); David Morgan, *Visual Piety: A History and Theory of Popular Religious Images* (Berkeley: University of California Press, 1997), and *The Sacred Gaze: Religious Visual Culture in Theory and Practice* (Berkeley: University of California Press, 2005); and Sally M. Promey, *Painting Religion in Public: John Singer Sargent's Triumph of Religion at the Boston Public Library* (Princeton: Princeton University, 2001), and "The "Return" of Religion in the Scholarship of American Art," *Art Bulletin.* 85, no. 3 (2003): 581–603.

19. *Chicago Defender,* June 1979.

20. In chapter 1, I am more specific with this characterization by referring to a "semitic" type per Tanner's own descriptions of looking at Jewish models for his biblical figures. Here this type is more in between because of Evans's reliance on Sallman's more northern European model.

21. According to Brian James Hallstoos in his dissertation, "Windy City, Holy: Willa Saunders Jones and Black Sacred Music" (PhD diss., University of Iowa, 2009), Jones revised this play by adding more biblical scenes and changing its title until her death in 1979 so that it responded to contemporary racial politics in the United States during each Easter season. For more on the 1946 production in Chicago see Hallstoos, "Windy City, Holy," 333ff. Some black religious plays were also made into films. For more on the relationship between locally produced theater and the role religion played in Black film during the 1940s see Judith Weisenfeld, *Hollywood Be Thy Name: African American Religion in American Film, 1929–1949* (Berkeley: University of California Press, 2007). It is also important to note that the use of all-black casts in these films presented black biblical figures in yet another type of popular visual culture.

22. For more on the Black Arts Movement see Addison Gayle's historic collection *The Black Aesthetic* (New York: Doubleday, 1972), and these two more recent works: James Edward Smethurst , *The Black Arts Movement: Literary Nationalism in the 1960s*

and 1970s (Chapel Hill: University of North Carolina, 2006); and Lisa Gail Collins and Margo Natalie Crawford, *New Thoughts on the Black Arts Movement* (New Brunswick, N.J.: Rutgers University Press, 2006.

23. Important Chicago mural studies include: Eva Cockcroft, John Pitman Weber, and James Cockcroft, *Toward a People's Art: The Contemporary Mural Movement* (Albuquerque: University of New Mexico Press, 1977); Mary Lackritz Gray, *A Guide to Chicago's Murals* (Chicago: University of Chicago Press, 2001); Victor A. Sorell, *A Guide to Chicago's Murals: Yesterday and Today* (Chicago: Chicago Council on Fine Arts, 1979); Robin J. Dunitz and James Prigoff, eds., *Walls of Heritage, Walls of Pride: African American Murals* (San Francisco: Pomegranate Communications, 2000); *The People's Art: Black Murals* (Philadelphia: Philadelphia African American Historical and Cultural Museum, 1986); Lee Andrews Ransaw, "Black Mural Art and its Representation of the Black Community" (PhD diss., Illinois State University, 1973).

24. For more on King's year in Chicago see James R. Ralph, *Northern Protest: Martin Luther King, Jr., Chicago and the Civil Rights Movement* (Cambridge: Harvard University Press, 1993).

25. Walker's best-known tour de force of social critique in the city is *History of the Packinghouse Worker* (1974), which is extant and restored at 48th and Wabash, on the side of what was once the the former headquarters building of District 1, United Packinghouse Workers of America, CIO. Based on Upton Sinclair's *The Jungle* (1906), the mural features a confrontation between meatpacking workers and corporate and political leaders who move diminutive workers around on a chessboard (one of Walker's signature metaphors). Strikingly rendered scenes of black and white workers performing their trade flank this central scene of conflict. The massive, sculptural quality of the figures and mixed scale shows a great debt to Diego Rivera.

26. CPAG is restoring some of these older murals each year. Their website, http://www.cpag.net (last accessed July 19, 2015), provides information on which ones are still extant, restored, or destroyed. Critic and historian Jeff Huebner is currently writing a monograph on Walker. See his article, "The Man behind the Wall," *Chicago Reader*, August 28, 1997, http://www.chicagoreader.com/chicago/the-man-behind-the-wall/Content?oid=894264 (last accessed July 19, 2015). See also the very comprehensive website "The Wall of Respect on the Web," http://www.blockmuseum.northwestern.edu/wallofrespect/main.htm (last accessed July 19, 2015), for more info on specific parts of the wall and its many changes by Walker and others.

27. Quoted in Dunitz and Prigoff, *Walls of Heritage, Walls of Pride*, 62.

28. As quoted in Michael D. Harris, "Urban Totems: The Communal Spirit of Black Murals," in Dunitz and Prigoff, *Walls of Heritage, Walls of Pride*, 24. See also Margo Natalie Crawford, "Black Light on the Wall of Respect: the Chicago Black Arts Movement," in Collins and Crawford, *New Thoughts on the Black Arts Movement*, 23–41.

29. Cockcroft et al., *Toward a People's Art*, 84, 73.

30. William Walker, interview by Victor Sorell, 1991, Archives of American Art, Smithsonian Institution, 27–28; hereafter cited as Walker, AAA interview.

31. Gregory Foster-Rice, "The Artistic Evolution of the Wall of Respect," available at Crossing the Street Files, http://crossingstreet.files.wordpress.com/2007/09/artistic_evolution_wall_respect.pdf, 4 (accessed July 20, 2015).

32. Robert Sengstacke, email correspondence, July 18, 2010.

33. Eugene Wade, interview by the author, July 2, 2011.

34. He replaced Muhammad and the Muslims with a man in a blue patterned dashiki and a crowd of brightly clad protestors holding the same signs as in the earlier version. By 1969 he had repainted that section, including where Sengstacke's photos once were, red, black, and orange. A medallion of confrontational white and black faces held up by one disembodied white hand and one black hovers in the middle of this color field. The words "Peace and Salvation" loop around the medallion's border.

35. See reproduction in Dunitz and Prigoff, *Walls of Heritage, Walls of Pride*, 64.

36. This information was revealed by Eda at the William Walker Memorial held at the South Side Community Art Center in Chicago, October 30, 2011. Near the mural *Peace and Understanding* Walker encouraged people in the community to paint two other murals themselves and one was biblical and done by a local lay preacher and painter John Robinson. Cockcoft et al., *Toward a People's Art*, 76.

37. John Pitman Weber describes the lost interior in "William Walker and Mitchell Caton in the Heart of the Mural Tradition," unpublished essay, March 11, 2000, 5–7.

38. Walker, AAA interview, 73.

39. Ibid., 69.

40. Foster-Rice, "The Artistic Evolution of the Wall of Respect." See also Weber, "William Walker and Mitchell Caton," 5, for more on the painted "posters" Walker erected there over the course of ten years.

41. Ronald E. Brown and Carolyn Hartfield, "The Black Church Culture and Politics in the City of Detroit," Center for Urban Studies, Wayne State University Detroit, October 2001, Working Paper Series, no. 5–8. Cleage's church later changed its name to the Pan African Orthodox Christian Church, as it is called today. Original images of the Black Messiah and Madonna are still extant in the church. Wade also painted the mural *Wall of Meditation* on the back of Olivet Church in Chicago in 1970. The mural is no longer extant but is illustrated in Dunitz and Prigoff, *Walls of Heritage, Walls of Pride*, 67. Wade represented Moses on one side and images of contemporary black heroes such as Malcolm X and the Black Panthers on the other with allusions to a black exodus, physical and phychological, out of the ghettos and chains of racial oppression. For more on the murals in Detroit, see Jeff Huebner, "Detroit Murals," unpublished manuscript, 2011.

42. Jeff Huebner, email correspondence with the author, May 7, 2009. Two of Walker's first murals were Crucifixion and Good Shepherd scenes he painted in 1953

in Zion COGIC church in Columbus, Ohio, while attending the Columbus College of Art. In these images and later in drawings from 1980, Walker represented a white European Christ in the context of church decoration. However, these figures were still presented as militant and wrathful. Later, Walker consistently presented African and African American religious leaders Elijah Muhammad, Martin Luther King Jr., or Jesse Jackson in his murals to define religion's most prominent role in black communities, or at least, as Walker considered them to be. The black Christ in Detroit was a conflation of these contemporary leaders and the historical Jesus.

43. Larry Neal, "Any Day Now: Black Art and Black Liberation," *Ebony*, 24, August 1969, 54.

44. Elijah Muhammad threatened to sue Walker over this composition because of his break with Malcolm X. Walker recounts a few instances when he was threatened by letter or physical intimidation over his representation of Muhammad (Walker, interview by Sorell). This conflation of religious figures with these particular black leaders also had an impact on murals outside of Chicago. Babatunde Folayemi knew Walker and the *Wall of Respect*, so in 1971 when he painted a religious scene in a mural at 126th Street in New York City, he gave Christ the features of George Jackson, a martyr of the Black Power Movement. His disciples were Martin Luther King Jr., Malcolm X, and H. Rap Brown, all with raised fists. Janet Braun-Reinitz, Amy Goodman, and Jane Weissman, *On the Wall: Four Decades of Community Murals in New York City* (Jackson: University of Mississippi Press, 2009, 45–47.

45. Walker, AAA interview, 87–88.

46. Evans, unpublished autobiography.

47. Philips S. Foner, ed., *The Life and Writings of Frederick Douglass, Early Years, 1817–1849* (New York: International, 1950), 162.

48. Wright, "The Challenge to the Black Church" recording of sermon given at the Trinity United Church, Chicago, February 22, 1980. Reaganomics was a hot-button topic. Recordings of Trinity's services are available from the church. William Walker created a mural in Chicago and a series of drawings entitled *Reaganomics* between 1980 and 1982. For more info on these works see Victor Sorell, ed., *Images of Conscience: The Art of Bill Walker* (Chicago: Chicago State University Galleries, 1987), 22–24.

49. Mona Phillips, widow of the artist, interview by the author, June 18, 2011. Most information about Phillips's life and the Trinity commission are from a series of interviews conducted with Mona Phillips June 18–19, 2011, unless otherwise cited.

50. Wright, *Sankofa Moment*, 261–62.

51. Phillips often made carbon copies of his own letters, so inquiries he sent to church officials and theologians are also in the archives of his Cleveland studio.

52. "We are interested in having one section in the sanctuary reflect scenes from the biblical tradition with Africans as the persons depicted and having in the other sanctuary window scenes from the historical African and African-American

tradition (Augustine and Tertulian, Bishop Henry McNeil Turner, Hirum Revels, Marcuc Delaney, Nat Turner and persons from the United Church of Christ such [as] Amos Beamon and Martin Luther King.)" Letter from Phillips to Wright, January 27, 1995.

"In the windows that make up the two entrances, we want persons from African-American history to include, but not be limited to El Hadj Malik Shabazz, W. E. B. DuBois, Harriet Tubman, Sojourner Truth, Queen Nzinga, Tuthmoses, Nefertiti, Pianichy, Tutankhamen, Marcus Garvey, the founding Pastor of our church, Dr. Arthus Gray, Dr. Charles Cobb, and other persons (Male and Female) from the historic and contemporary traditions of an African-American congregation within the United Church of Christ." Letter from Wright to Phillips, April 13, 1994. Both letters Collection of Phillips Glass Studio, Cleveland, Ohio.

53. "Old Medium, New Messages: Stained Glass Windows, Designed, Built by Cleveland Artist Are a Testament to Freedom," *Ebony*, December 1971, 40, 33–42.

54. See also chapter 4 and the conclusion for information on the stained glass programs at Saint Edmund's and Holy Trinity.

55. "St Mel Holy Ghost History: From St. Mel's Grade School Centennial Book, 1886–1986," St. Mel Holy Ghost Class of 1960 Reunion website, 2010, http://smhg60 .com/St%20Mel%20Holy%20Ghost%20History807.htm (last accessed July 20, 2015).

56. New Mount Pilgrim Church: Church History, http://www.newmtpilgrim.org/ about/church-history/ (last accessed July 20, 2015).

57. James H. Cone, *God of the Oppressed* (Maryknoll, N.Y.: Orbis, 1997), 177.

58. All biographical information and quotations are from Tom Feeling's author page on the Penguin Books website, http://www.penguin.com/author/tom-feelings/237775 (last accessed July 20, 2015).

59. 2011 New Mount Pilgrim Missionary Baptist Church newsletter and flyer.

60. Gwendolyn Brooks, "To the Diaspora," in *To Disembark* (Chicago: Third World Press), 41.

61. Much has been written on Wright and his impact on the contemporary black Church and its role in American politics; for example, see Anthony B. Pinn, *The Back Church in the Post–Civil Rights Era* (Maryknoll, N.Y.: Orbis, 2002), 62ff; and Clarence E. Walker and Gregory D. Smithers, *The Preacher and the Politician: Jeremiah Wright, Barack Obama, and Race in America* (Charlottesville: University of Virginia Press, 2009).

62. Barack Obama, "A More Perfect Union," Obama Speech on Race at the National Constitution Center, Philadelphia, March 18, 2008, http://constitutioncenter.org/ amoreperfectunion/ (last accessed July 19, 2015).

63. Cockcroft, et al., *Toward a People's Art*, 37.

64. Whitney-Schenck, "Unashamedly Black and Unapologetically Christian," 16.

Chapter 4. Father Tolton's Soldiers: Black Imagery in Three Catholic Churches

1. Historical information about Saint Monica and Saint Elizabeth is at http://www .stelizabethchicago.com/Page.html (last accessed September 5, 2013).

2. As quoted in Milton C. Sernett, *Bound for the Promised Land: African American Religion and the Great Migration* (Durham, N.C.: Duke University Press, 1997), 159.

3. M. Shawn Copeland, O.P., "African American Catholics and Black Theology: An Interpretation," in *African American Religious Studies: An Interdisciplinary Anthology*, ed. Gayraud S. Wilmore (Durham, N.C.: Duke University Press, 1989), 229.

4. Old St. Mary's Church: A Brief History of Old St. Mary's Church, http:// oldstmarys.com/about-us/history/ (last accessed July 21, 2015).

5. Albert J. Raboteau, *A Fire in the Bones: Reflections on African American Religious History* (Boston: Beacon Press, 1995), 15, 121–24.

6. Ibid., 136.

7. Ibid., 117, 130–36. For James Cone's response to this crisis and his recommendations to Catholics on how to address it, see "Black Liberation Theology and Black Catholics: A Critical Conversation," *Theological Studies* 61 (2000): 731–47. For more on black Catholics, see Anthony B. Pinn, *African American Religious Cultures* (Santa Barbara, Calif.: ABC-CLIO, 2009), 48–58; Diana L. Hayes and Cyprian Davis, O.S.B., eds., *Taking Down Our Harps: Black Catholics in the United States* (Maryknoll, N.Y.: Orbis, 1998); Cyprian Davis, O.S.B., and Jamie T. Phelps, O.P., eds. "*Stamped with the Image of God": African Americans as God's Image in Black* (Maryknoll, N.Y.: Orbis, 2003.); and Shawn Copeland, ed., *Uncommon Faithfulness: The Black Catholic Experience*, (Maryknoll, N.Y.: Orbis)

8. Raboteau, *A Fire in the Bones*, 136.

9. Copeland, "African American Catholics and Black Theology," 233–34. Vatican II made changes such as allowing priests to perform the liturgy in languages other than Latin between 1962 and 1965.

10. All biographical information about Pfleger and his history at Sabina can be found in the recent biography: Robert McClory, *Radical Disciple: Father Pfleger, St. Sabina Church and the Fight for Social Justice* (Chicago: Lawrence Hill Books, 2010).

11. Ibid., 3. For more information and images of Kenar's work, see his website: http://www.religiouskenar.com/liturgical_art.html (last accessed December 5, 2010).

12. This title is taken from John 3:16: "For God so loved the world that he gave His only Son, so that everyone who believes in Him might not perish but might have eternal life."

13. Tracy Dell'Angela, "Rev. Fernando Arizti, 1933–2006: Paintings Were Priest's Prayer," *Chicago Tribune*, March 23, 2006, http://articles.chicagotribune.com/2006 -03-23/news/0603230206_1_murals-jesuit-priest-painting (last accessed July 21, 2015).

14. Gerald Arman, email correspondence, November 17, 2011.

15. Dr. Kimberly M. Lymore, phone interview May, 20, 2011, and email correspondence, May 24, 2011. Using congregants, the common man, as models was common in other well-known regional churches, such as the 1968 black Christ in Saint Cecelia in Detroit, which Devon Cunningham modeled after his barber. Jennifer Lynn Strychasz, "Jesus Is Black: Race and Christianity in Black American Church Art, 1968–1986" (PhD diss., University of Maryland, 2003), 132.

16. *Chicago Sun Times*, June 9, 1984, 21.

17. Biographical information from "Samuel Akainyah," History Makers: Art Makers, interviewed July 18, 2008, and December 14, 2009, http://www.thehistorymakers .com/biography/samuel-akainyah-41 (last accessed July 22, 2015).

18. Elizabeth Abel, *Sign of the Times: The Visual Politics of Jim Crow* (Berkeley: University of California Press, 2010), 35.

19. Ibid., 11. A neon sign hangs above the altar at Saint Sabina and therefore in front of the mural. One experiences the two together so that the yellow neon signifies or witnesses in words the image of the black Christ with outstretched hands. The neon underscores this urban context for this type of pro-black imagery. The sign was supposed to be temporary, but Pfleger kept it hanging in the church to honor the storefront church origins of black worship in Chicago (McClory, *Radical Disciple*, 3). In a podcast from April 22, 2011, Pfleger mentioned the storefront in relationship to the type of black worship with which he identifies as his own: "I don't know, I never know how long I'll be here but as of 10:45 I'm still the pastor of St. Sabina Church. . . . And if I am in a storefront, come by the storefront too" (podcasts are archived at Saint Sabina's, and DVDs of specific sermons can be purchased by contacting the church). The pastor was referring to the Chicago cardinal's threat to move him to another church when he had said on National Public Radio's *Tavis Smiley Show* weeks earlier that he would leave the Catholic Church if he had to leave Sabina.

20. Quoted from West's annual Black History Month visit to Sabina on February 13, 2011. West has been making this visit to the church and other public appearances with Pfleger for more than twelve years.

21. Abel, *Sign of the Times*, 5.

22. Robert McClory, *Radical Disciple, Father Pfleger, St. Sabina Church, and the Fight for Social Justice* (Chicago: Lawrence Hill, 2010), 59–60. All of the details regarding this campaign against these billboards are recounted in the chapter "Painting the Town Red," 59ff.

23. See Jim Jaworski, "Pfleger on Martin: Protect Our Children," *Chicago Tribune*, March 25, 2012, http://www.chicagotribune.com/news/local/breaking/chi -michael-pfleger-trayvon-martin-st.-sabina-story.html (last accessed August 26, 2015). A wooden sculpture also sat in the front pew in a hoodie holding Skittles and an Arizona Ice Tea, the objects so widely reported as all that Martin had on him

when his body was found; see photo at http://www.chicagotribune.com/news/local/ breaking/chi-ct-ct-met-trayvon-0120120325124559,0,7530600.photo (last accessed July 24, 2015). See also http://www.finalcall.com/artman/publish/article_3650.shtml (last accessed December 10, 2010).

24. Like the "Mothers Wall" of photos memorializing the children murdered in Chicago, the cross became a permanent installation at the church.

25. Erika Doss, *Memorial Mania: Public Feeling in America* (Chicago: University of Chicago Press, 2010), 71.

26. Ashahed M. Muhammad, "Silent March: A Solemn Reminder of Youthful Lives Lost," *The Final Call*, June 27, 2007, http://www.finalcall.com/artman/publish/ National_News_2/Silent_march_A_solemn_reminder_of_youthful_lives_l_3650. shtml (last accessed December 10, 2010).

27. All biographical information and quotations by Repasi are from email correspondence with author, August 12, 2009, unless otherwise stated.

28. Burroughs, the cofounder of the city's DuSable Museum and founding member of the South Side Community Art Center, was a very influential and beloved African American artist, activist, and cultural icon in the city who also served many years in the mayor's office.

29. Beginning in the late 1990s, Chicago's Catholic schools began closing due to low enrollments and diminishing funding as congregations shrank. In 2005 the archdiocese closed twenty-three schools, most located in predominantly black and Latino neighborhoods where free public school education is preferred. "23 Chicago Catholic Schools Closing," *Chicago Tribune*, February 25, 2005.

30. All biographical information for Claver comes from *The Catholic Encyclopedia*, Volume 11 (New York: Robert Appleton Company, 1911), unless otherwise noted.

31. See Knights of Peter Claver website at http://www.knightsofpeterclaver.com/ (last accessed July 17, 2009).

32. These murals on canvas are still in the gym but have been covered for decades. This author has been able to see parts of them and believes they may be by Pilgrim's muralist William E. Scott.

33. "The Holy Angels Mural," Holy Angels Catholic Church, April 7, 2013, http:// www.holyangels.com/node/5 (last accessed July 24, 2015).

34. Ibid.

35. There are many books and articles on these quilts. A recent one is Kyra E. Hicks, *This I Accomplish: Harriet Powers' Bible Quilt and Other Pieces* (n.p.: Black Threads Press, 2009).

36. Richard Hunt, interview with author, August 2, 1998.

37. Jan Garden Gastro, "Richard Hunt: Freeing the Human Soul," *Sculpture* 17, no. 5 (1998): 38. For more on Hunt see Sharon F. Patton, *African-American Art* (Oxford:

Oxford University Press, 1998), 212, 218, 231–32, figs. 111–12; and Adrienne Drell, "Sculptor Richard Hunt: Even His Trash Is Art," *Chicago Sun-Times*, November 27, 1994. Sect. B. p. 16.

38. Hunt quoted in "Something of Value," Jeffery McNary's blog, April 27, 2009, http://jefferymcnary.blogspot.com/2009/04/something-of-value.html. *The Bush Was Not Consumed*, welded brass and bronze, and *Eternal Life*, welded bronze, both of Temple B'nai Israel, Kankakee, IL; *St. Procopius*, welded bronze, Saint Procopius Abbey, Lisle, Illinois; *Three Crosses*, welded stainless steel and bronze, University Park Baptist Church, Charlotte, North Carolina; and *Memorial Cross*, welded bronze, Immanuel Lutheran Church, Charlotte, North Carolina.

Chapter 5. Urban Street Faith: Murals, T-shirts, and Devout Graffiti

All lyric transcriptions were made by Reed himself and sent to me in email correspondence on January 4, 2012.

1. He will be the lead restorer on the upcoming repainting of Walker's only surviving church mural, *All of Mankind*, also discussed in chapter 3.

2. Information concerning the church's history and the stained glass windows can be found at the website for Saint Edmund's, http://www.stedmundschicago.com (last accessed July 25, 2015). In keeping with all of the church histories in this book, the charismatic Dr. Richard Lamar Tolliver became the church's pastor in 1989, and by 1991 he had founded Saint Edmund's Redevelopment Corporation (SERC), which has revitalized this corner of Washington Park and the church. With a doctorate in political science and having traveled abroad extensively while in the Peace Corps serving in Kenya, Tolliver has always considered cultural revitalization as important as economic. The pastor has been a board member of the Art Institute of Chicago and Ravinia Arts Festival; he also collects art.

3. For images and names for each window, see "Stained Glass Windows," Saint Edmund's Episcopal Church, http://www.stedmundschicago.com/index.php?page=stained-glass (last accessed July 25, 2015).

4. Bernard Williams, interview by the author, July 22, 2011.

5. Marshall invited an artist whose generation influenced him and one from the group ahead of him at each venue for this exhibition. It was his way of acknowledging some black artists who had not received the attention they deserve while promoting emerging ones.

6. For more on rap and religion see Anthony B. Pinn, *Noise and Spirit: The Religious and Spiritual Sensibilities of Rap Music* (New York: New York University Press, 2003); and Efrem Smith and Phil Jackson, *The Hip-Hop Church: Connecting with the Movement shaping our Culture* (Downers Grove, Ill.: InterVarsity Press, 2005).

7. Artist's statement from Chicago Public Art Group, http://www.cpag.net/home/artistbios/reed.html (last accessed September 29, 2013).

8. Smith and Jackson, *The Hip-Hop Church*, 25.

9. Ibid., 151.

10. Ibid., 204–5.

11. Ibid., 215.

12. Damon Lamar Reed, email correspondence with author, December 28, 2011.

13. Louise Vincent, "Steve Biko and Stoned Cherrie: Refashioning the Body Politic in Democratic South Africa," *African Sociological Review* 11, no. 2 (2007): 80–93. The rash of gang-related murders of schoolchildren in the last decade has brought the '90s urban trend of wearing memorial T-shirts back in vogue. Families and friends of victims of police violence also frequently make memorial T-shirts (often partly as fundraisers for the unexpected burial expenses). It is not uncommon to see a parade of mass-produced T-shirts with portraits of the deceased at televised rallies and funerals. In some instances religious motifs, such as a cross or a crown of thorns are included. The use of the memorial tee, according to Jen Shreve, gained widespread currency in Los Angeles in the 1990s to remember slain gang members, most notably rapper and movie actor Tupac Shakur. For more on memorial T-shirts see Jenn Shreve, "A Fitting Memorial: The Growing Popularity of the Memorial T-shirt," Slate, August 26, 2003, http://www.slate.com/id/2087407 (last accessed July 25, 2015); Emily Yellin, "New Orleans Epitaph: Dead Man Shirts," *New York Times*, April 17, 2000; Allison Engel, "In the Rear Window, Tributes to the Dead," *New York Times*, December 11, 2005; Erika Doss, "Death, Art, and Memory in the Public Sphere," *Mortality*, no. 7 (2002): 63–82. And more recently, in the spring of 2011, the Chinese government made it illegal to represent the image of jailed artist Ai Wei Wei after a graffiti artist started placing stencils, T-shirts, and projection of his face with the phrase "Who's Afraid of Ai Wei Wei" around Hong Kong. These examples show what a powerful tool of dissent a less static public art such as the worn T-shirt can be in an urban environment that guarantees an instantaneous mass audience.

14. For more on unpacking the significance of the tattoo on the black body see Michael Eric Dyson, "I Got Your Name Tatted on My Arm: Reading the Black Body," in *Holler If You Hear Me: Searching for Tupac Shakur* (New York: Basic Civita, 2001), 231–46.

15. David Morgan, *Protestants and Pictures: Religion, Visual Culture, and the Age of American Mass Production* (Oxford: Oxford University Press, 1999); and David Morgan and Sally Promey, eds., *The Visual Culture of American Religions* (Berkeley: University of California Press, 2001).

16. http://www.bombingscience.com/index.php/blog/viewThread/1772 (last accessed March 15, 2012). Jesus Saves considers himself a man of God as a graffiti evangelist who lead Bible studies and counseled fellow inmates while serving at Riker's Island. His tags sometimes include other biblical passages.

17. James H. Cone, *God of the Oppressed* (Maryknoll, N.Y.: Orbis, 1997), 110.

Conclusion. Where the Black Christ Suffers and the Politics of Tragic Space in Chicago

1. Kenneth E. Foote, *Shadowed Ground: America's Landscapes of Violence and Tragedy* (1997; Austin: University of Texas Press, 2003), 5. I also found Craig L. Wilkins's *The Aesthetics of Equity: Notes on Race, Space Architecture and Music* (Minneapolis: University of Minnesota Press, 2007) to be very insightful into these issues of race and space.

2. Erika Doss, *Memorial Mania: Public Feeling in America* (Chicago: University of Chicago Press, 2010), 94.

3. Cornel West, "Subversive Joy and Revolutionary Patience in Black Christianity," *The Cornel West Reader* (New York: Civitas), 437–38. In his book *Is God a White Racist* (Boston: Beacon Press, 1973), William R. Jones questioned the centrality of suffering in Black Liberation Theology. He considered it to be as oppressing as traditional Christianity and argued for a theism for oppressed peoples that offered more spiritual autonomy divorced from suffering.

4. Lewis R. Gordon, ed., *Existence in Black: An Anthology of Black Existential Philosophy* (New York: Routledge, 1997).

5. Karla F. C. Holloway, *Passing On: African American Mourning Stories, A Memorial* (Durham: Duke University Press, 2002), 2. Holloway uses the term "black death" throughout the book much in the same way I deploy the black tragic space as something culturally rich and very active within the formation of African American identity. She considers "black death" "a cultural haunting, a re-memory along the lines of that found in Toni Morrison's *Beloved*" (3). She also gives examples in history, literature, and popular culture where multiple narratives of black loss are constantly fused together creating a unity of sorrow, a cornerstone of the construction of African American history.

6. For more on these fires as part of a recurrent theme in African American church history, see Anthony B. Pinn, *The Black Church in the Post–Civil Rights Era* (Maryknoll, N.Y.: Orbis, 2002), 35–36.

7. Within weeks of the fire, the church had retained Johnson & Lee Architects/Planners to head up the rebuilding design. They have also been working with Quinn Evans of Ann Arbor, Michigan, a leading architecture firm that has experience in preservation and merging old and new designs. A new mural will also be installed. Complete plans are available at http://www.rebuildpilgrim.org/plans (last accessed September 29, 2013).

8. See Kymberly Pinder, "Missus Kara E. Walker: Emancipated, and On Tour," review of *Kara Walker: My Complement, My Enemy, My Oppressor, My Love*, Walker Art Center, Minneapolis, *Art Bulletin* 90, no. 4 (2008): 640–48.

9. In addition to fleeing hounds and sleeping in caves, Addy and her mother had to leave her one-year-old sister on the plantation. Online games for this character

include raising money to help the church reunite slave families. In 2006, Addy's story became a play, and in 2007–8 the play toured the United States.

10. bell hooks, "In Our Glory: Photography and Black Life, " in *Picturing Us: African American Identity in Photography*, ed. Deborah Willis (New York: New Press, 1994), 47. In 1970 Mitchel Caton, with poetry by C. Siddha Sila Webber, commemorated Hampton's death in the mural *Universal Alley*, (1968–1973), located at 50th Street and Champlain. This mural, like *The Wall of Respect,* became a community meeting place for prayer, readings, and jazz performances for many years. It was never restored, so very little of it is still visible. See Robin Dunitz and John Prigoff, eds., *Walls of Heritage, Walls of Pride: African American Murals* (San Francisco: Pomegranate Communications, 2000), 68.

11. The motel is currently a part of the National Civil Rights Museum. In 2006 a controversy raged over the renaming of this block of Monroe Street "Fred Hampton Senior Way."

12. In an attempt to invigorate desegregation efforts in the North, in 1966 Martin Luther King Jr. temporarily moved his family into an apartment at 1550 S. Hamlin Avenue, in the heart of a black slum. For more on King's efforts in Chicago see James R. Ralph Jr., *Northern Protest: Martin Luther King, Jr., Chicago and the Civil Rights Movement* (Cambridge: Harvard University Press, 1993). Currently, local and national agencies are planning a new housing complex, park, and community center on this vacant lot to commemorate MLK's protest against unfair housing practices in Chicago.

13. Doss, *Memorial Mania*, 115. See pages 96–97 in Doss's chapter on grief for her discussion of how race and class play a factor in how some deaths are given more public media attention and, therefore, valued more than others.

14. Mary Schmich, "Slow Change Coming Fast at Cabrini-Green: Last Buildings Are Almost Gone, but Where Will the Last of the Residents Go?," *Chicago Tribune*, August 20, 2010, http://articles.chicagotribune.com/2010-08-20/news/ct-met-schmich-0820-20100819_1_cabrini-green-building-residents (last accessed July 25, 2015). The artist Jan Tichy installed 134 LED lights in this remaining building at 1230 N. Burling Street for the duration of the three weeks it took to bring the last building down. His installation, which could be viewed via a live feed 24/7 (http://www.projectcabrinigreen.org/video.php; last accessed April 5, 2010) was destroyed with this last vestige of Cabrini-Green. The live feed and onsite experience allowed viewers from all over the world to witness an important moment in urban history, and, I would argue, in the history of black tragic space in Chicago, that would have otherwise gone largely unnoticed and undocumented. Tichy's lights would flash intermittently from 7 P.M. until 1 A.M. each night. Online they appeared more like morse code, SOS signals from trapped residents or insistent ghosts, emphasizing a history, a home, a site of memory that was disappearing floor by floor each day. When viewed on site the lights were like spotlights briefly illuminating the empty rooms, revealing dangling

fixtures or sometimes colorfully painted cement block. Ironically, on site, the flashing lights looked more like the flashes from welding tools, suggesting construction rather than destruction among the crumbling walls.

15. David Theo Goldberg, *Racist Culture: Philosophy and the Politics of Meaning* (Oxford: Blackwell, 1993), 188.

Index

KYMBERLY N. PINDER is Dean of the College of Fine Arts at the University of New Mexico and editor of *Race-ing Art History: Critical Readings in Race and Art History.*

The New Black Studies Series

The University of Illinois Press
is a founding member of the
Association of American University Presses.

Designed by Jennifer S. Holzner
Composed in 10.5/13 Minion Pro
with Helvetica Neue LT Std display
by Kirsten Dennison
at the University of Illinois Press
Manufactured by Bang Printing

University of Illinois Press
1325 South Oak Street
Champaign, IL 61820-6903
www.press.uillinois.edu